Indians first came to Fiji as indentured labourers in 1879. Since the Rabuka coup d'état in 1987, and three subsequent Fiji coups, Indian-Fijians have been emigrating from the country in earnest.

Newsflas

Television news, Fiji, 28 June 2000

h: George

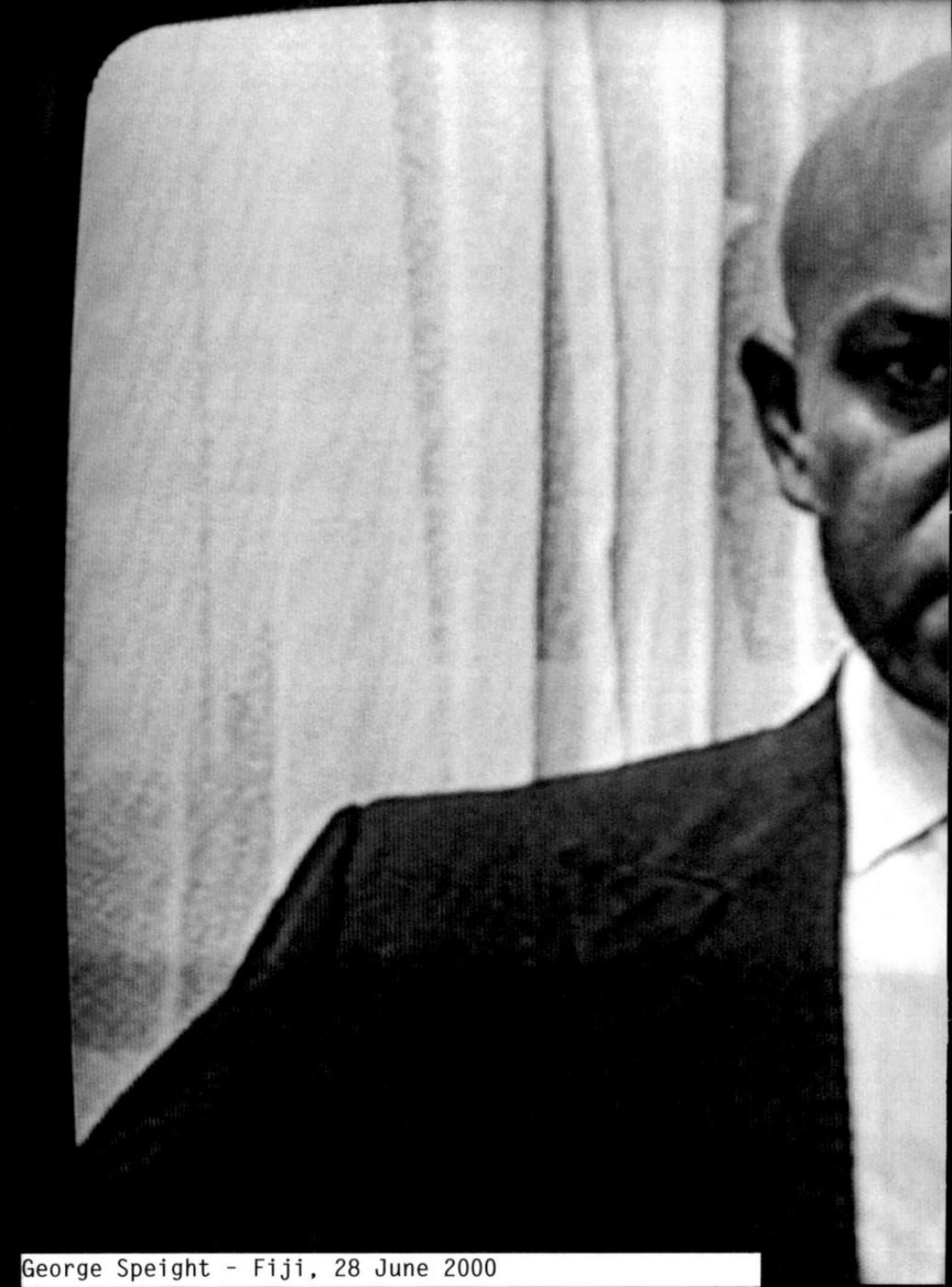
George Speight - Fiji, 28 June 2000

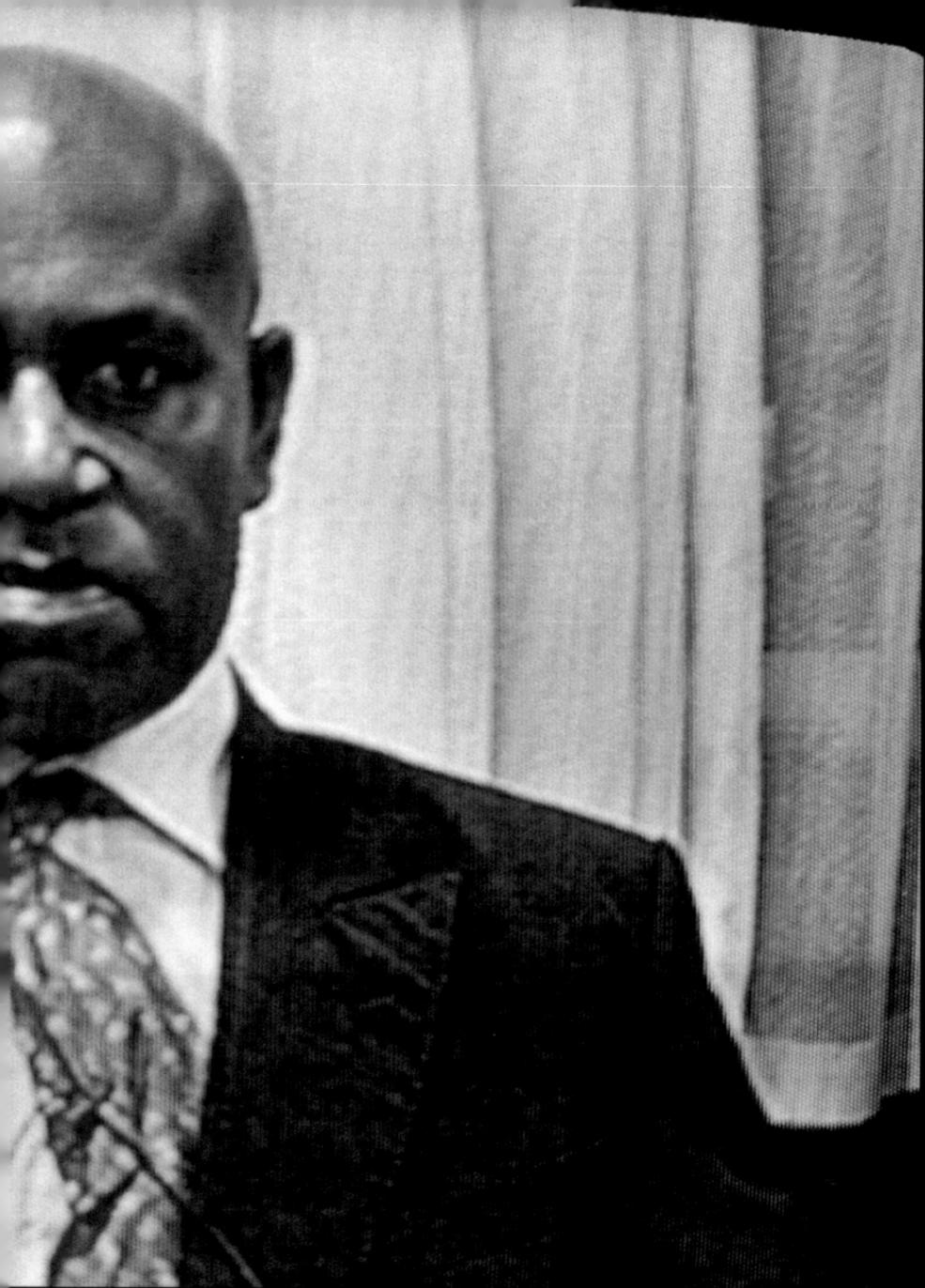

WITH A STORY BY BRIJ V LAL

STOPOVER

Bruce Connew

HAWAI

UNIVERSITY OF HAWAI'I PRESS
HONOLULU

a story of migration ...

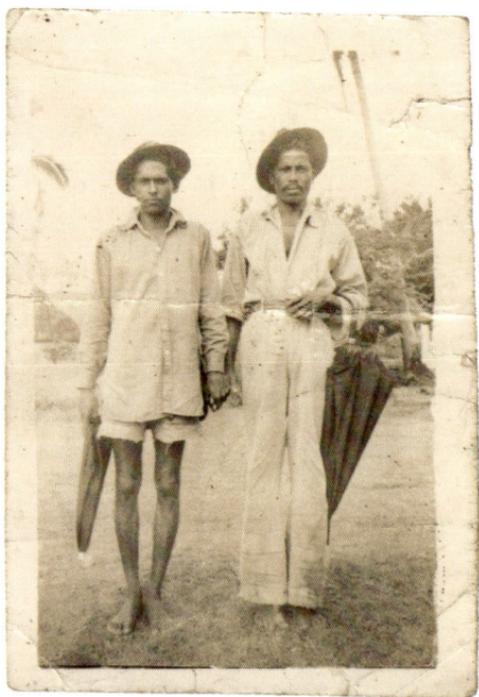

THE AGED PHOTOGRAPH on the preceding page is of two Indian-Fijian men. They are most likely early descendants of indentured Indian immigrants brought to Fiji between 1879 and 1916 to cut sugar cane on unforgiving, five-year contracts; or perhaps one of them is an indentured Indian immigrant, and out of indenture given the likely date of the photograph, holding hands with his son. No one is quite sure. I came across it loose inside the back cover of Aren Kumar's family photo-album. I hadn't been looking for photographs from the past. I was after recent snapshots of Aren's relatives, especially those who had emigrated to such bright lights as Vancouver, Sydney and San Francisco since the coups in Fiji in 1987 and 2000. As I thumbed through the album's pages, there were plenty of colour prints to choose from, sent home proudly as evidence of settlement from family members now in new countries and placed with care as pictures of aspiration; and not only in Aren's family album, but also in those of others in the valley. Emigrating was the big thing, and, in and out of earning a small living, still is.

I had been staying with Aren's younger brother Dharmen, a short walk up the dirt road that ran between their tall, abundant sugar cane crops. I had

returned six times to Vatiyaka since the 2000 coup, each
time lodging in a back room of the home Dharmen shares with
his wife Padma and their two young boys, Kushal and Koonal.
When I was first introduced to Dharmen in the midst of the
coup, he was *sirdar* of his local sugar cane cutting gang.
The gang was made up of men, mostly from his extended fam-
ily. Like him, they lived, and on the whole still do, near
one another on leased 10-acre sugar cane plots in Vatiyaka,
a valley in the west of Viti Levu, Fiji's biggest island.
Each sugar cane season, by means of a proper arrangement,
the men of the gang harvest one another's crops. Aren owns
the lorry that hauls the cut sugar cane to the mill.

　　　　　　At the time George Speight and his
co-conspirators embarked upon the 2000 coup, taking hostage
the Indian-Fijian prime minister, Mahendra Chaudhry, and
elected members of his government, my two elder daughters
in New Zealand both had Fijian partners. I hadn't thought
this so extraordinary, but with news of the coup I began
to think: how do I deal with this? One is an Indian-Fijian
who arrived in New Zealand with his parents in 1987 after
the previous two coups — the Rabuka coups — and the other
an indigenous Fijian here on a university scholarship. They
were almost as dear to me as my daughters. They got on well,
and in fact once lived not far from each other in a mid-
dle-class suburb of Suva. But when we sat around the table
talking after Speight had stormed parliament, it brought to
mind other conversations we'd had. I could remember think-
ing during some of those conversations that each of them
was describing a different Fiji, a different country almost
— two countries called Fiji.

　　　　　　A week after Speight sets free the
last of the hostages, I will watch my second daughter's

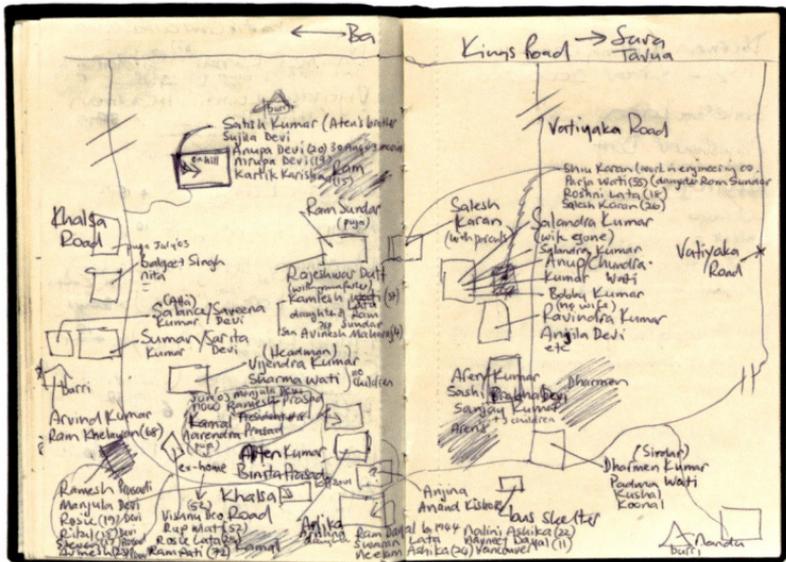

My diary map of Vatiyaka

Fijian partner caress her temple as a contraction takes
hold. Before morning, they will have had a son, my first
grandchild, a boy, the first boy of the eldest son, a half-
caste, 'the boss', says his Fijian grandfather. The next day,
the Indian-Fijian partner of my eldest daughter will sit on
the edge of the hospital bed and hold the swaddled baby close
to him as he reads the front page of a newspaper.

I was keen to look around these coun-
tries, I had told them some weeks earlier. My plan, I said,
was to be back in plenty of time for this birth. My reason
for being in Fiji was no more than that.

After two days in Fiji, the parents
of my second daughter's partner invite me to the funeral of
a paramount chief on Bau Island, an island potent well beyond
its few indigenous hectares. It is the seat of the *Vunivalu*,

the king of Fiji, except there hasn't been one for 10 years or more, not since the last died in November 1989. They loan me a school history book, so I'll better understand the weighty significance of Bau. It is day 39 of the coup. They tell me to photograph the ironies at the funeral, and I wonder how do you photograph ironies, and which are the ironies? I must look at the mourners, they explain. I flip back to the names given me the previous evening: tribal enemies, family enemies, political enemies, business enemies, and some of them, all of these at the same time. Bickering bitternesses, dark histories. It's so convoluted that rather than unravelling the detail of power, the plethora of opinions only pulls the knot tighter. Perhaps it is my imagination, but there is a smell in the air, on this day of farewell, of unclean affiliations and shifting powers. An unlikely mix of people, here from all over the country, will whisper not a word of the squalor consuming Fiji. They will enter the church, heads bowed, and sing as one 'The Sands of Time are Sinking', 'The Lord is my Shepherd', and 'Now Praise We Great and Famous Men'.

 Later, while settling in between the concrete block walls of my motel room, I see Chaudhry and a cluster of hostages briefly on television pacing up and down a path next to the building where they were routinely confined. It is unexpected. Any view of the hostages has been rare. Chaudhry walks separately from the others and appears meditative. It is sickening. Gazing back to this time, I figure it is then, at a moment of witness when Fijians are seen to hold Indians hostage, that I resolve to move on from the curse of dishonest power. A five-hour bus journey takes me across the top of Viti Levu to the sugar cane fields of Ba, the grassroots of Chaudhry's support,

where he was born in the midst of the unfortunate history of Indian indenture.

George Speight and his small band of army mutineers held their hostages for 56 days. While some said the coup concerned race issues, as time moved on, there was more talk of greed and a spiteful tilt at power. Whatever explanation will finally emerge, the several coups, including this Speight fiasco, have persuaded Indian-Fijians — who, third-, fourth- and fifth-generation Fijians, are forbidden to own land in Fiji — to suppose their future lies beyond the country of their birth. It is hardly unexpected that educated Indian-Fijian youth have aspirations, as their parents have for them, well clear of cutting sugar cane. And while the Fiji sugar industry has long been the sweet asset of Fiji's economy on the back of Indian labour and farming flair, its influence is certain to decline. The migration of Indian-Fijians to first world countries continues.

Speight was convicted of treason and condemned to death, a sentence quickly commuted to life imprisonment. Chaudhry's government was not reinstated when the army finally moved to end the crisis. Instead, the army leader, Commodore Voreqe Bainimarama, prescribed an interim civilian government and a new election. The Fiji Labour Party, Chaudhry's party, failed to win that election, and nor did it win the following election in May 2006. At that time, people — amongst them high-ranking Fijians — were still, although unhurriedly, being brought to account for their part in the 2000 coup. There are more yet to be rooted out, some of whom were members of the May 2006 government when, on 5 December 2006, it was ousted by the army in the fourth coup d'état in 20 years — the Bainimarama coup.

A coup is a blunt instrument, even when bringing down an elected government deserving of not much compassion. It is unfortunate that Pacific leaders New Zealand and Australia, during the years since the Speight coup, failed to sufficiently encourage fitting governance out of Fiji's elected administration.

This old photograph caught my eye because I had seen very few photographs of the sugar cane cutters' forebears. I figured it must have been taken in the 1940s, perhaps earlier, and wherever I went in the valley, I asked about other such photographs, but there seemed none to be had. In conversations with the elderly of Vatiyaka, I endeavoured to establish far-off family lines, but it was rare that someone could help me. This knowledge seemed unavailable, as if their roots had withered from distraction. The children of the valley and their parents, some of them, could name the early ships that brought Indian indentured labour to Fiji to cut sugar cane, but I was told they had learnt this at school and not through the oral handover of family history. A woman in the valley explained that the early immigrants from India were largely uneducated and could neither read nor write. They soon lost touch with family across a sea of impossible distance. I asked Aren who these two men were. He couldn't tell me, and neither could Dharmen when I borrowed the photograph to ask him. No one else could either. They were kin, Dharmen and Aren both said, but they couldn't fit them in. They were unknown.

BRUCE CONNEW

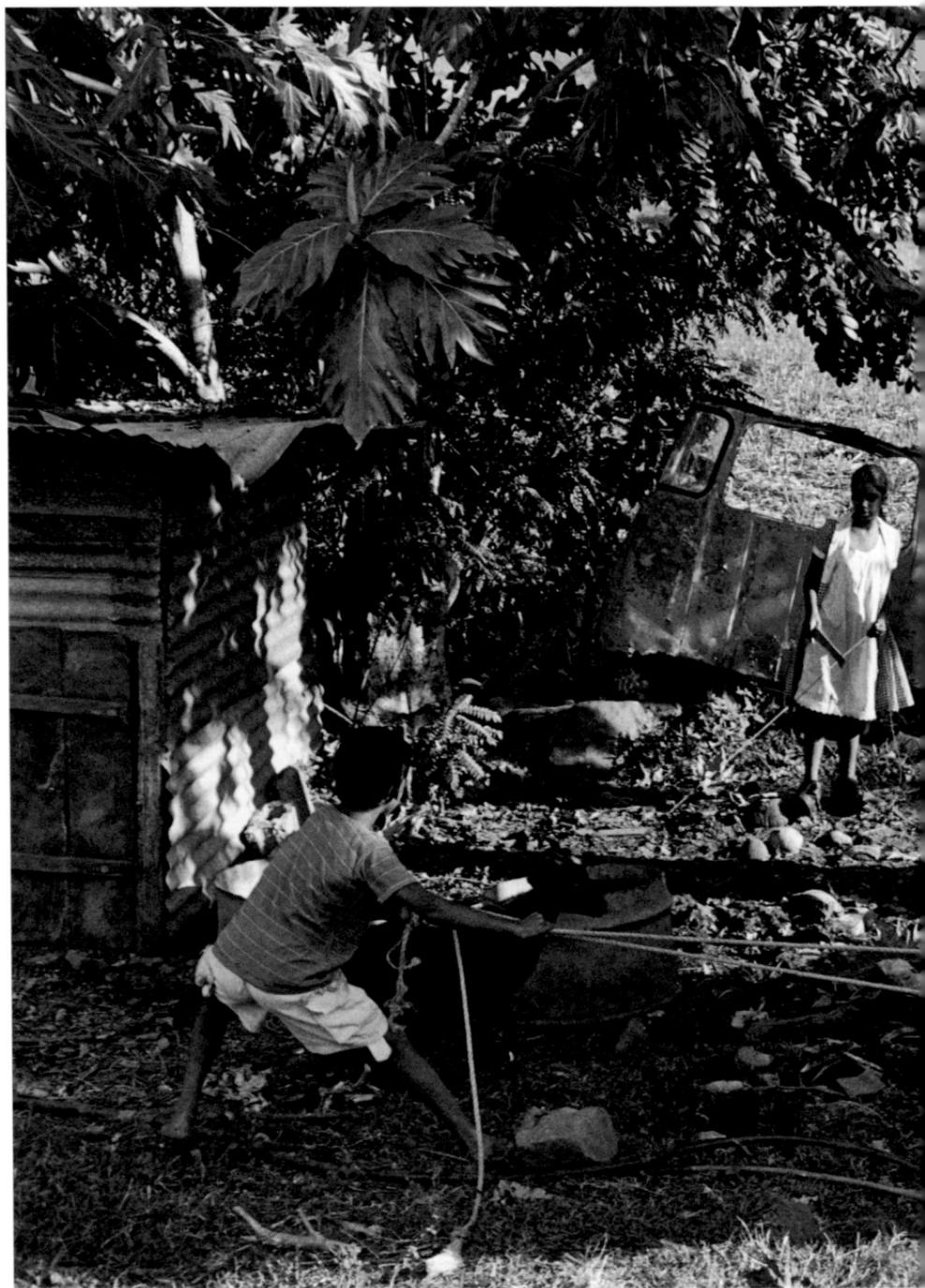

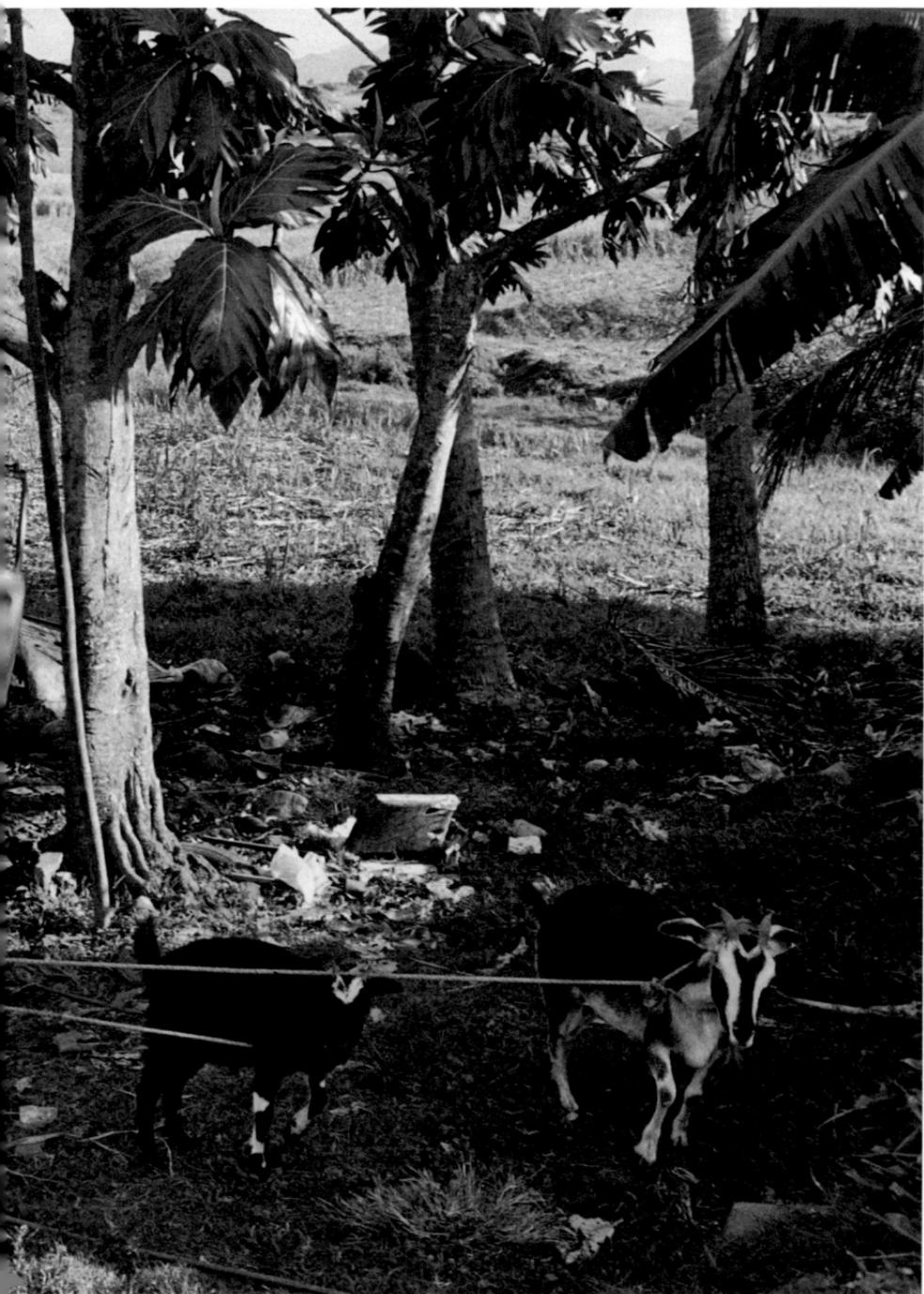

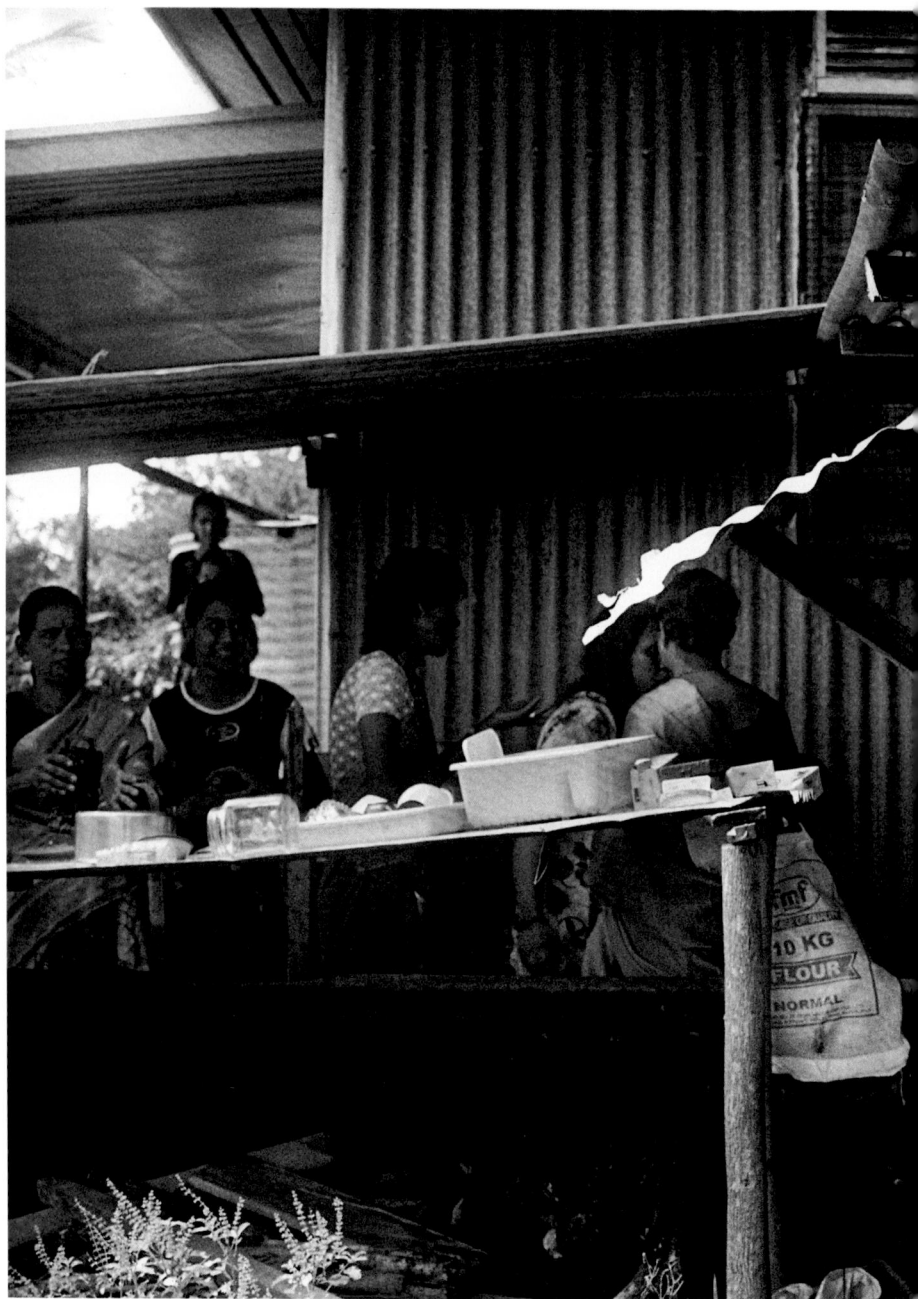

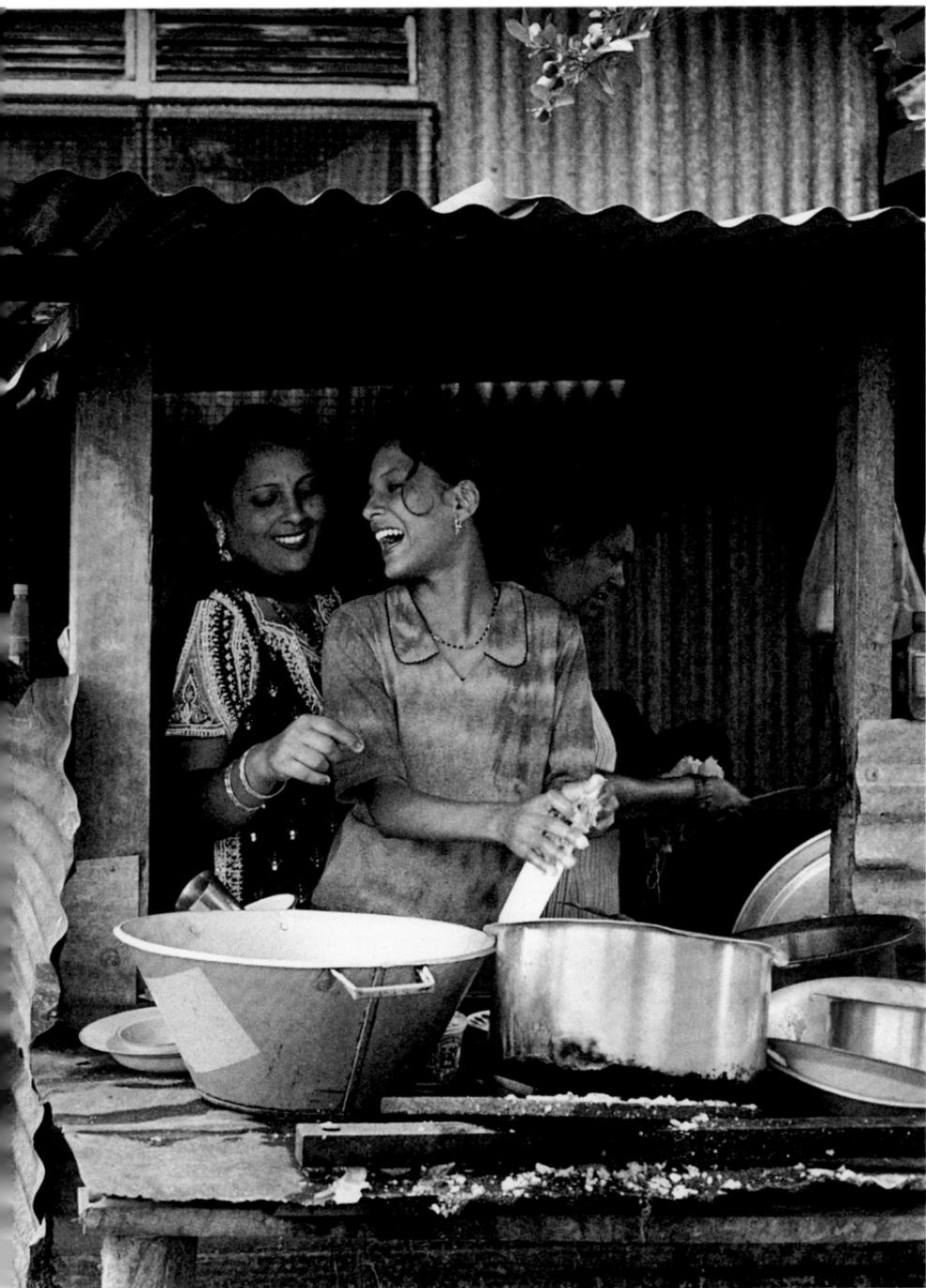

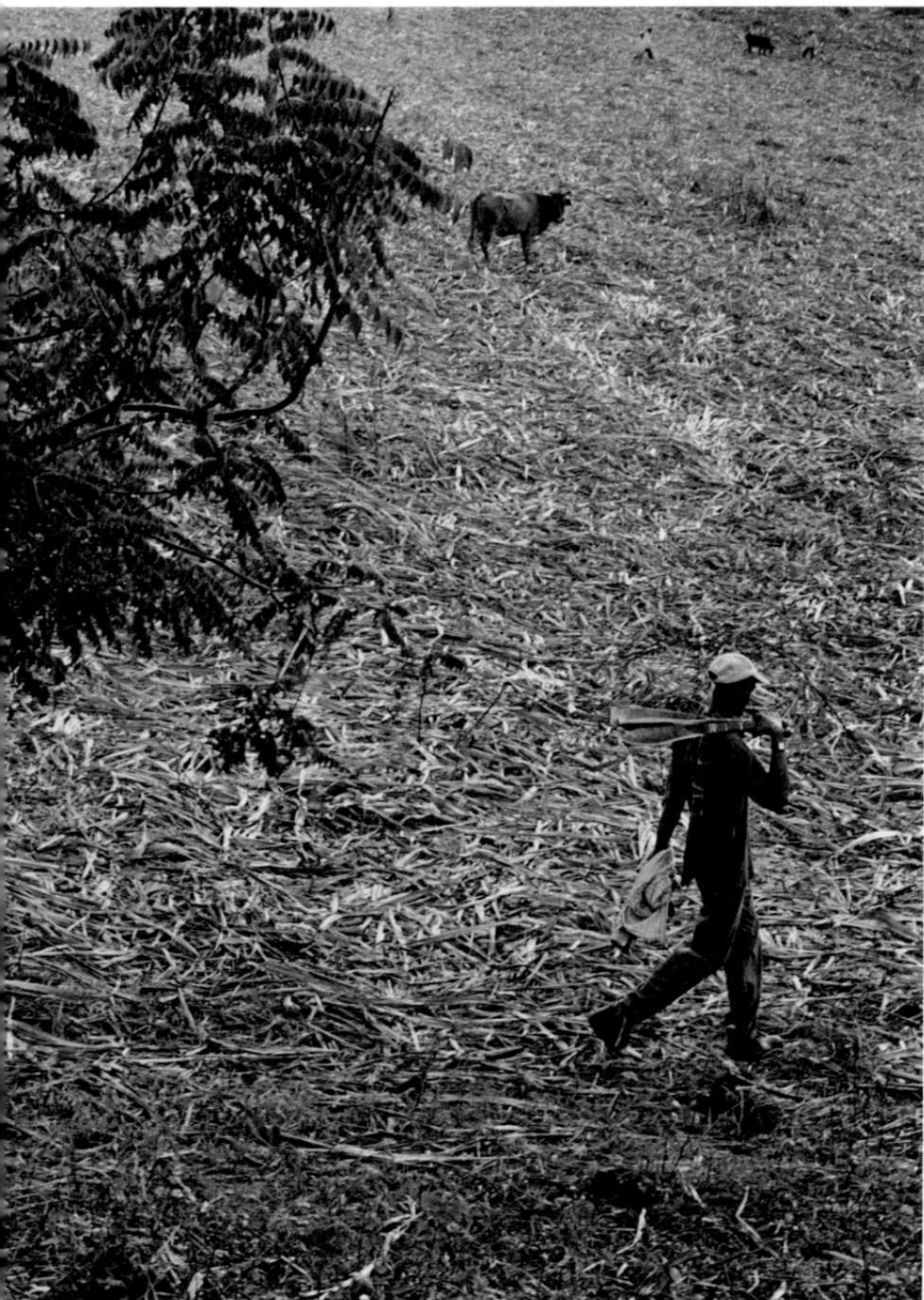

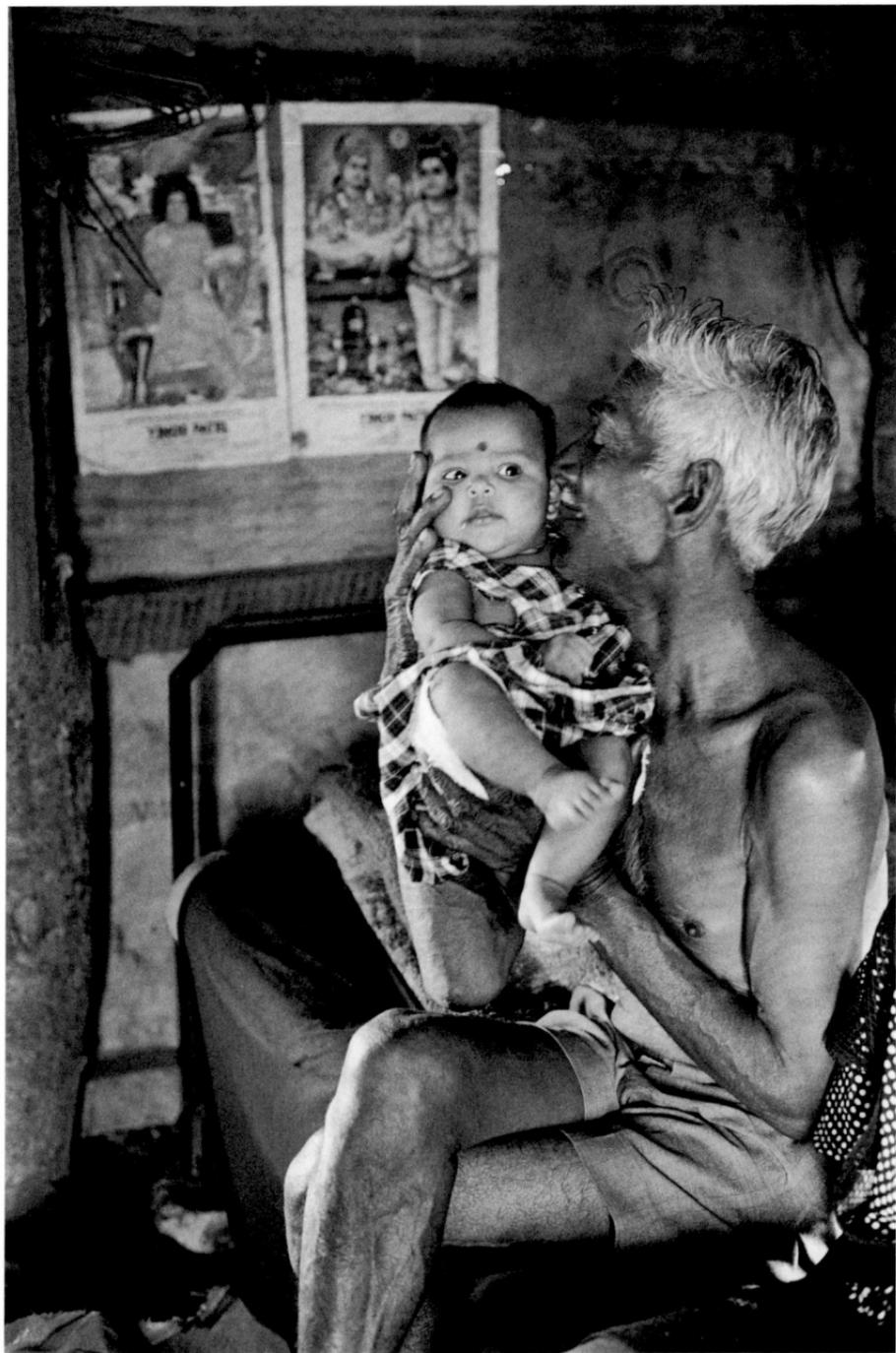

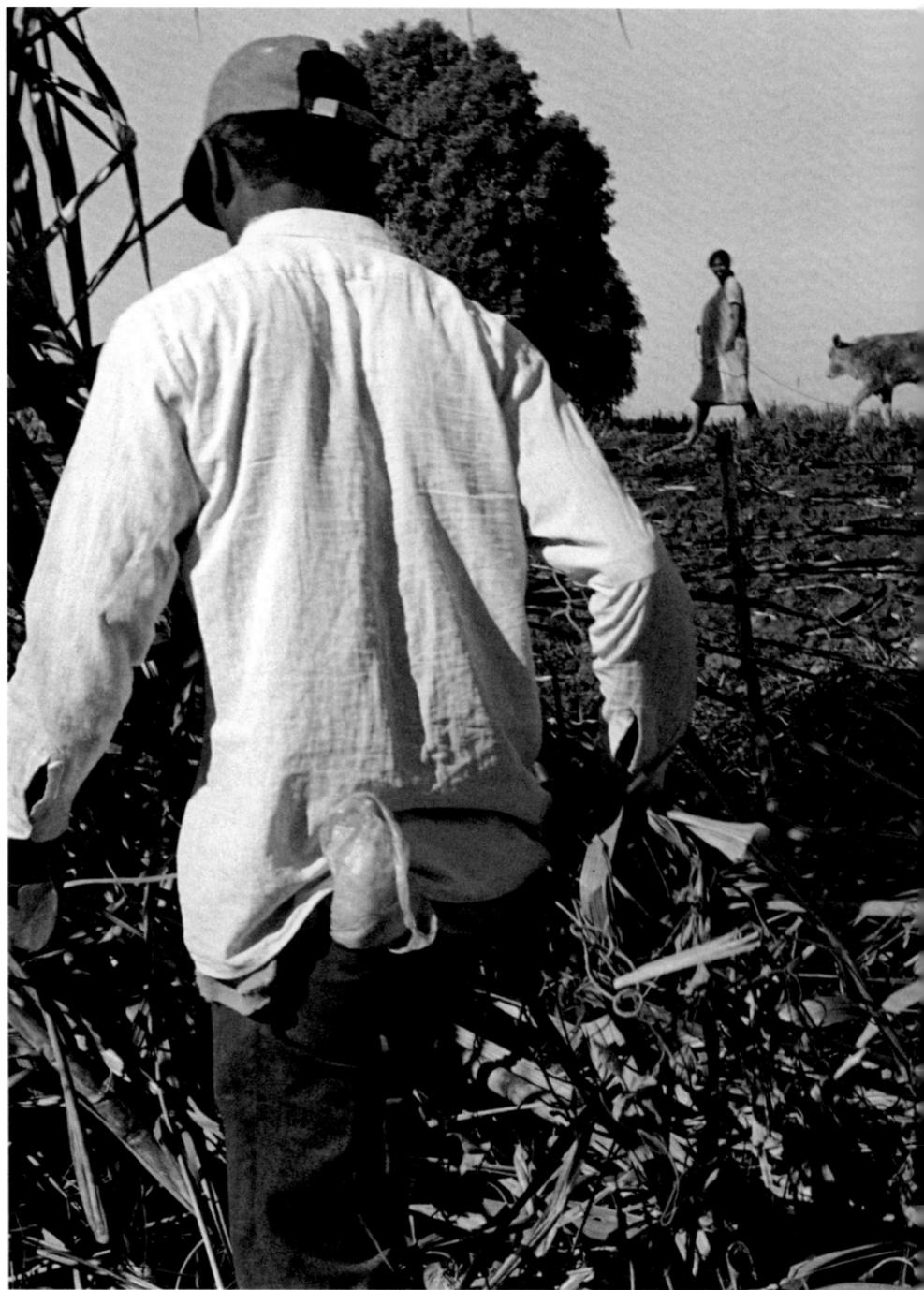

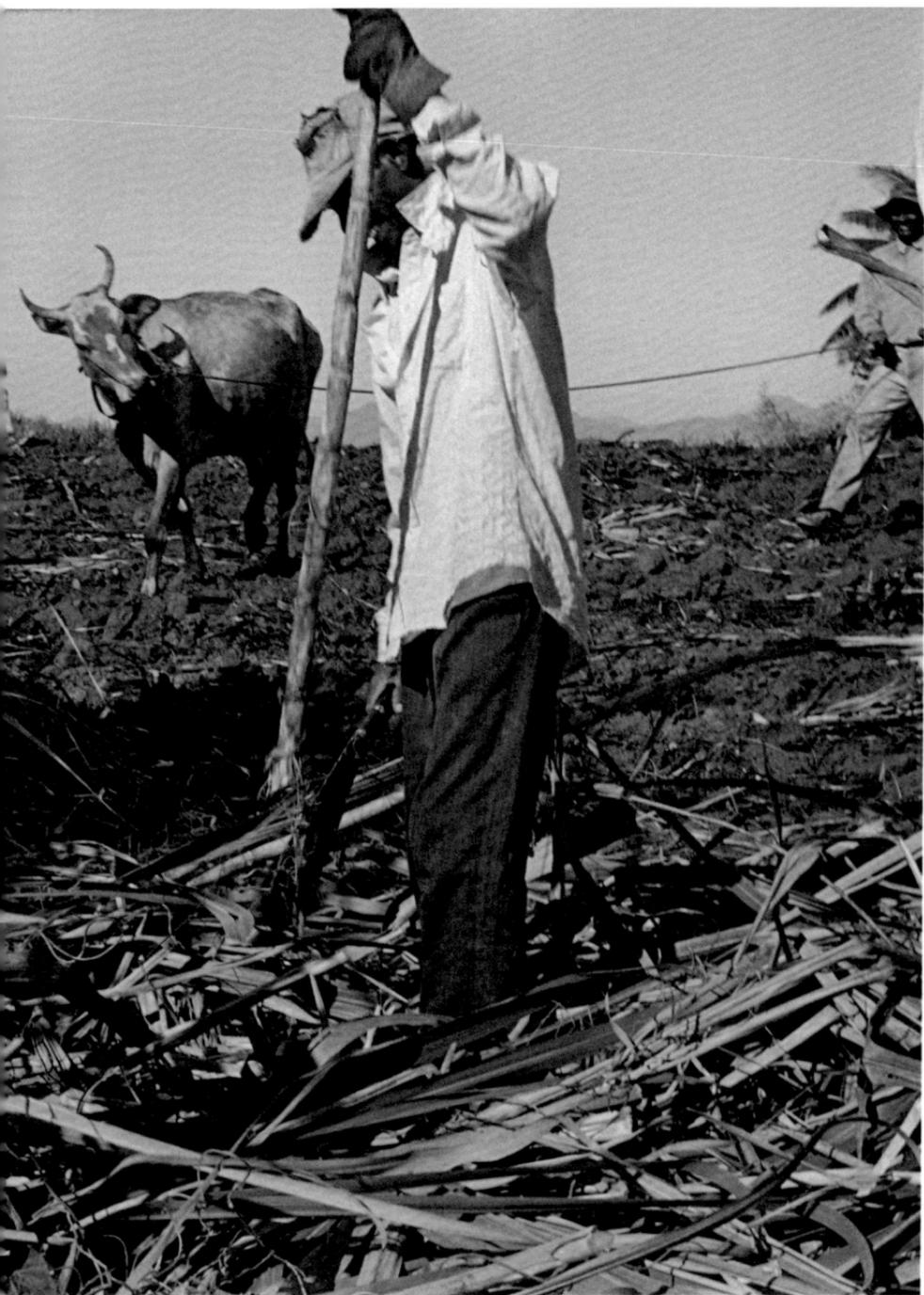

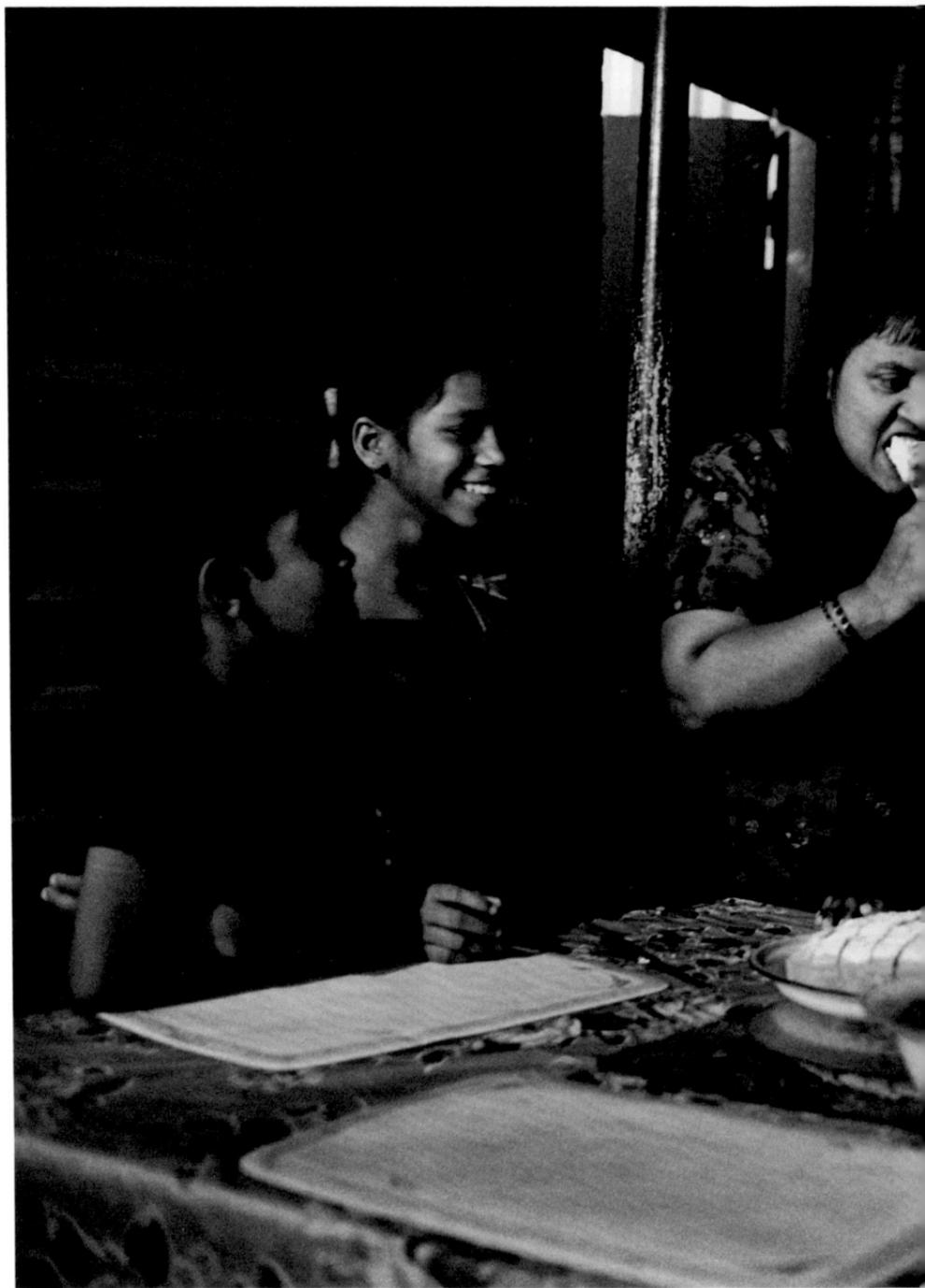

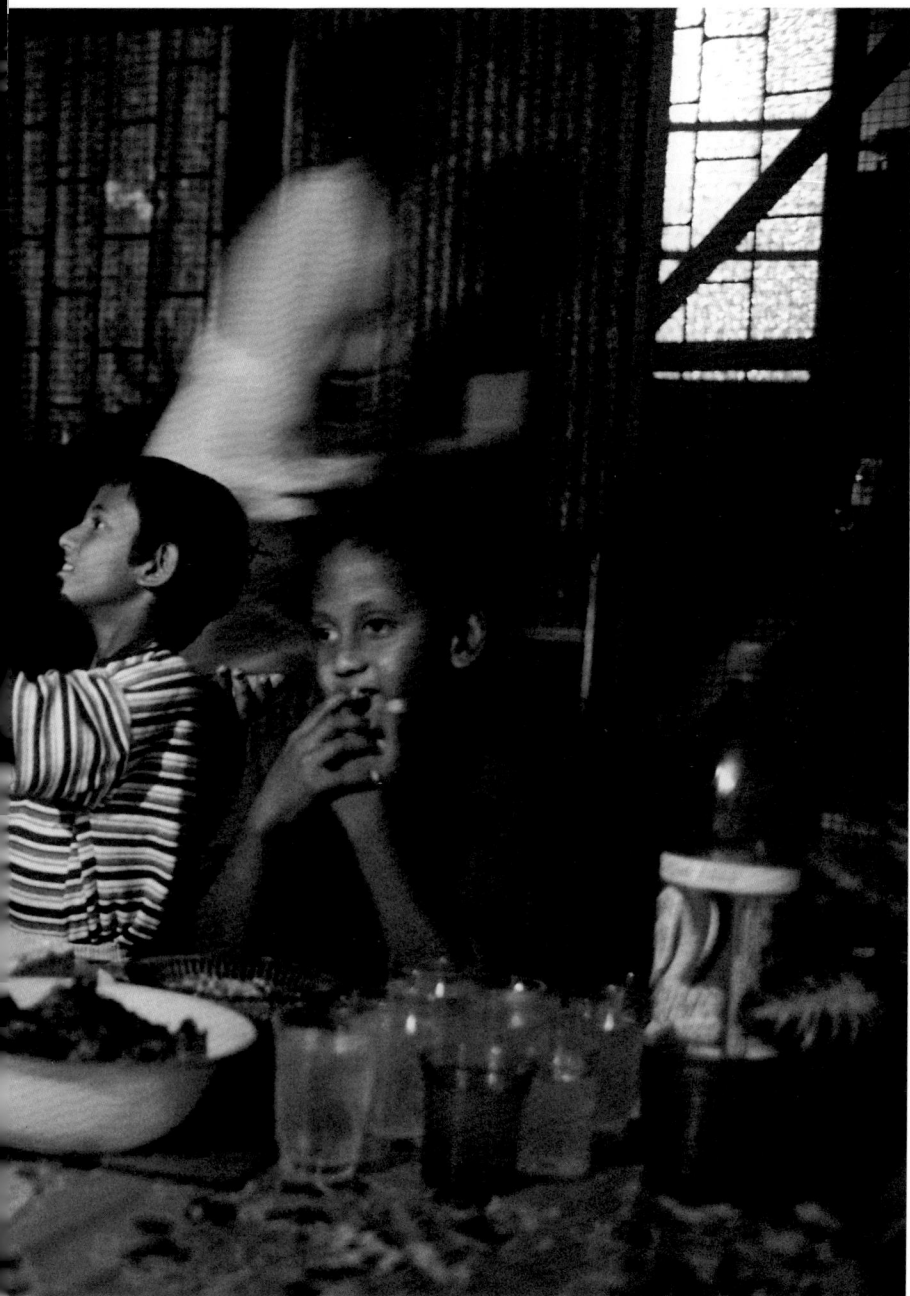

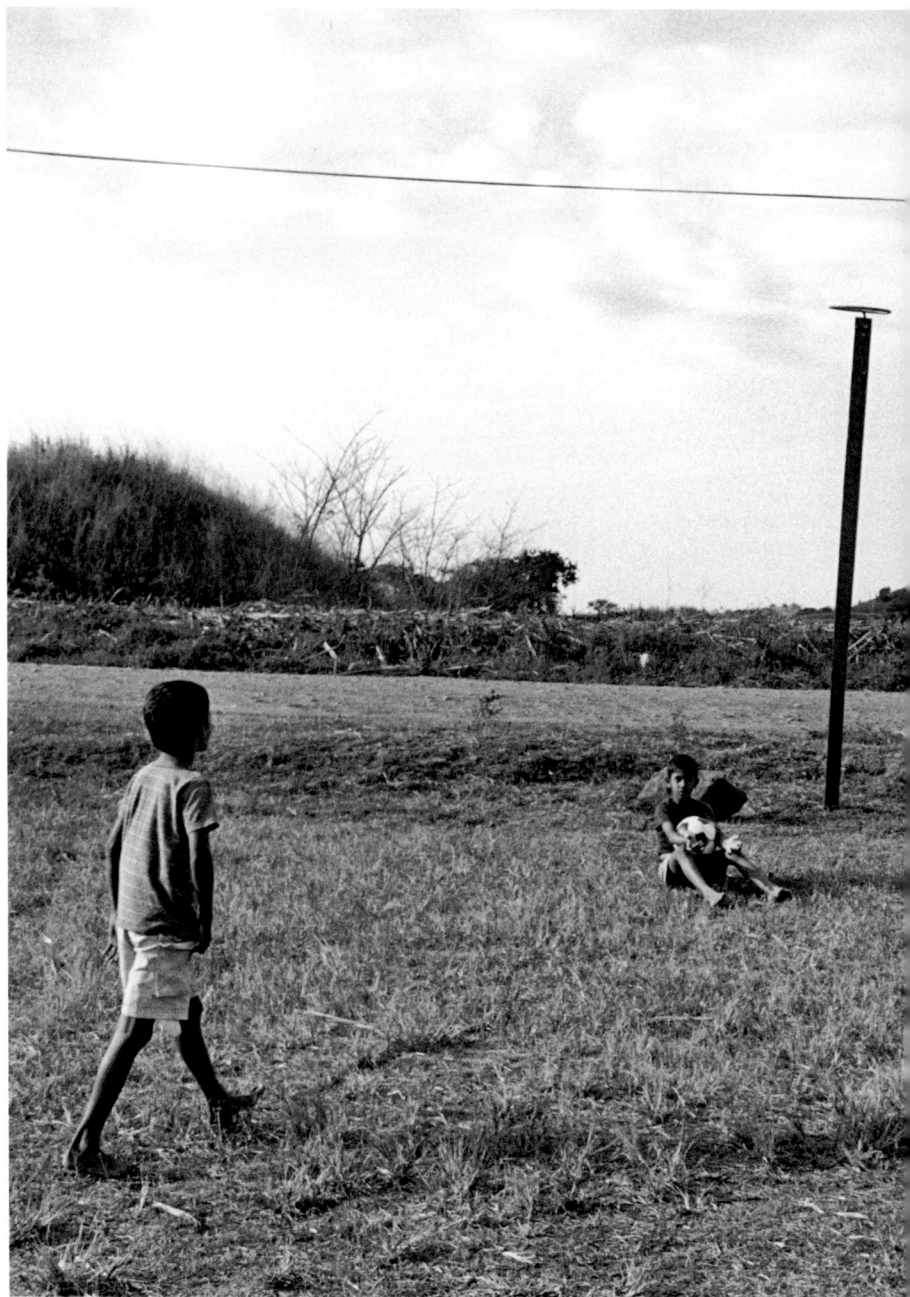

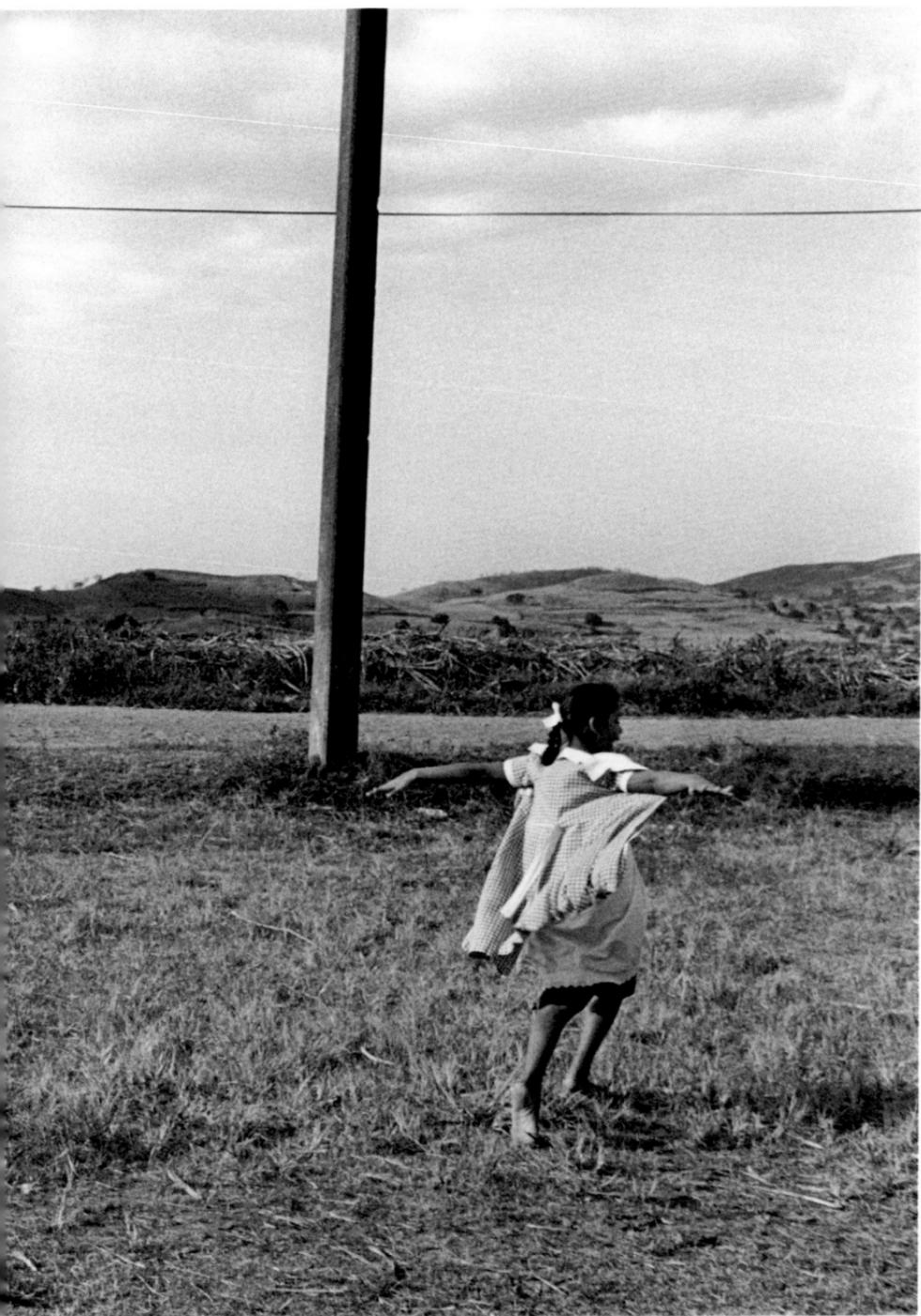

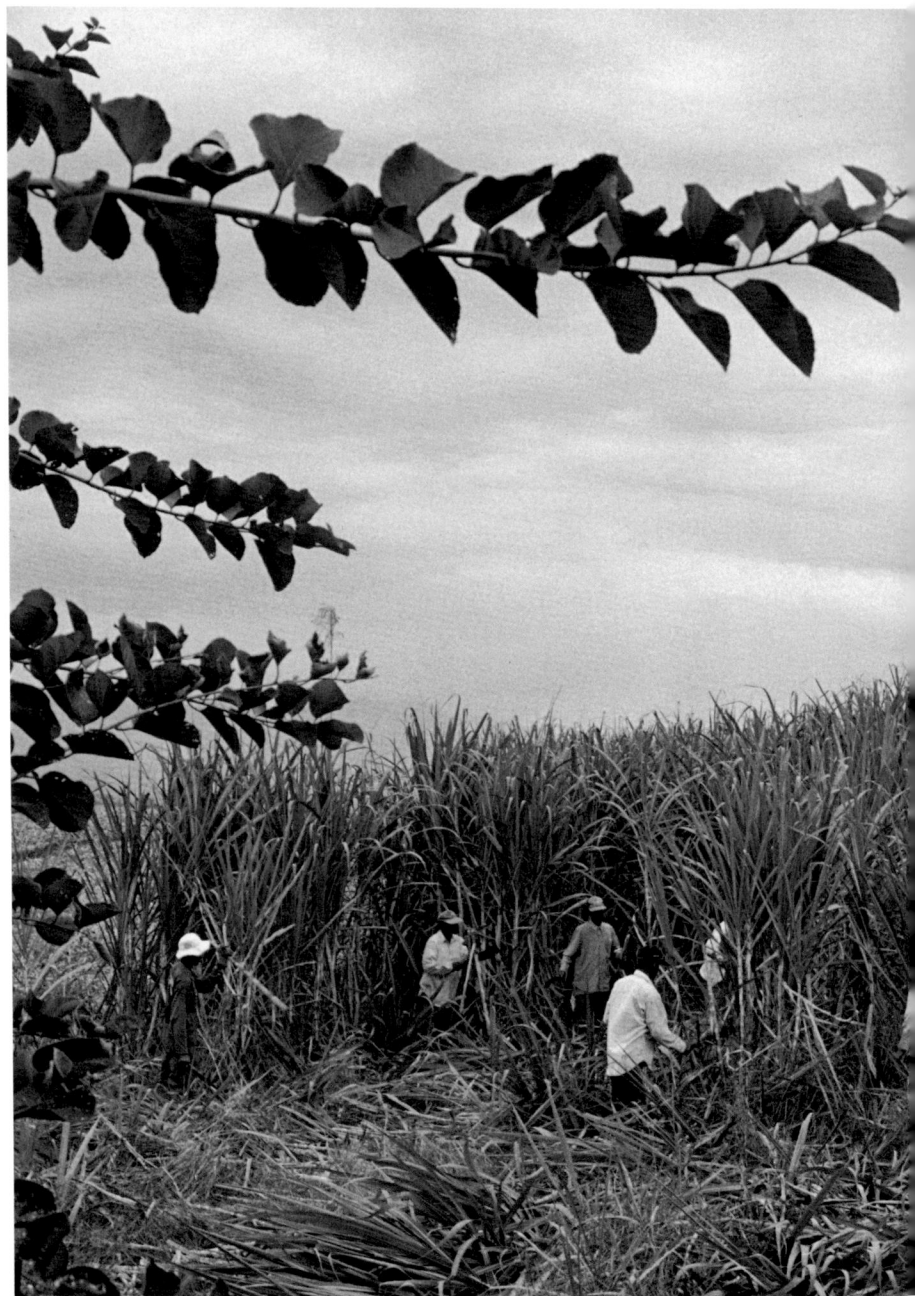

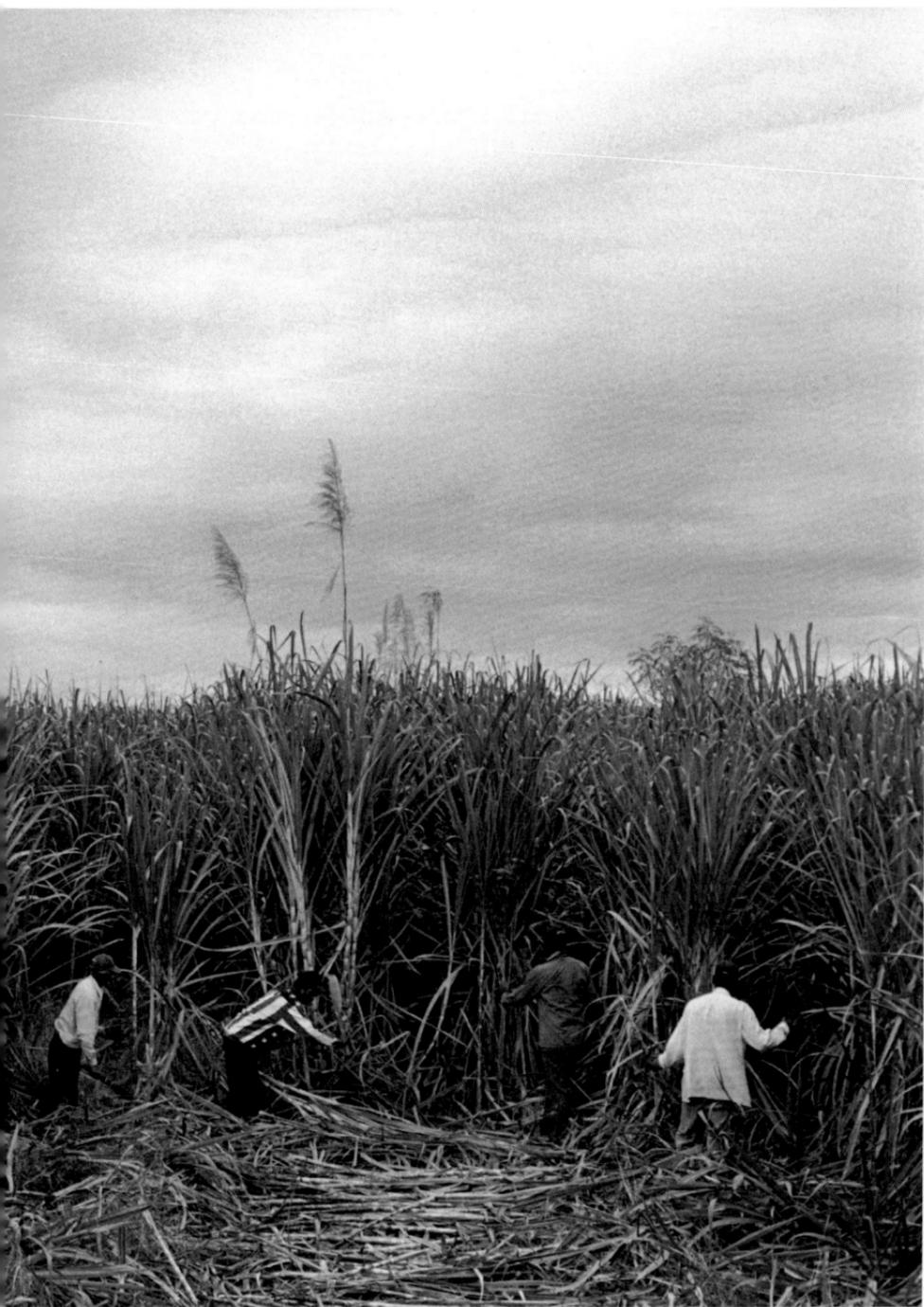

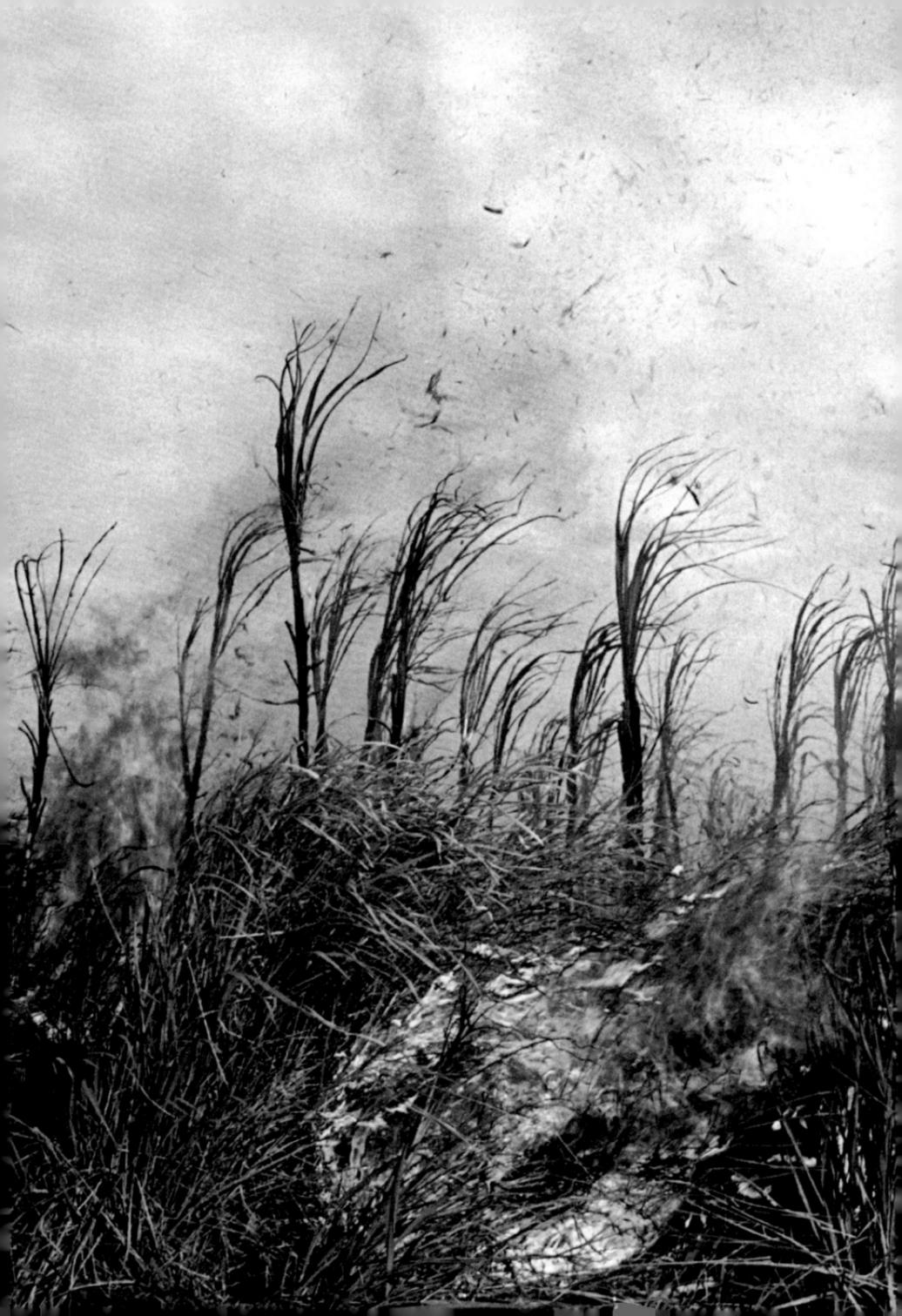

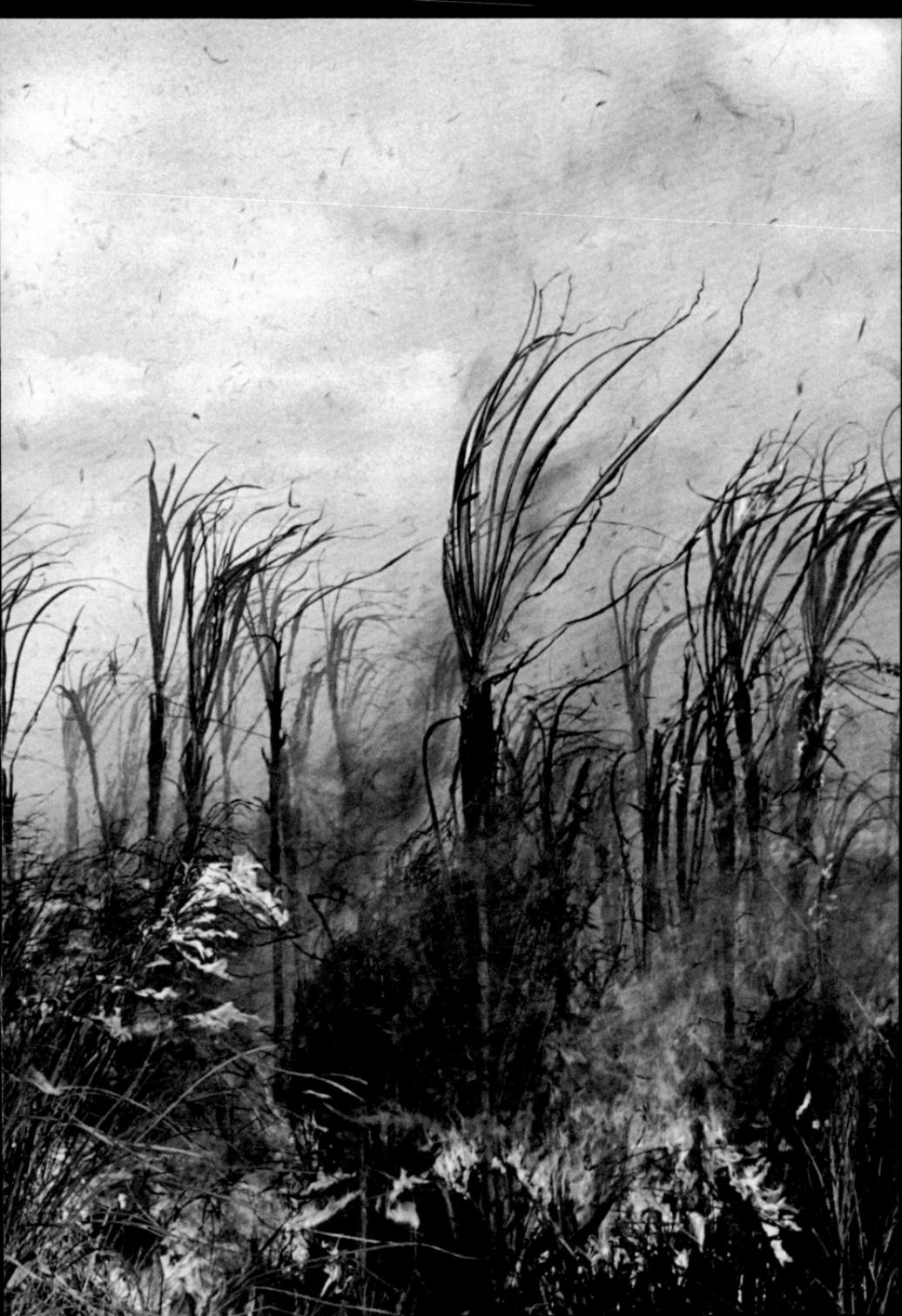

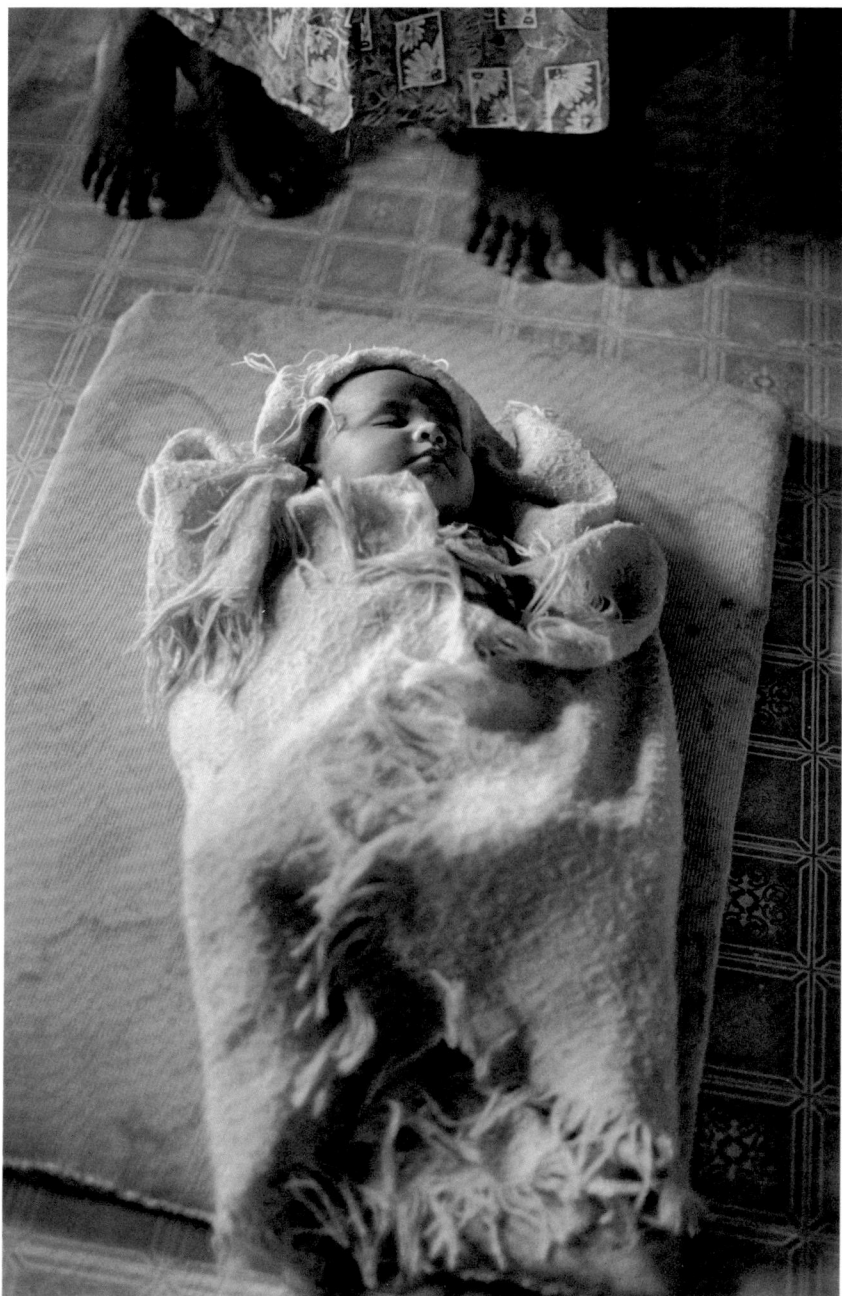

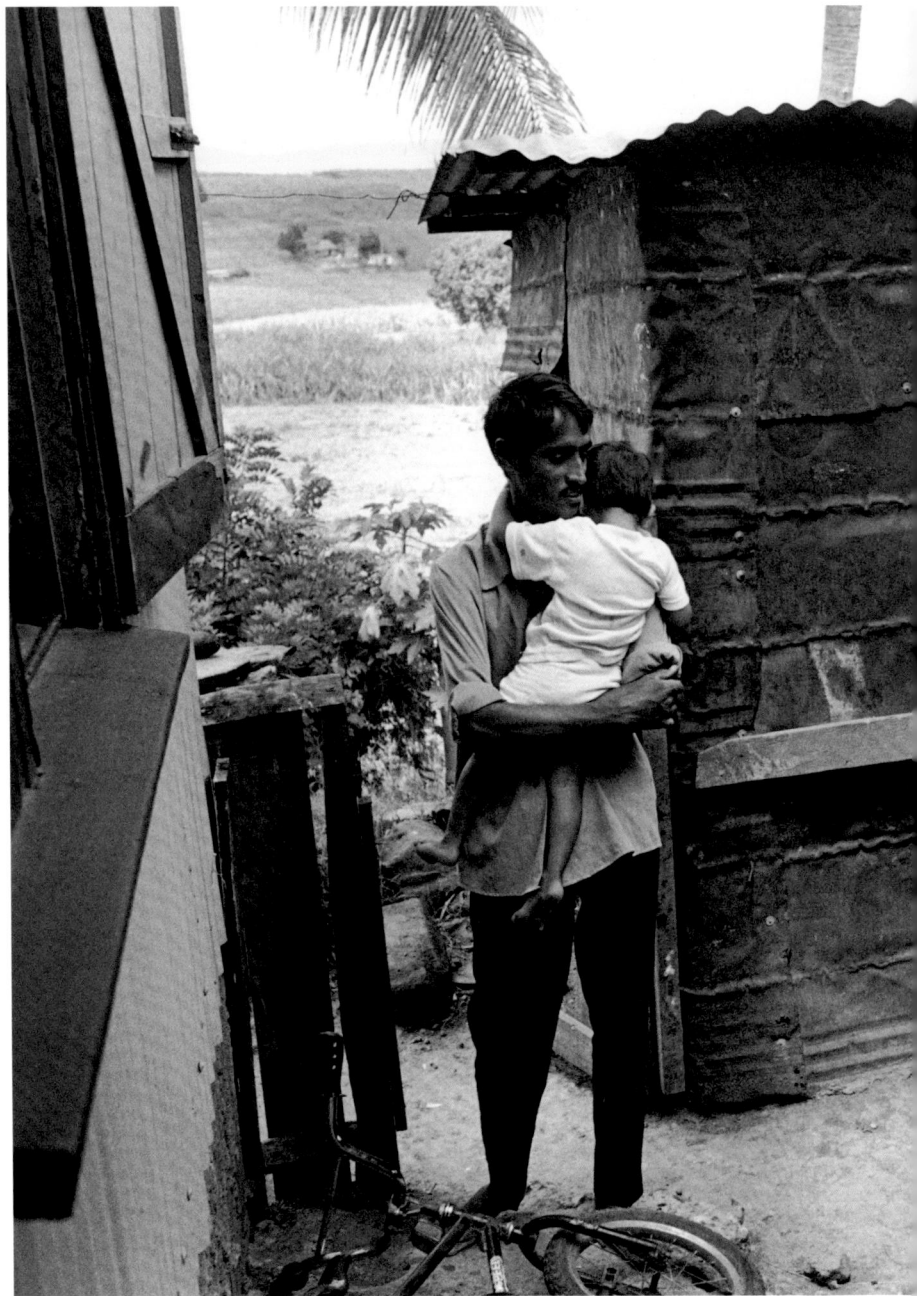

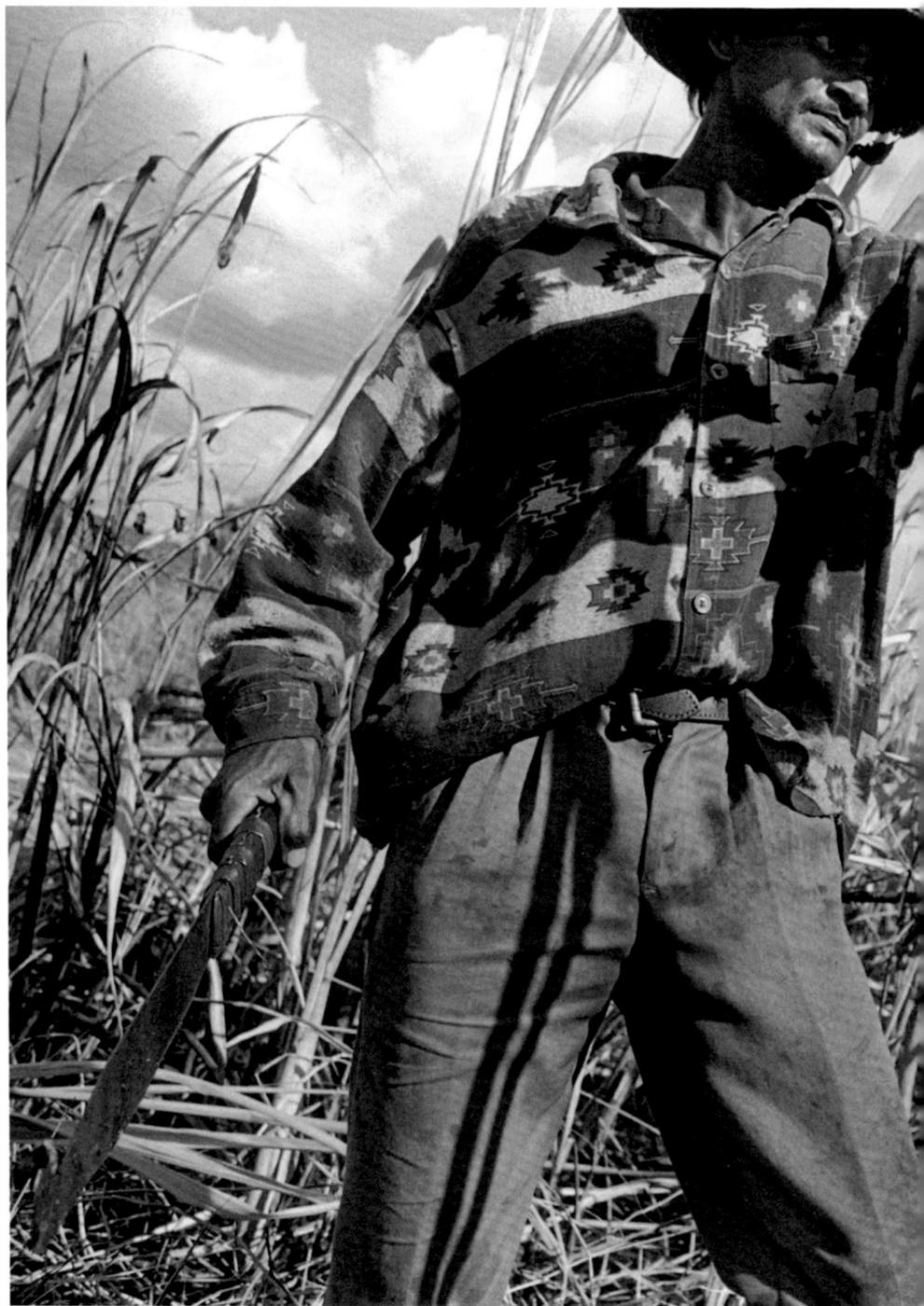

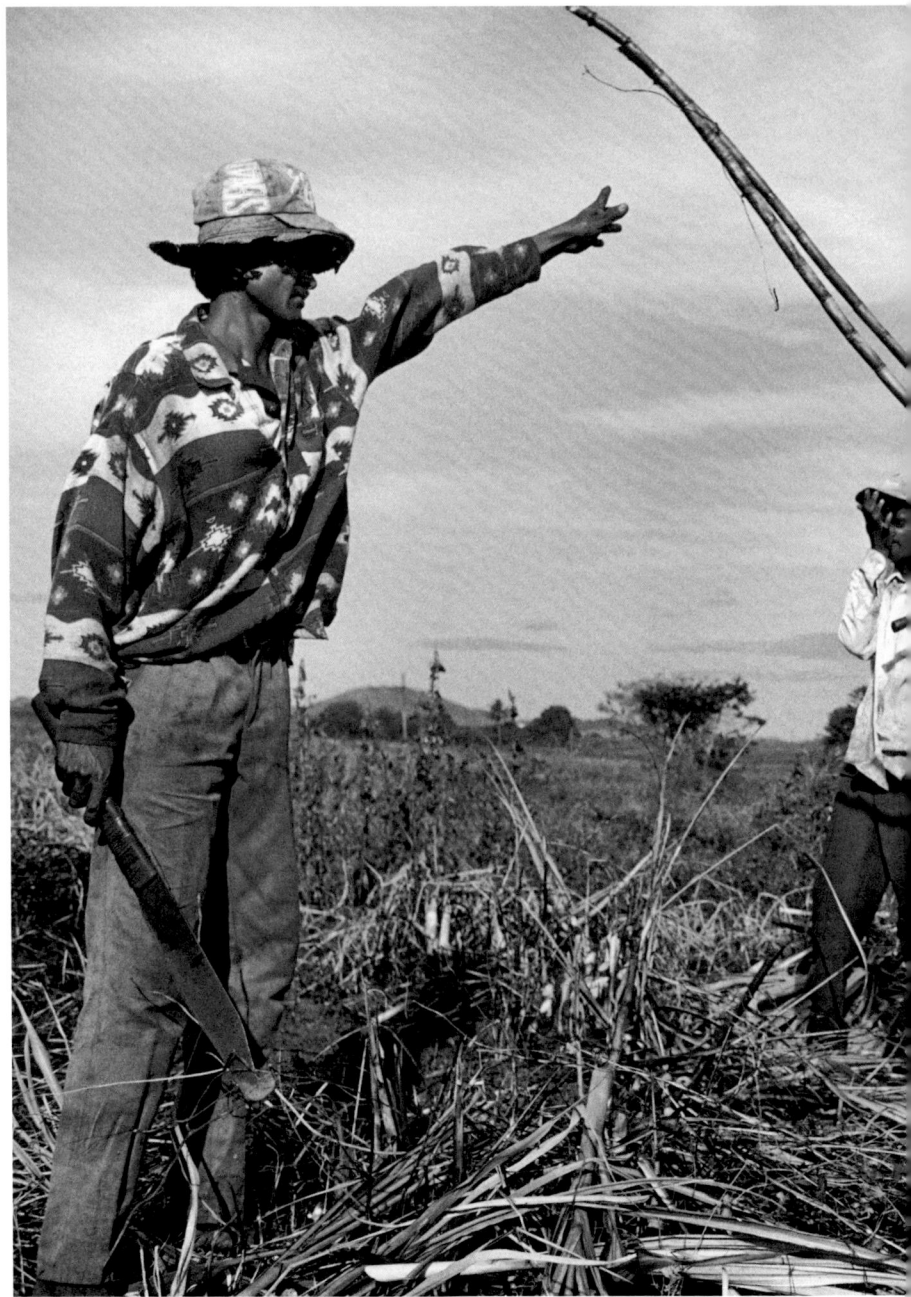

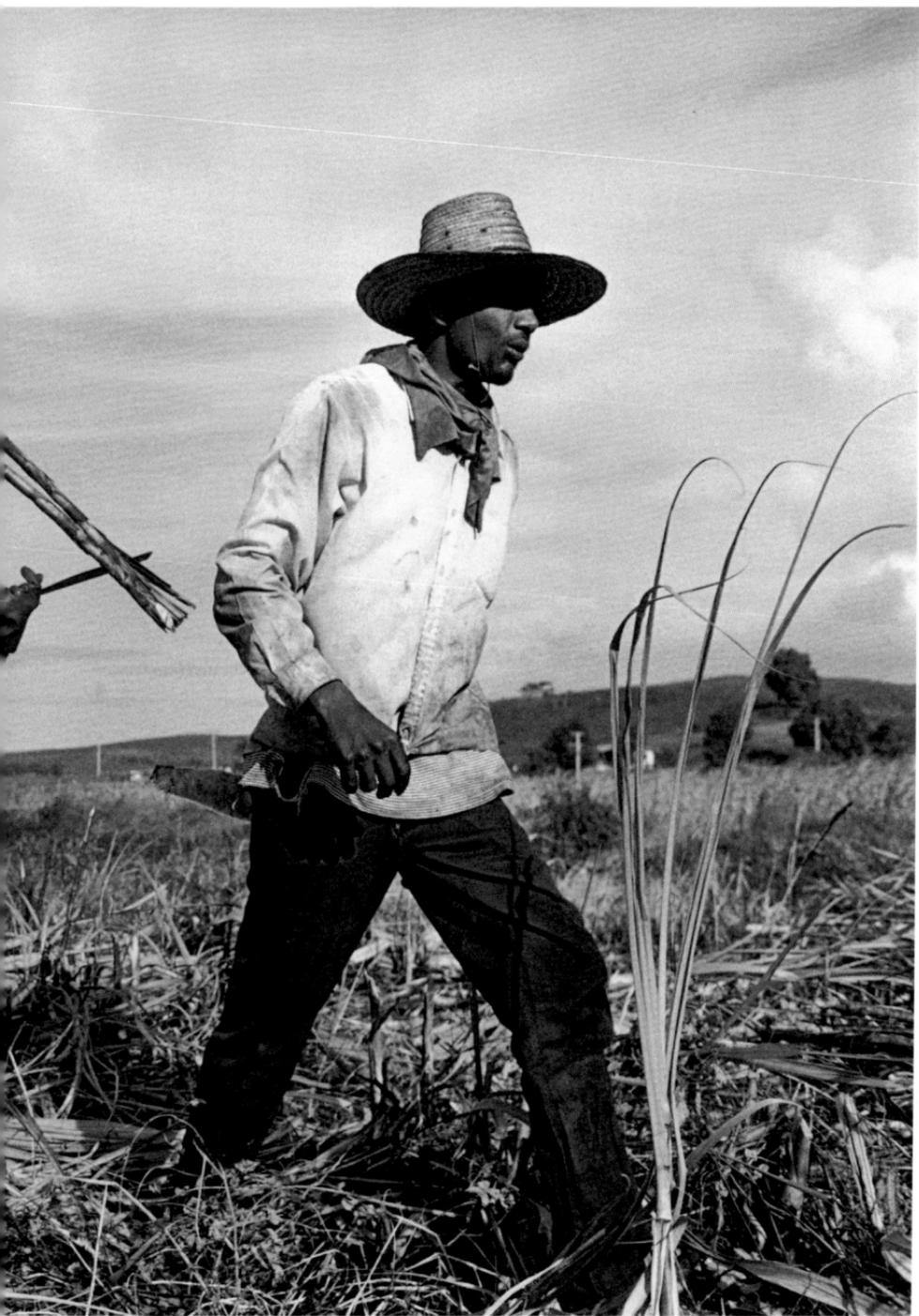

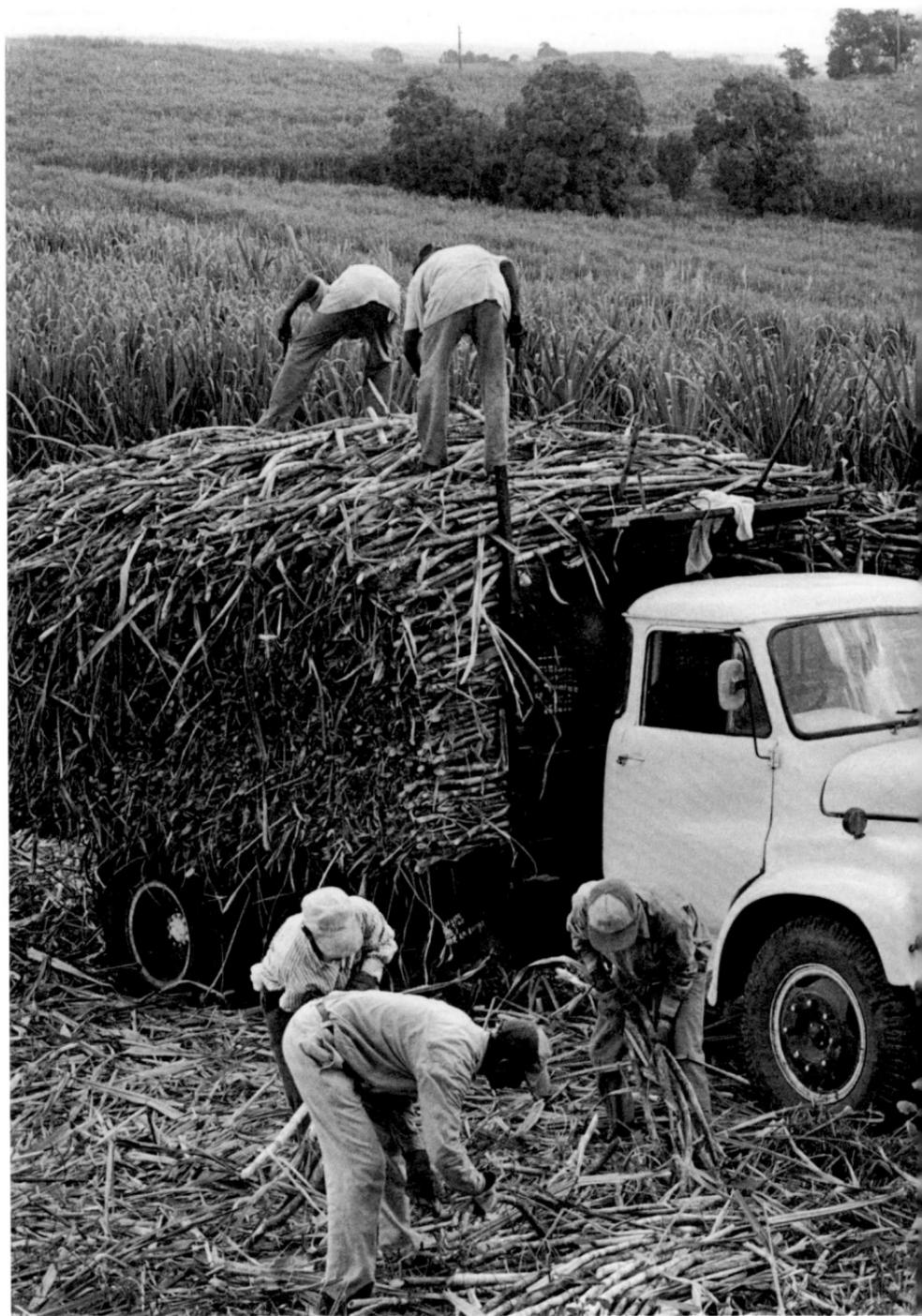

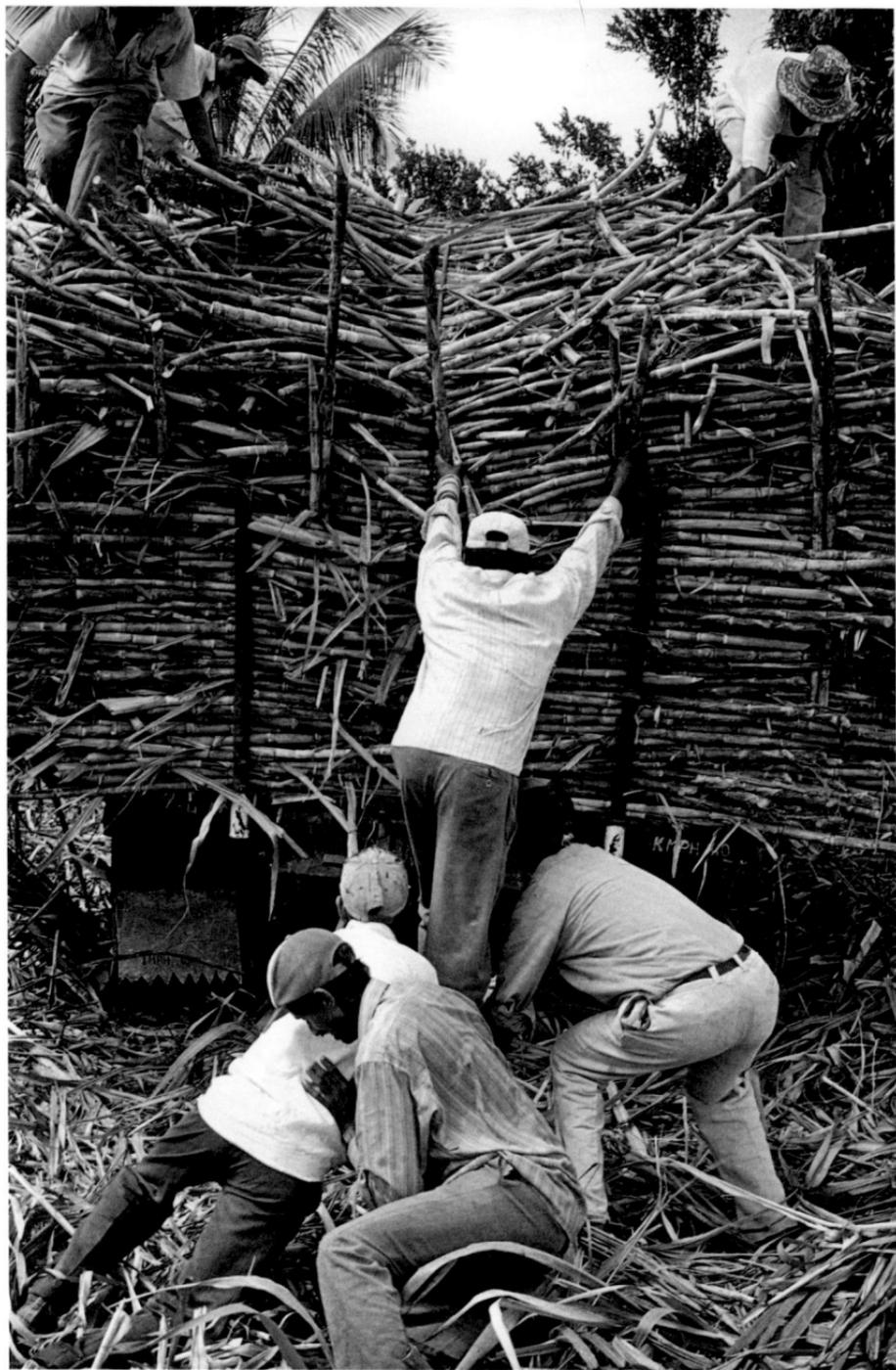

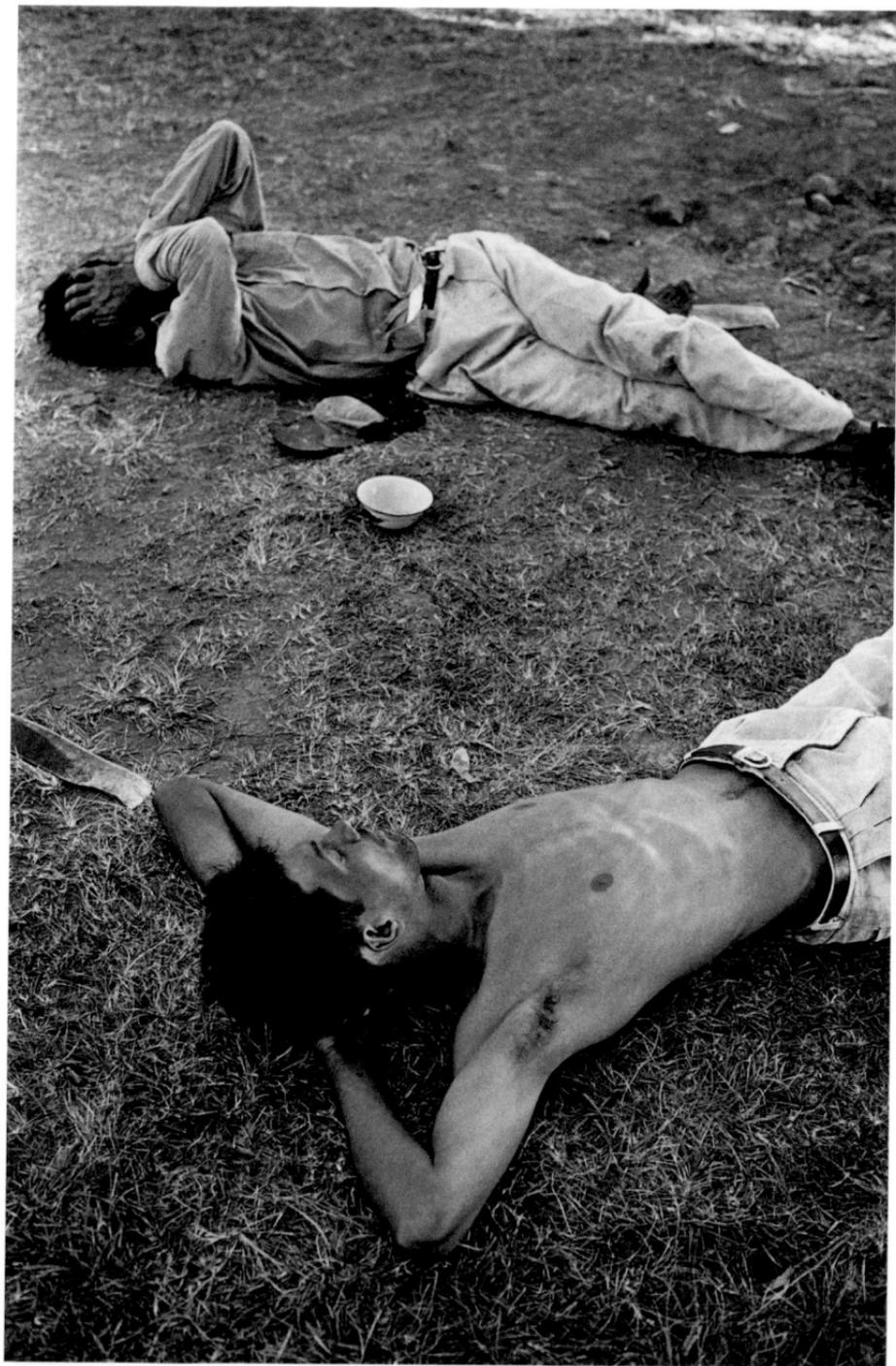

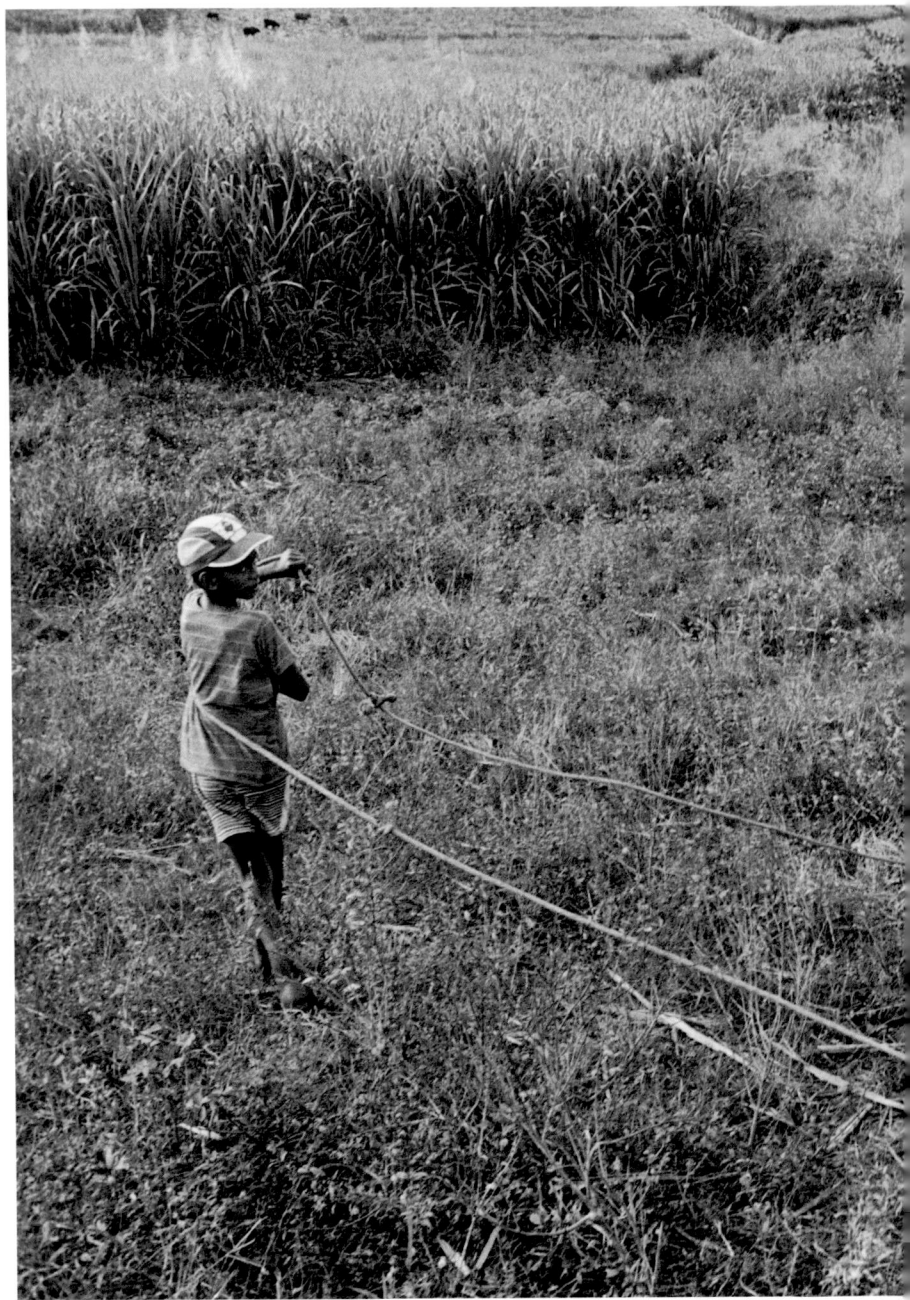

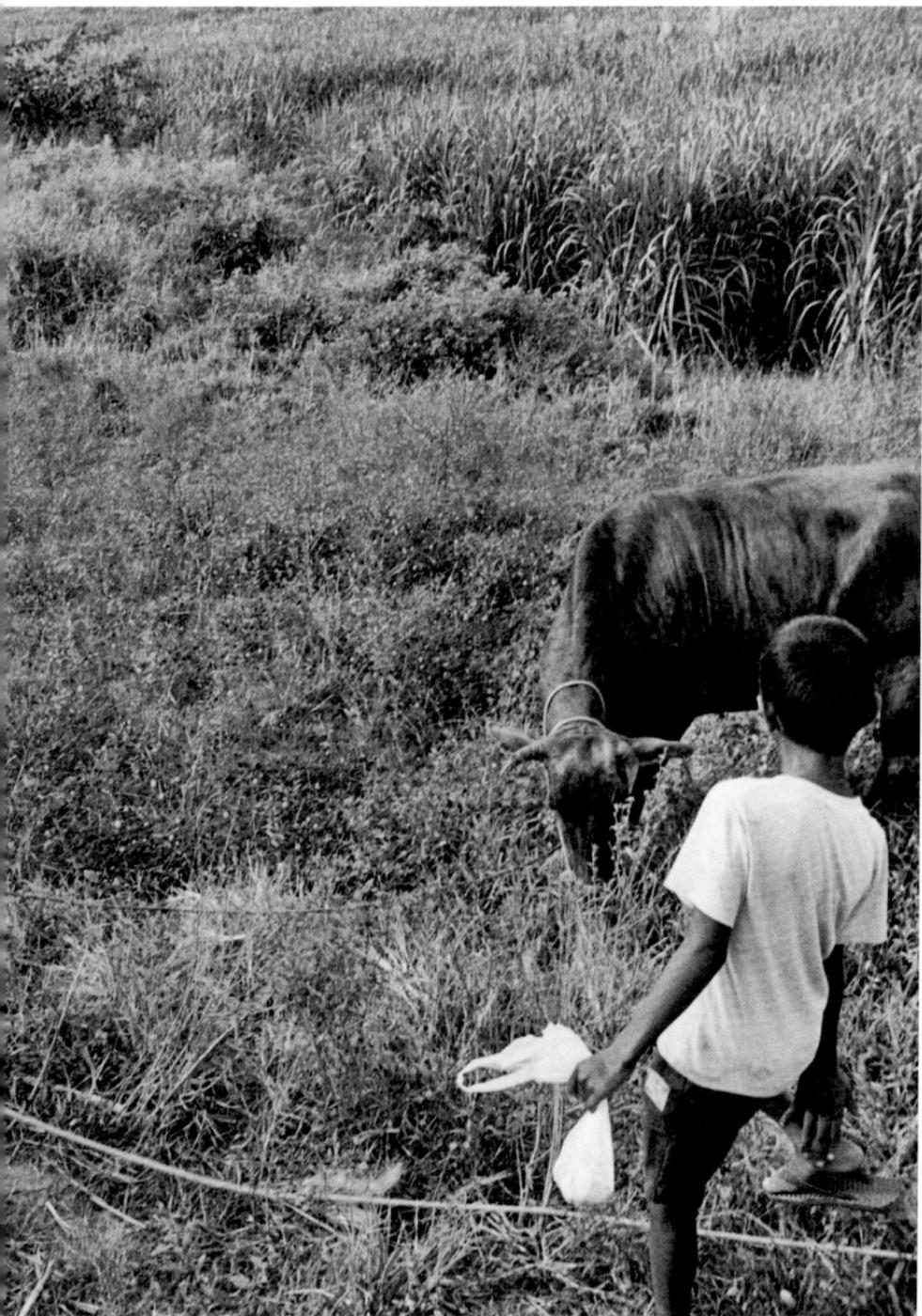

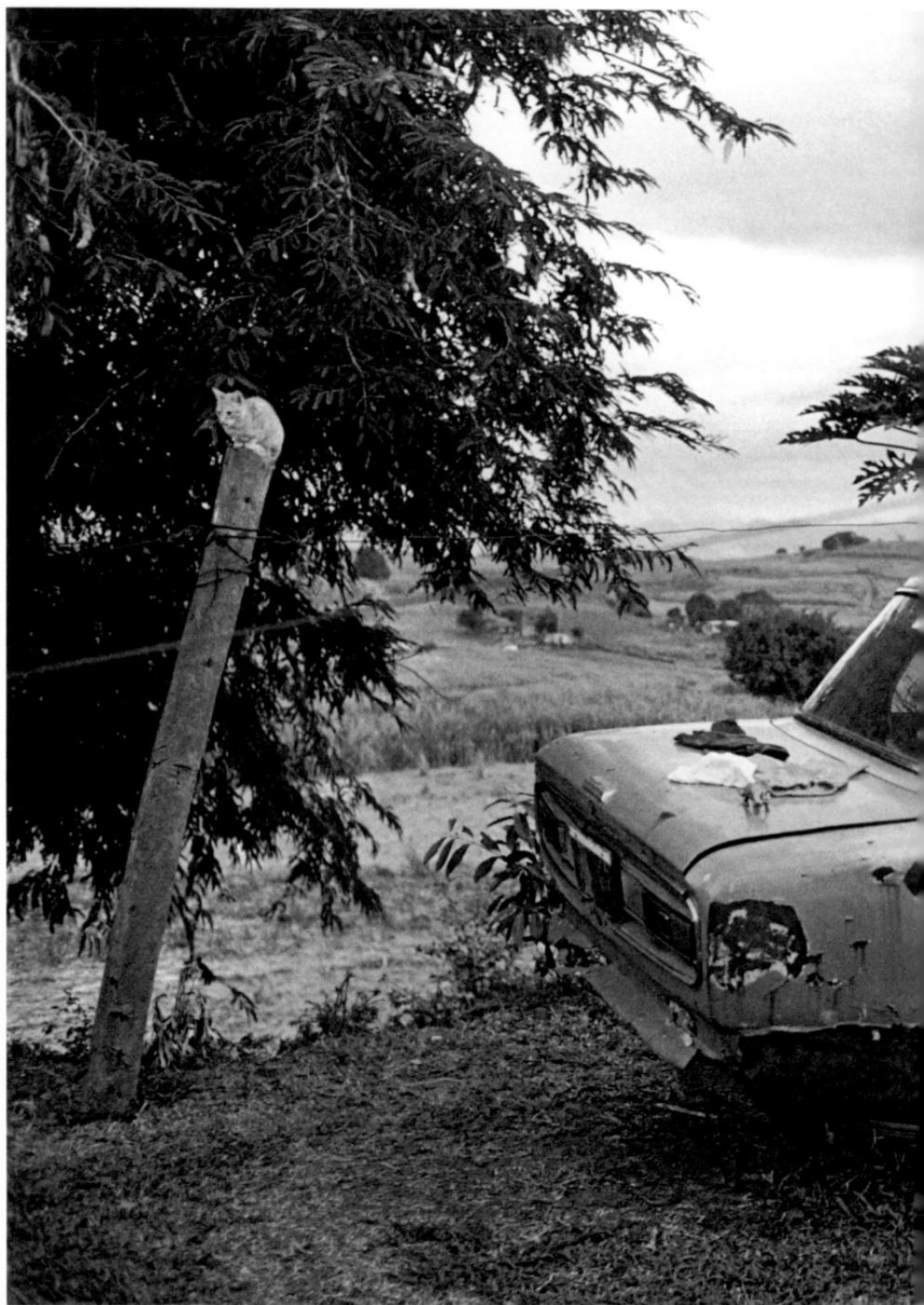

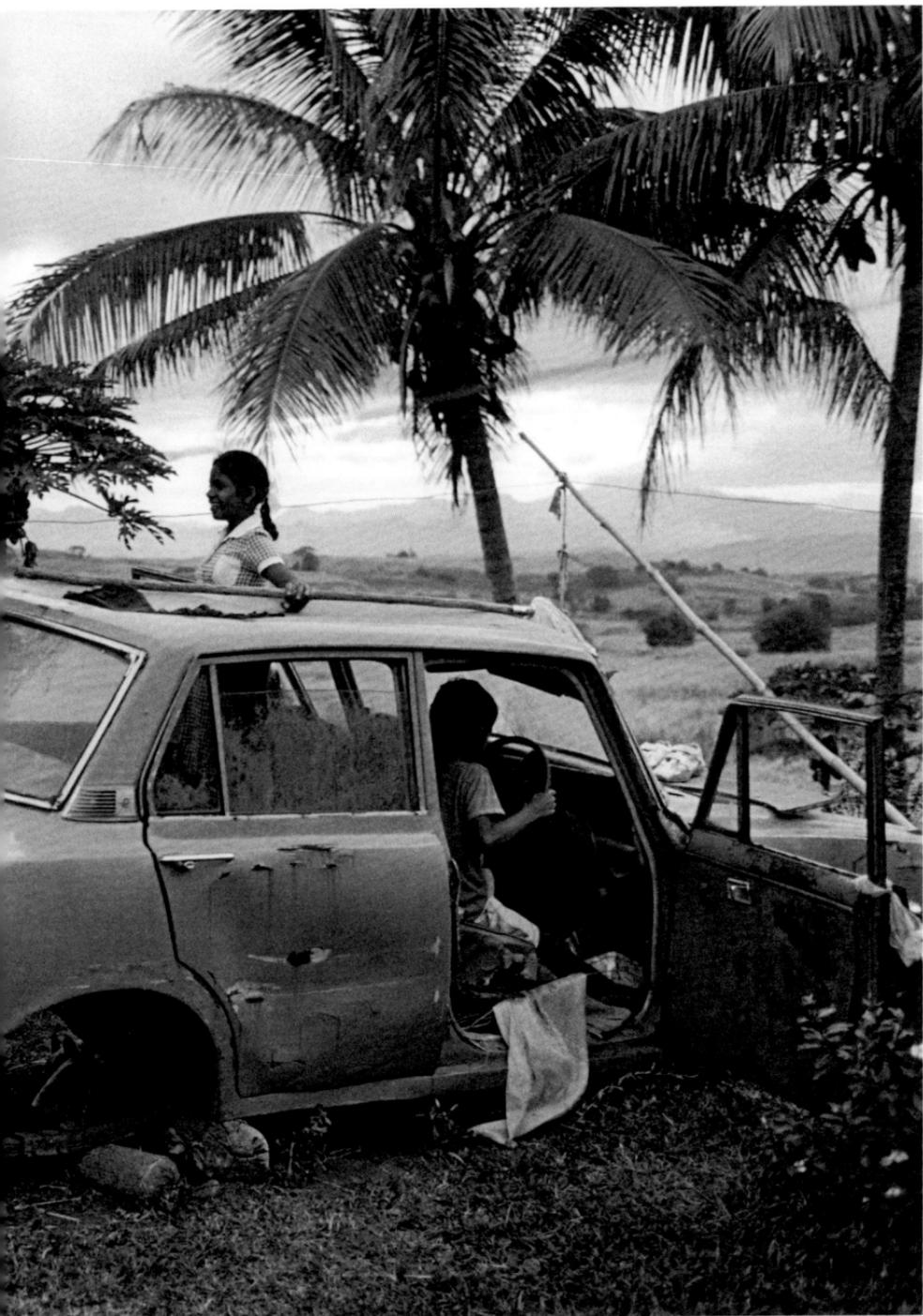

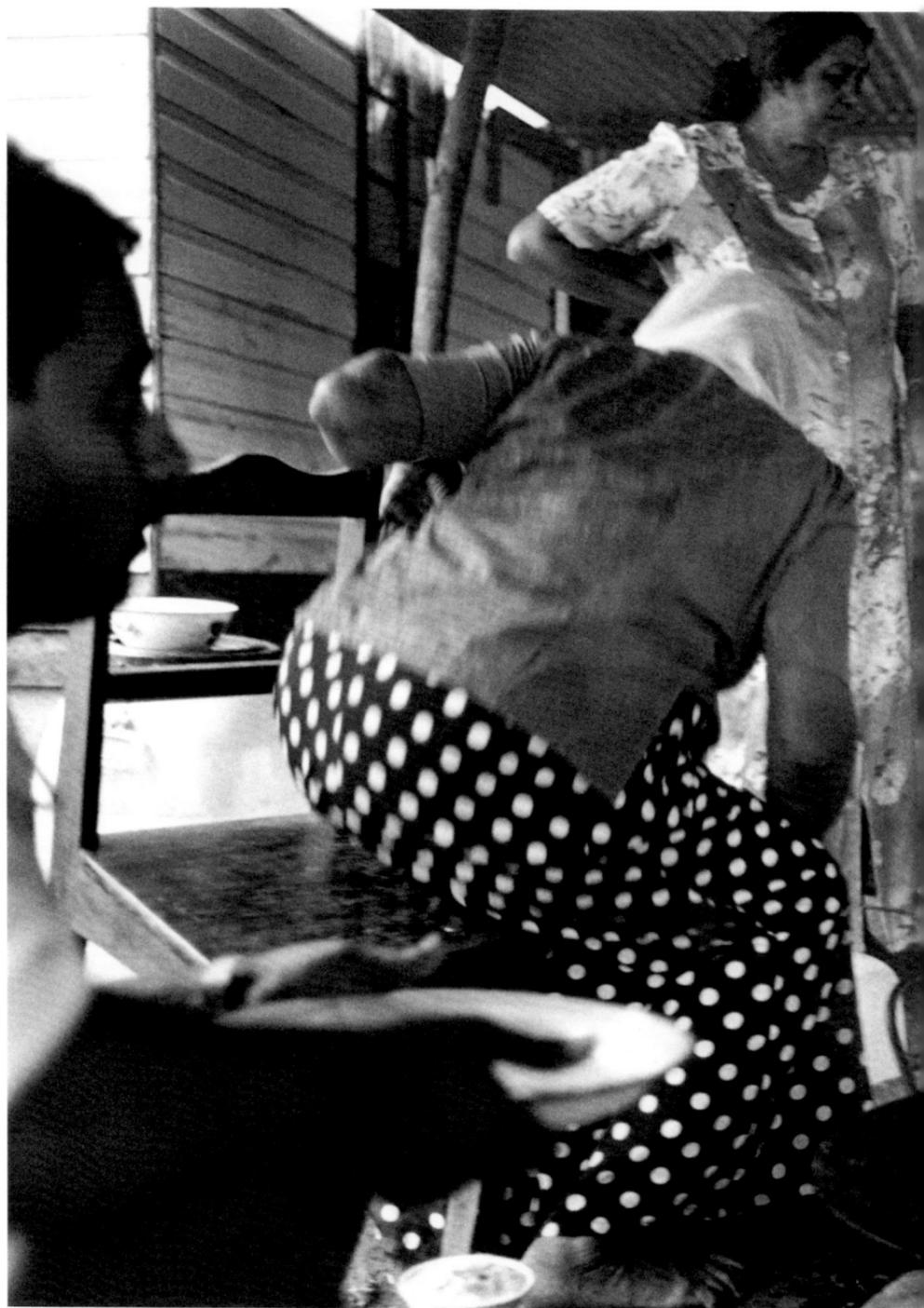

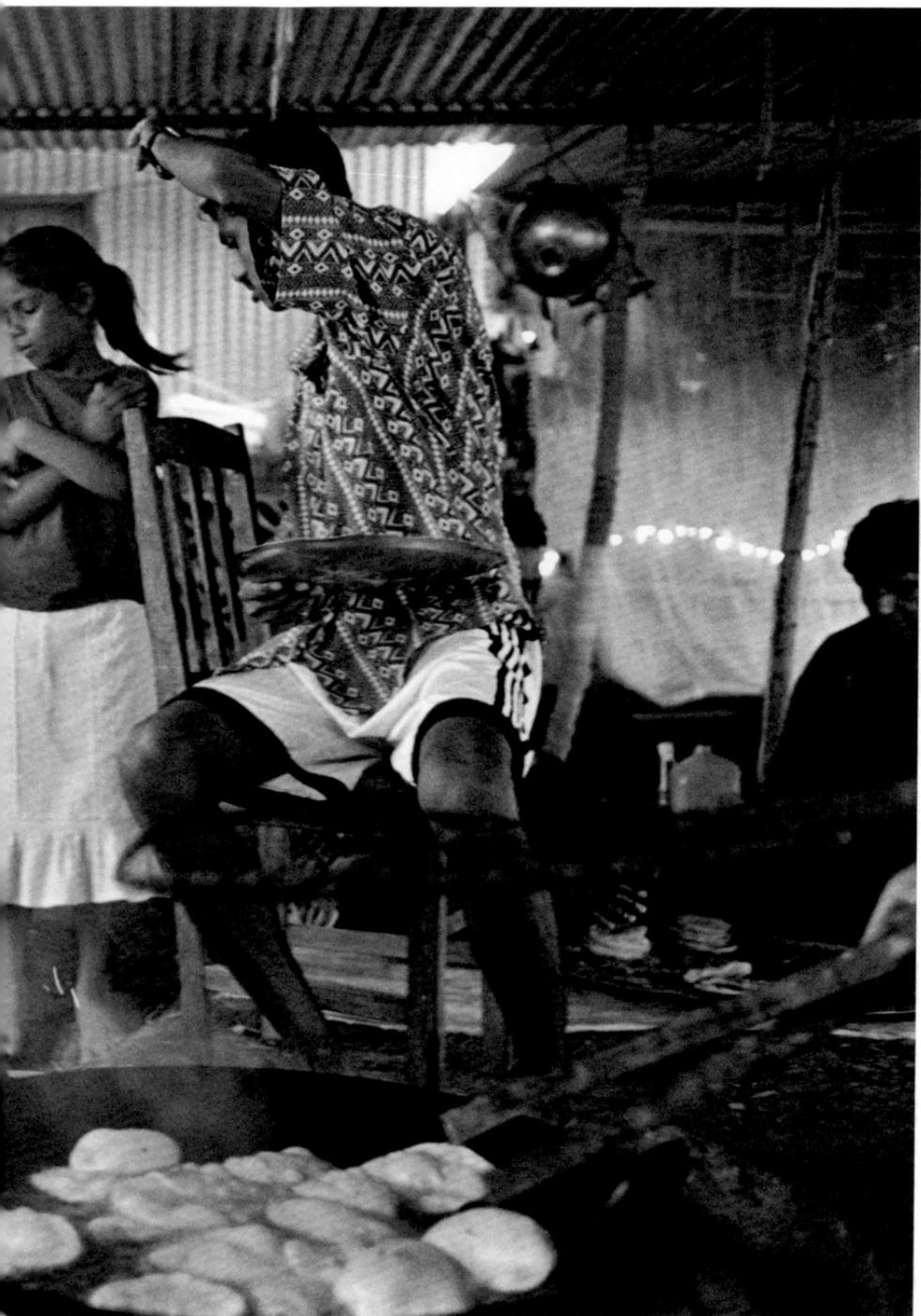

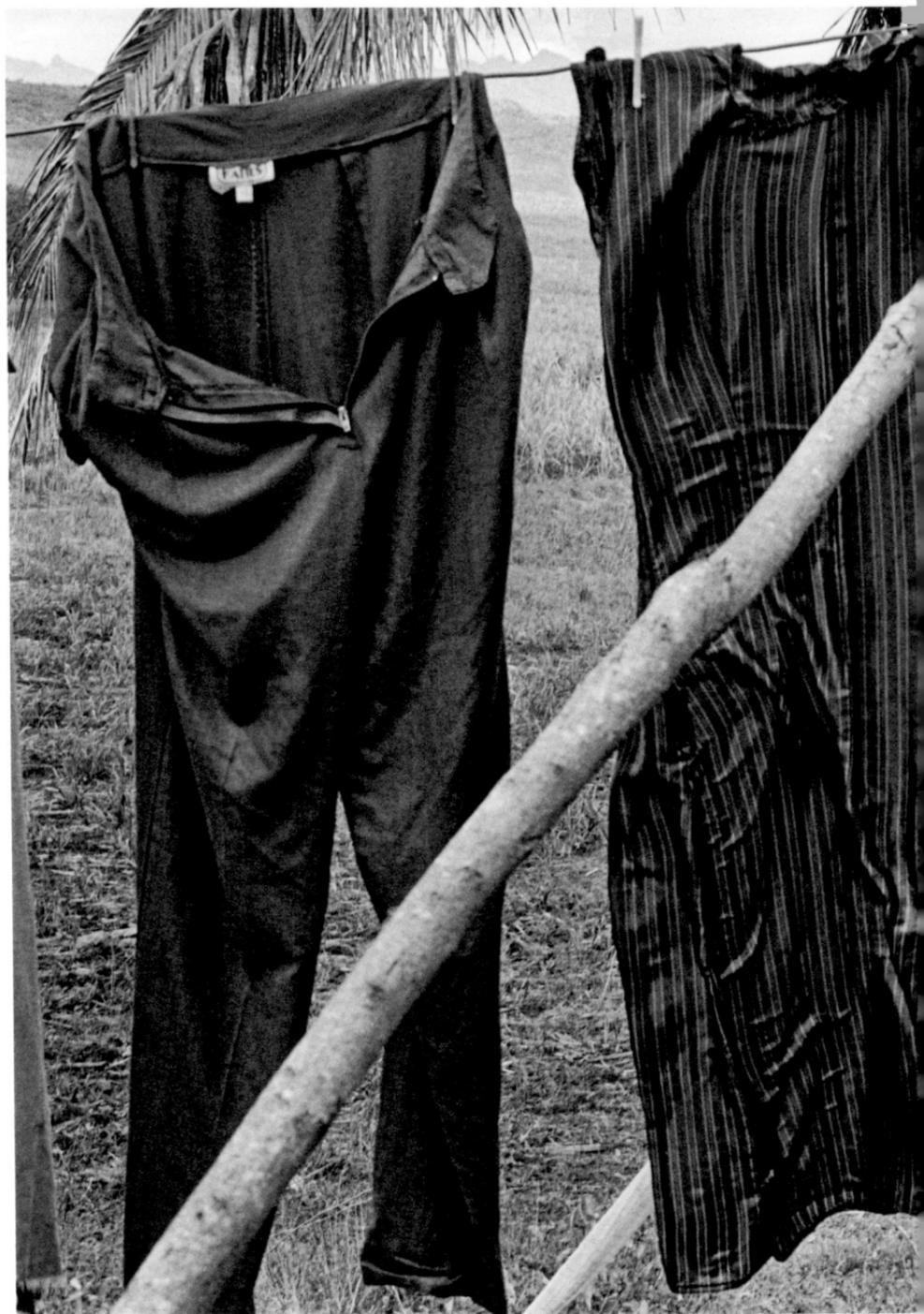

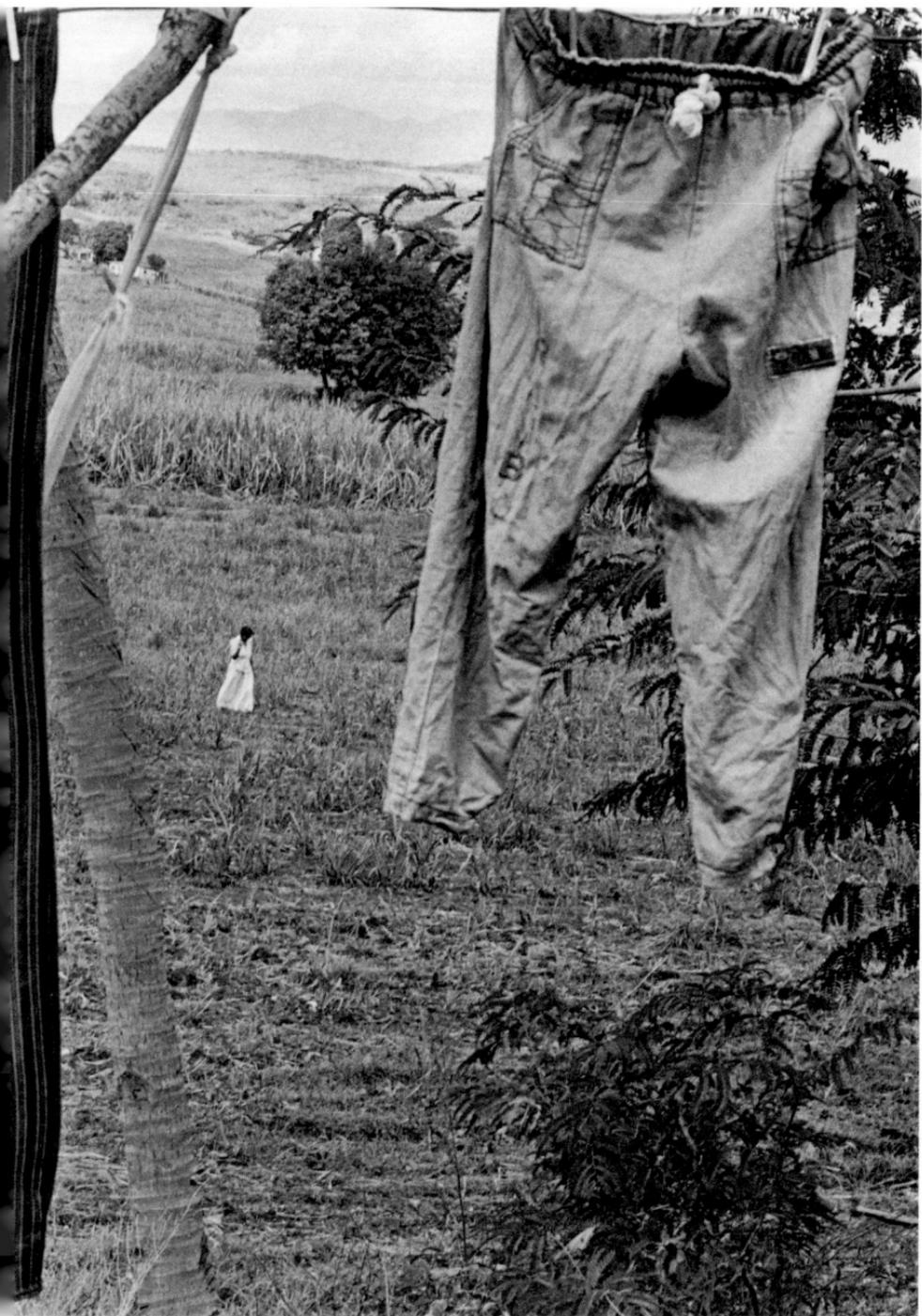

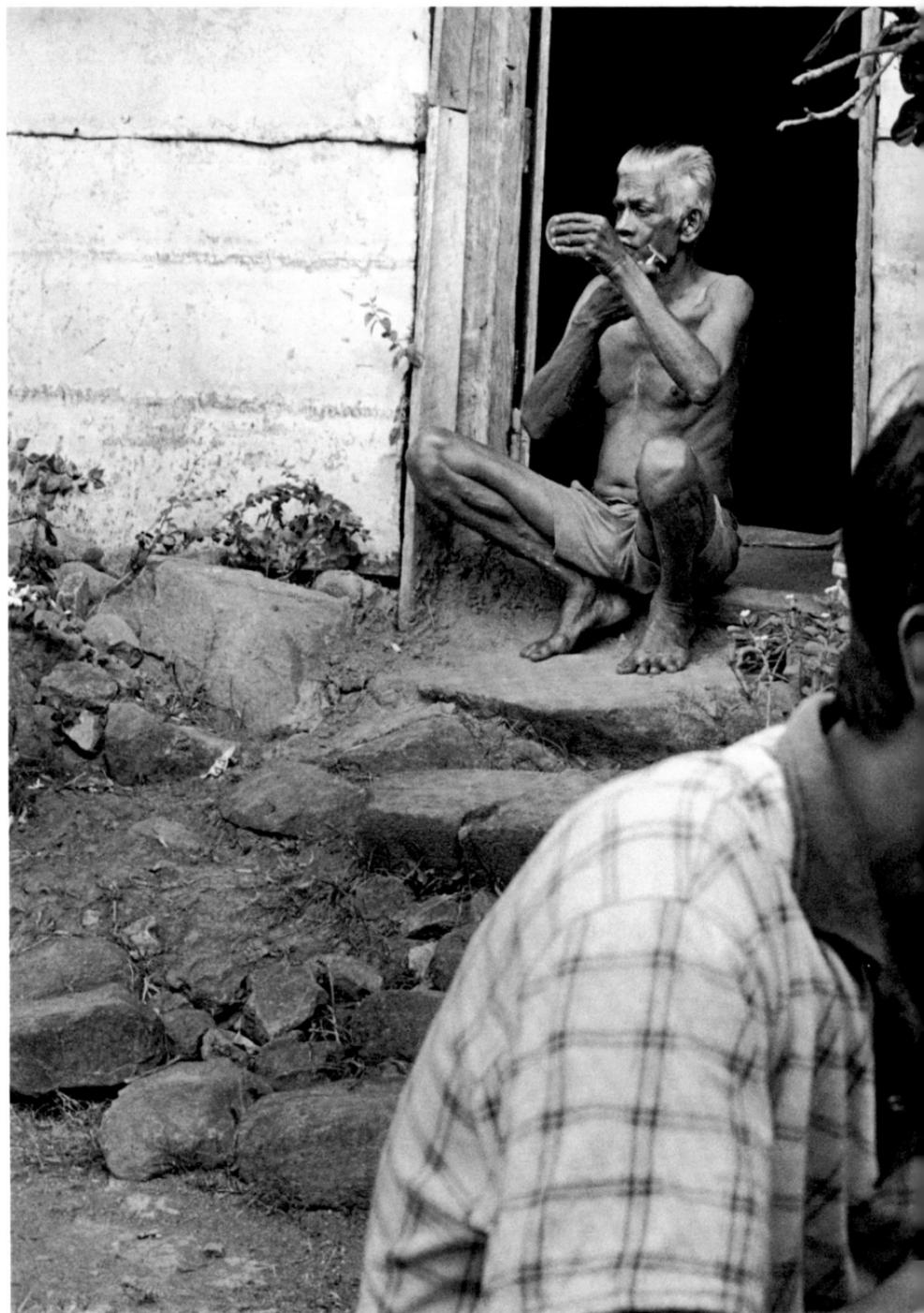

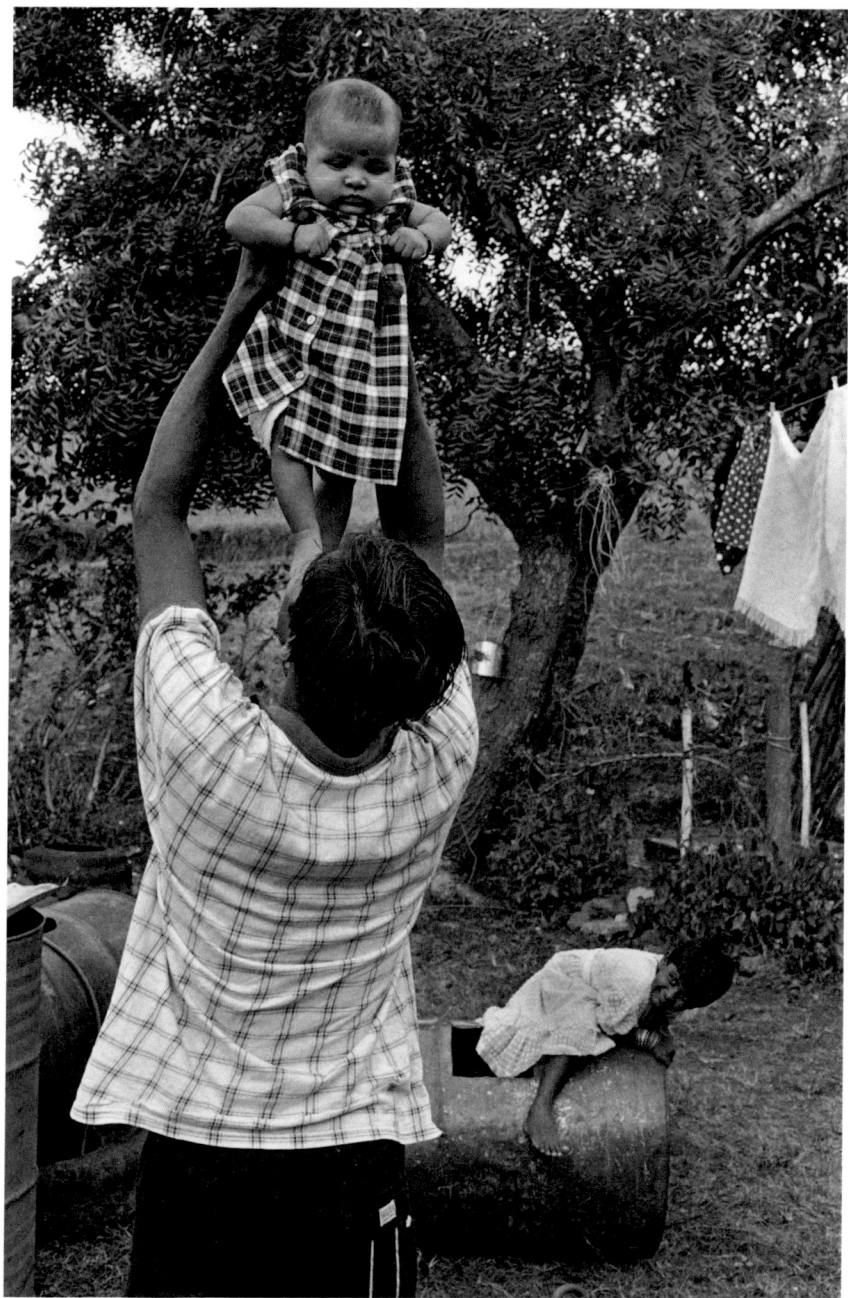

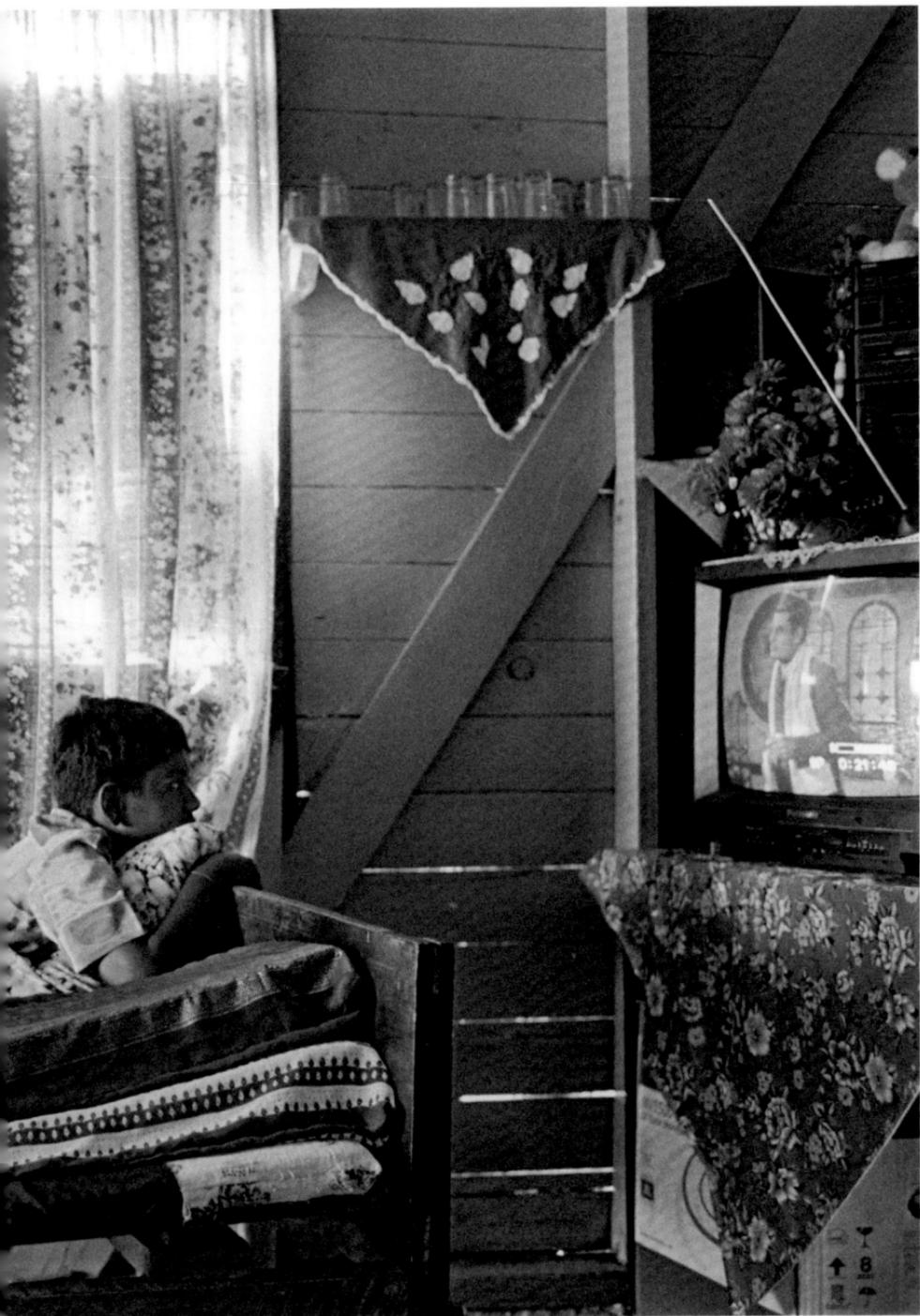

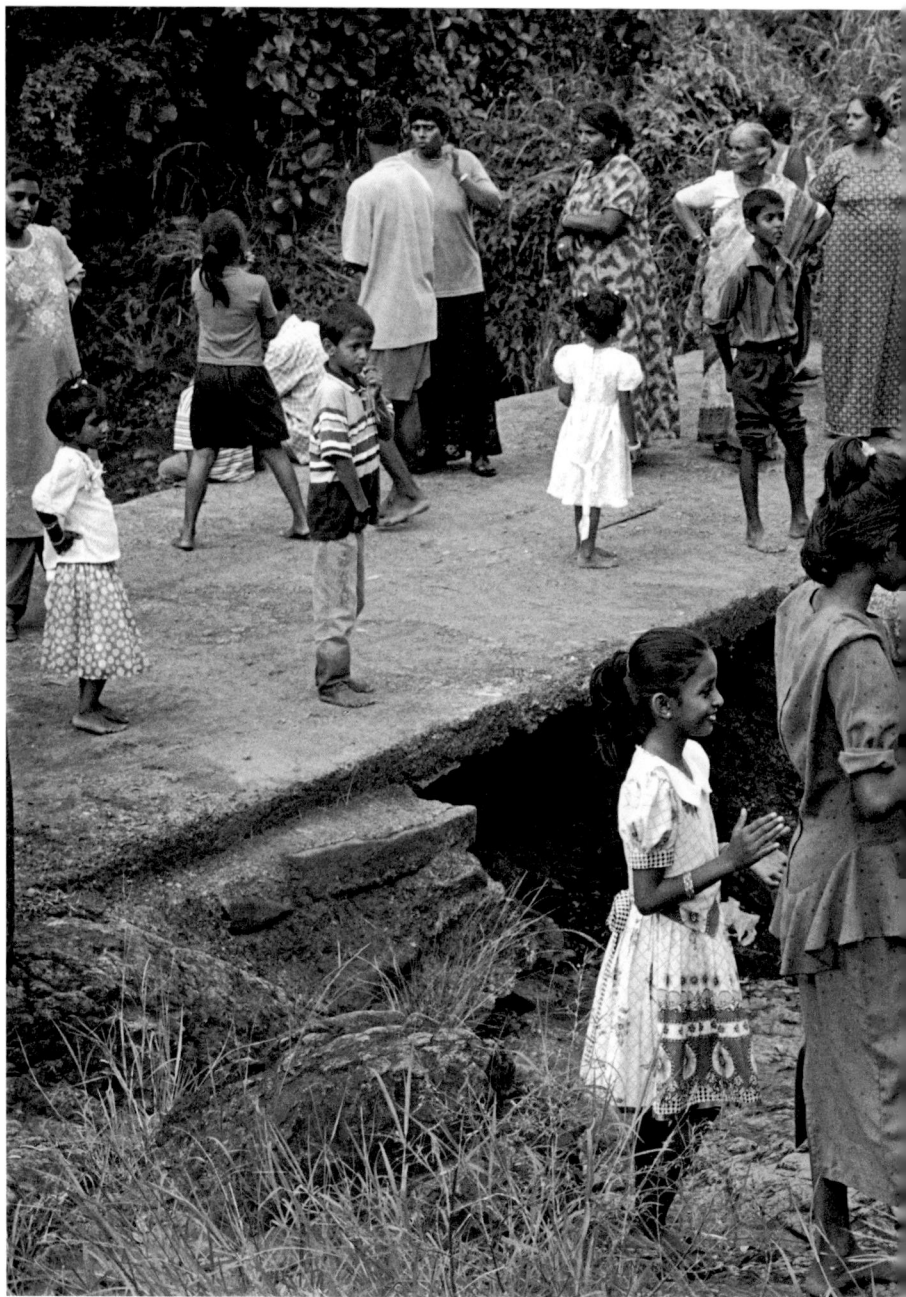

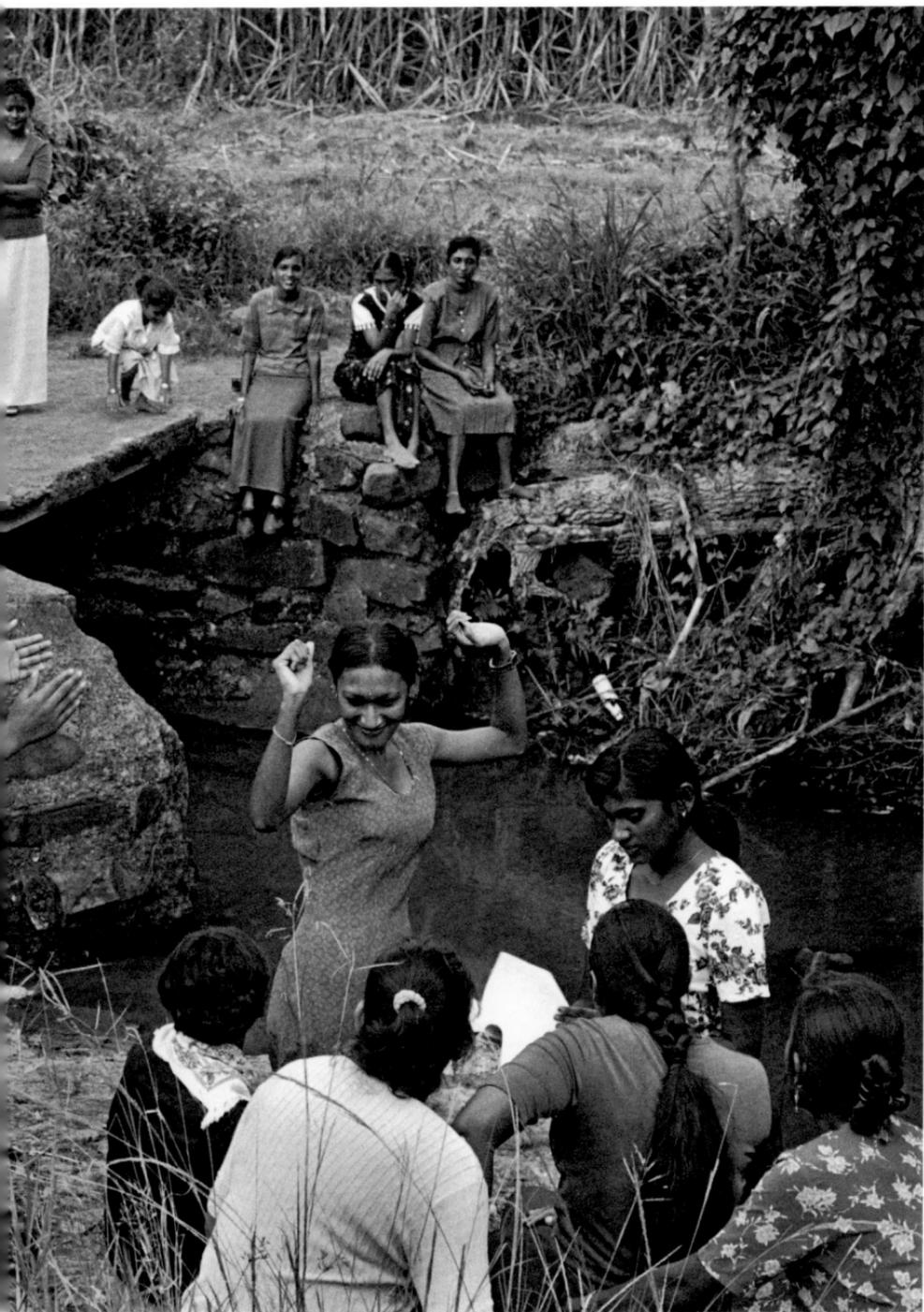

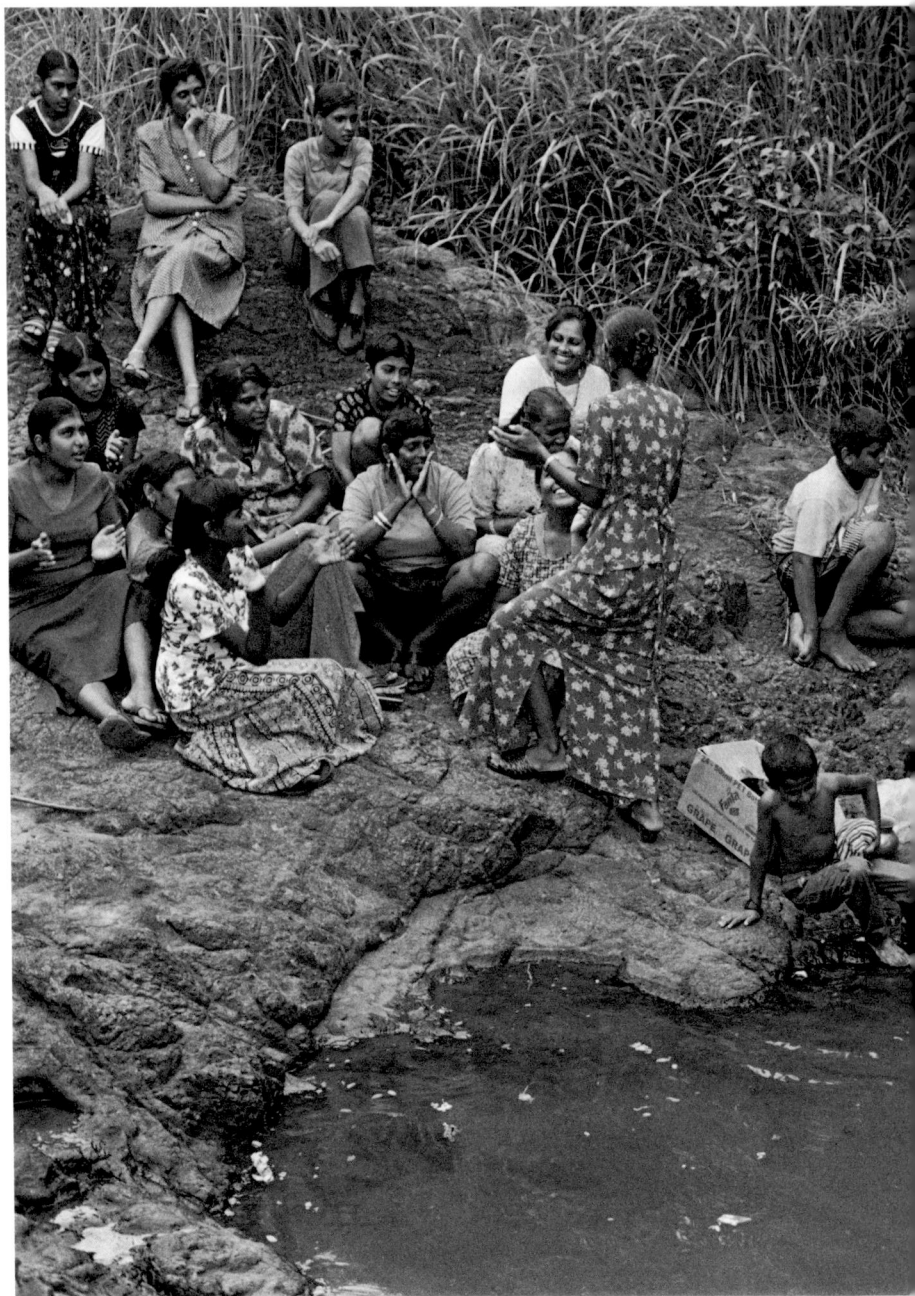

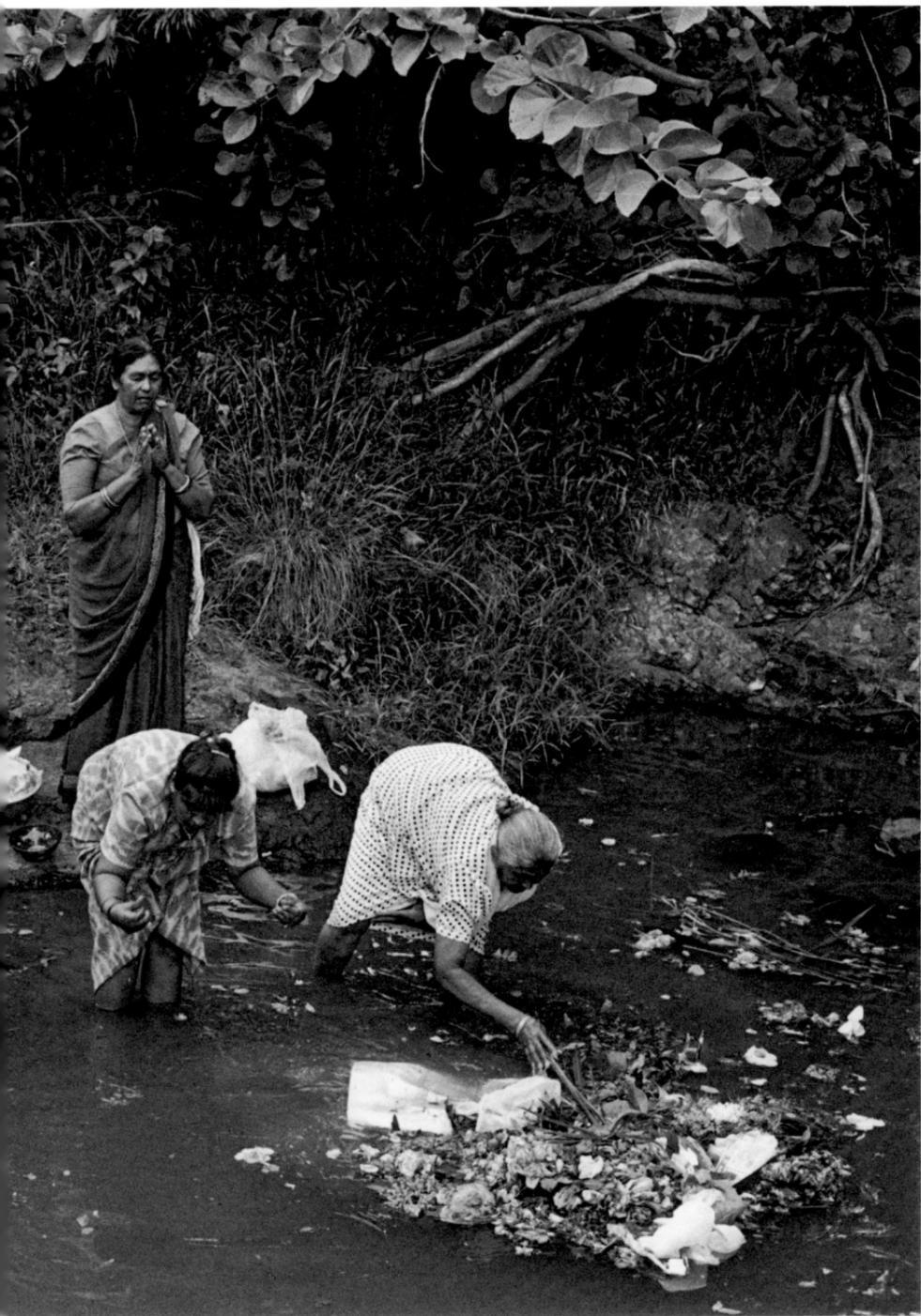

MR ARJUN

A STORY BY BRIJ V LAL

I SELDOM VISIT Tabia now, the village of my birth and childhood. The place is a labyrinth of memories better left untouched. But on the rare occasion I do, I always make an effort to see Arjun Kaka. Now in his late seventies, he is the only one in the village who has a direct connection to my father's generation, the last link to a fading past. He knows my passion for local history and we talk endlessly about past events and people. Kaka is illiterate and a vegetarian and teetotaller. Everyone in the village knows him as a man of integrity, a man with a completely unblemished reputation. His wife died about a decade ago and he now lives on the farm with the family of his deceased son. The other three boys, bright and educated, migrated to Australia after the 1987 coups. He misses them desperately, for this is not the way he had wanted to spend his twilight years. He now wishes one of them had remained behind. There is no telephone in the house and letters from his children are rare. He wonders about his grandchildren, how old they are, what they look like, if they remember him, ruminating like old men usually do.

A few years ago, covering a general election, I went to Labasa and visited Kaka. 'Why don't you visit Krishna and the other two boys, Kaka?' I said after he had mentioned how badly he missed his children. 'At my age, Beta, it is difficult,' he said sadly. 'You know I cannot read and write. Besides, my health is not good.' 'Kaka, so many people like you travel all the time,' I reminded him. 'Look at Balram, Dulare, and Ram Rattan.' Formerly of Tabia, they had moved to town when their leases were not renewed. Some had even gone to Viti Levu. Kaka nodded but did not say anything. Then an inspired thought occurred to me. I was returning to Australia a few weeks later and could take Kaka with me. When I made the offer, his face lit up, all the excuses forgotten. They were excuses, really, nothing more. He had a deep yearning to travel and see his children and grandchildren but not knowing how. '*Beta, e to bahut julum baat hai*,' he said — this is very good news indeed, son. He embraced me. 'You are like my own son. Bhaiya [my father] would be very proud of you.' If truth be known, since dad's death, I regarded Arjun Kaka as a father figure.

Once a rural backwater, Labasa was on the move. There was a time when going to Suva was considered 'going overseas', an experience recounted in glorious and often embroidered detail for years. Australia and New Zealand were out of the question. 'The place is emptying day by day, especially since all the *jhanjhat* [trouble] started.' He meant the coup. 'There is no growth, no hope. Young people, finishing school, leave for Suva. No one returns. There is nothing to return to.' '*Dil uth gaye*,' Kaka said — the heart is no longer here. Kaka's observation reinforced what I had been told in Suva. There was hardly a single Indo-Fijian family in Fiji which did not have at least one

member abroad. 'The best and the brightest are leaving,' a friend had remarked in Suva. 'Only the *chakka panji* [hoi polloi] remain.' The wealthy and the well-connected had their families safely 'parked' in Australia and New Zealand, he had said. An interesting way of putting it, I thought, suggesting temporariness, a readiness to move again if the need arose. I had heard a new phrase to describe this new phenomenon: frequent flyer families. Those safely abroad talked of loyalty and commitment to Fiji, of returning one day, but it was just that, talk, nothing more. I felt deeply for people who were trapped in Fiji, victims of fate, living in suffering and sufferance.

As the news of Kaka's planned trip to Australia spread, people were genuinely happy for him. At Tali's shop the following evening, Karna bantered, '*Ek memia lete aana, yaar*' — bring a white woman along with you. '*Kab tak bichari patoh tumhar sewa kari*' — how long will your poor daughter-in-law continue to look after you? 'Learn some English words,' Mohan, the village bush lawyer, advised. 'Thank you, goodbye, hello, how are you, mate.' 'Make sure you are all "suit-boot" [well dressed], not like this' — referring to Kaka's khaki shorts and fading floral shirt. 'We don't want others to know that we are *ek dam gawar* [country bumpkins].' 'Which we are,' Haria interjected. 'Yes, but we don't have to advertise it!' Mohan countered. Bhima wondered whether some of the *kulambar* [CSR overseers] were still alive and whether Arjun Kaka might be able to meet some of them in Australia. Mr Tom, Mr Oxley, Mr Johnson.

Mr Tom: now, there was a name from ancient history. He was the first white man I ever saw. Tall, pencil-thin, white hard hat, his face like a red tomato in the midday sun, short sleeve shirt and trousers, socks

pulled up to the knees, the shirt pocket bulging with pens and a well thumbed note book. The overseers had a bad reputation as heartless men driven to extract the maximum from those under their charge. Was that true, I wondered. 'Well the Company was our *mai-bap*,' Kaka said — our parents. 'You did what you were told,' Bhima chimed in. 'The *kulambar* were strict but fair.' So it wasn't all that bad? I wanted to know more. Bhima continued: 'As far as they were concerned, we were all the same, children of coolies. They didn't play favourites among the farmers. Look at what is happening now.' I had no idea. 'Look at all the *ghoos-khori* [corruption].' He went on to explain how palms had to be greased at every turn — to get enough trucks, to get your proper turn to harvest. 'In the old days, if you did your work, you were left alone.' Nostalgia for a simpler, less complicated time perhaps, I wondered, but said nothing.

People in the village had very sharp memories of the overseers. 'Mr Tom drank kava like fish,' Mohan remembered. 'And chillies,' Karna added. 'A dozen of those "rocketes", no problem. *Chini-pani, chuttar pani*.' We all exploded. *Chini-pani* in the cane belt meant 'sugar has turned to water' — the sugar content is down, which is what the overseers at the mill weighbridge allegedly told the farmers, cheating them of a fair income. *Chuttar pani* refers to washing your bum with water after going to the toilet, a reference in this case to Mr Tom's probably agonising toilet sessions after eating so many hot chillies. Overseers, I learnt, were expected to have some rudimentary Hindi because the farmers had no English. But sometimes their pronunciation of Hindi words left people rolling with laughter. Bhima recalled Mr Oxley once asking someone's address. '*Uske ghar kahan hai?*' — where is his

house? But the way he pronounced *'ghar'* — *gaar* — it sounded like the Hindi word for arse: 'Where is his arse!' Kaka recalled Mr Tom visiting Nanka's house one day wanting to talk to him, but Nanka had gone to town. Mr Tom asked Nanka's son whether he could speak to his mother. Instead of saying *'Tumar mai kahan baitho'* — where is your mother [*mai*] — he accidentally added the swear word *chod*, to fuck, a common swear word among overseers: *'Tumar mai-chod kahan baitho'* — where is your motherfucker! Which left Mrs Nanka tittering, covering her mouth with her *orhni* [shawl], and scuttling towards the kitchen.

This warm reminiscence of aging men brought back memories which until now had vanished. I recalled the excitement of the visit every three months or so of the CSR Mobile Unit coming to the village. On the designated evening, the entire village would gather in the school compound, sit on sheets of stitched sacks [*paal*], cover themselves with blankets in the colder months and watch a tiny screen with grainy pictures perched at the end of a Land Rover. At the outer edges of the compound would be placed a put-put-put droning generator to provide power to the projector. Sometimes, the documentary would be about a model Indian family, sometimes about some aspect of the sugar industry or good husbandry. 'This is Ram Prasad's family,' the voice-over would announce in beautifully cadenced English. Then we would see an overseer, in white hard hat, his hands on his hips, talking to Ram Prasad, in short sleeves and khaki pants, his amply-oiled hair neatly combed back, his hands by his side or behind his back, not saying much, avoiding eye contact with the overseer. Ram Prasad's wife would be at a discreet distance by the kitchen, wearing a *lehenga* and blouse, her slightly bowed head

covered with an *orhni*, while schoolchildren, in neat uniforms with their bags slung around their shoulders, walked past purposefully. The moral was not lost on us. We too could be like Ram Prasad's family, happy and prosperous, if only we were as dutiful, hard-working and respectful of authority as them.

Occasionally we would see documentaries about Australia. We did not understand the language, partly because of the rapid speed at which it was spoken, but the pictures remain with me: of vast golden-brown wheat fields harvested by monster machines, hat-wearing men on horseback mustering cattle in rough hilly country, wharves lined with huge container carriers, buildings tall beyond our imagination and streets choked with crawling cars. Pictures of parched, desolate land puzzled me. It seemed all so harsh to us surrounded by nothing but lush tropical green. I sometimes wondered how white people, who seemed so delicate to us, could live in a place like that. But the overwhelming impression remained of a vast and rich country. It was from there that all the good things we liked came: white purified sugar we used in our *puja*, the bottled jam, the Holden cars. The thought that we would one day actually live there was too outrageous to contemplate. And we did not.

I also remembered the annual school essay competition. The CSR would send the topics to the school early in the year. Usually, they were topics such as 'Write an Essay on the Contribution the CSR Makes to Fiji', or 'How the Sugar Industry Works'. The brighter pupils in the school were expected to participate and turn in neatly written and suitably syrupy pieces. I was a regular contributor. One day during the morning assembly, our head

teacher, Mr Subramani Gounden, announced that I had done the school proud by winning the *third* prize in the whole of Vanua Levu! The first one ever from our school, and the only one for several years, I was later told. I vividly recall trooping up to the front to receive my certificate scrawled with a signature at the bottom. Such success, such a thrill. It was at university that I realised how unrelenting and tough-minded the CSR was in the management of the sugar industry, but at primary school we were immensely grateful for the tender mercies that came our way. We were so proud that on prize-giving day we had an overseer, no less, as our guest of honour. Mr Tom was a regular and much honoured presence.

One day I asked Arjun Kaka what he thought Australia would be like. *'Nahin Jaanit, Beta'* — I don't know. 'There must be a lot of people like us there,' he said. 'Why do you say that?' I asked somewhat perplexed. 'You know white people. They can't plant and harvest sugar cane, build roads or do any other hard physical work like that. All that is our job. They rule, we toil.' Kaka spoke from experience — very limited experience of the world, needless to say — but I assured him that white people did indeed do all the hard work in Australia. They planted and harvested cane and wheat, worked as janitors and menial labourers, drove trucks, buses and cars. Kaka remained unconvinced. 'It must be cold there?' he enquired. I tried my best to explain the seasons in Australia. Knowing the Canberra weather in summer, I said 'Sometimes it gets hotter than Fiji.' 'But how come then white people there don't have black skin? Look at us: half a day in the sun and we become black like *baigan* [eggplants].' 'You will see it all for yourself, Kaka,' I said and left it at that. This old

man is in for the shock of his life, I thought to myself.
His innocence and simplicity, his complete lack of under-
standing of the outside world, was endearing in a strange
kind of a way. I made a mental note of things I would have
to do in the next few weeks: get Kaka's passport and visa
papers ready, ask Krishna in Sydney to purchase the ticket.
Then I left for Suva, promising to inform Kaka of the date
of travel well in time. I would see him in Nadi.

Kaka was relieved to see me again in
Nadi. This was his first visit to Viti Levu, the first out of
Labasa actually. In the late 1990s, the Nadi International
Airport resembled a curious mixture of marriage celebra-
tion and funeral procession as people arrived in busloads
to welcome or farewell friends and family. Men were dressed
in multi-coloured floral shirts and women in gaudy *lehenga*
and *salwar kamiz* and saris. I noticed a family huddled in
one corner of the airport lounge. One of them was leaving.
I could quite imagine the scene at their home the previous
night. A goat would have been slaughtered and close family
and friends invited to a party. The puffy red eyes told the
story of a sleepless night. A middle-aged woman, presumably
the mother, prematurely aged, with streaks of grey dishev-
elled hair, was crying, a white handkerchief covering her
mouth. And the father, looking anxious, sad and tearful,
was chatting quietly with fellow villagers, passing time.

This was a regular occurrence in
those days: ordinary people, sons and daughters of the
soil, with uncertain futures, leaving for foreign lands.
What was once a trickle is turning into a torrent right
before our eyes. To an historian, the irony is inescapable.
A hundred years ago, our forbears had arrived in Fiji,
ordinary folk from rural India, shouldering their little

bundles and leaving for some place they had not heard of before but keen to make a new start. A hundred years later, their children and grandchildren are on the move again: the same insecurity, the same anxiety about their fate. No one seems to care that so many of Fiji's best and brightest are leaving. Some Fijian nationalists actually want the country emptied of Indians. Kaka noticed my contemplative silence. He had read my thoughts. He asked, 'Beta, desh ke ka hoi?' — what will happen to this land? It was an interesting and revealing formulation of the problem. He hadn't said 'hum log' — a communal reference to the Indo-Fijians. He had placed the nation — desh — before the community. I wished Fijians who were applauding the departure of Indians could see the transparent love an illiterate man like Kaka had for the country.

Arjun Kaka seemed nervous as we entered the plane: this was only the second time he had ever flown in a plane. The first time was when he flew from Labasa to Nadi to catch the flight to Sydney. Kaka was watchful, nervous. 'So many seats, Beta,' he said. 'Jaise chota saakis ghar' — like a mini theatre. Not a bad description, I thought to myself. 'And so many people! Will the plane be able to take off?' I watched him say a silent prayer as the plane began to taxi. 'Everything will be fine, Kaka,' I reassured him. 'Yes, Beta, I just wanted to offer a prayer,' he said smiling. Sensing my curiosity, he said, 'Oh, I was just saying to God that I have come up this high, please don't take me any higher just yet.' We both smiled at the thought.

Half an hour after take-off, the drinks trolley came. I asked for a glass of white. Knowing that he was teetotaller, I asked Kaka if he would like anything soft. 'No, Beta, I am okay. Sab theek hai.' 'Nothing?

What about soft drinks: tomato or orange juice, water?' 'At my age, you have to be careful,' Kaka said to me some minutes after the trolley had gone. 'I have to go to the toilet after I have a drink. Can't contain it for too long.' '*Bahut jor pisaap lage*' — but there is a toilet on the plane, Kaka, I reassured him, gently touching his forearm. 'Actually there are several, both at the front and back of the plane.' That caught Kaka by complete surprise. A toilet on the plane? 'You can do the other business there, too, if you want,' I continued. But Kaka was unwilling to take the risk. Later I realised a possible reason for his hesitation: if he did the other business, he couldn't wash himself with water — toilet paper he had never used.

When lunch was served, Kaka refused once again. He was a strict vegetarian, a *sadhu* to boot. 'You can have some bread and fruit, Kaka,' I said. He still refused. 'You don't know what the Chinese put in the bread,' he said. In Labasa, all the bread was made by Chinese and a rumour was started, probably by an Indo-Fijian rival, that they used lard in the dough. I did not know but it did not matter to me. In the end, Kaka settled for an '*apul*' and a small bunch of grapes. 'I am sorry, Kaka, but I have ordered chicken,' I said apologetically. '*Koi bat nahin*,' he said — don't worry. Everyone in his family ate meat, including his wife. He was its only vegetarian.

My curiosity was aroused. How had Kaka become a vegetarian and a teetotaller? Most people in the village were not. I noticed that the back of his right hand was deformed, his skin burnt and his fingers crooked. 'Kaka,' I said, 'if you don't mind my asking, how did that happen?' 'It is a long story, Beta,' he said. 'But we have three hours to kill,' I replied. This is what Kaka told me.

Soon after he got married, he had a large itchy sore on the back of his right palm. Someone had obviously 'done' something. Magic and witchcraft, *jadu tona*, were an integral part of village life, I remembered. One possibility, he said, was his neighbour, Ram Sundar, who might have spread the rumour that Kaka had leprosy, the most dreaded social disease one could imagine, a disease with a bad omen. If Kaka went to Makogai Hospital (for lepers, in the remote Lomaiviti group), the whole family would be ostracised, no one would think of marrying into it, no invitations to marriages and festive occasions. Social pressure would force the family to move to some other place to start afresh, as far away from established settlement as possible. If Kaka had leprosy, he would have to move from the village and Ram Sundar would then finally realise his dream of grabbing Kaka's adjacent 10-acre farm. Such cunning, such heartlessness, and here was the outside world thinking that warm neighbourly relations characterised village life.

The extended family — because its reputation would be singed too by this tragedy — decided that something had to be done soon about Kaka's condition. Rumour was spreading fast. Instead of going to a doctor — no one in the village did or really believed in the efficacy of western medicine — his *girmitiya* [indentured] father sent him to an *ojha*, a sorcerer, in Wainikoro some thirty or so miles away to the north. The *ojha*, Ramka, was famous — or dreaded — throughout Vanua Levu. He had once saved the life of a man, Ram Bharos, who had gone wild, squealing like a mouse sometimes and roaring like a lion at others, clenching his teeth and hissing through closed lips, because he had faltered trying to master magic rituals which would enable him to destroy people and cattle and

property, even control the elements. To acquire that power, Ram Bharos was told — by whom it was not known — that he would have to eat a human heart sharp at midnight. Nothing was going to deter Ram Bharos from realising his ambition. He killed his own aged father. At night, he went to the graveyard, opened his father's chest with a knife and put the heart on a banana leaf. After re-burying the body, he walked to a nearby river, with the heart in his hands, and waded chest-deep into the river. Then something frightening happened. He saw a man shrouded in white walking towards him. Suddenly there was a blinding flash of light. Ram Bharos stumbled, forgot the names of deities he was supposed to invoke. He went mad. Ramka cured him partly, restoring a semblance of normalcy to Ram Bharos' damaged personality. This sounds like an improbable story, but I believed Kaka. Labasa, dubbed the Friendly North, has its dark side as its residents know only too well.

It was to this famous *ojha* that they had taken Arjun Kaka. In a dimly lit room, Ramka did his magic. He rubbed Kaka's damaged palm with fat and turned it over the fire for a very long time, chanting words in a language that was incomprehensible to him. By the time he had finished, the skin had been charred. A few days later, the bones had twisted. But Kaka was 'cured', he did not have leprosy, the family's honour was saved, and the farm remained intact. Ramka asked Kaka never to touch meat and not have pork cooked at his home. That was how Kaka had become a vegetarian.

Magic, witchcraft, sorcery, belief in the supernatural, the fear of ghosts and devils, blind faith in healers and magic men: it all recalled for me a world which the *girmitiya* had brought with them and of

which we all were a part, but which now belonged to an era long forgotten, for the present generation nothing more than stories of a twisted imagination. And this man, from that world, was going to Australia! 'I have forgotten the details, Beta,' Arjun Kaka apologised. 'You are the first person to ask me.' I am glad I did. After Kaka had spoken, I recalled the pin-drop silence of unlit nights in the thatched *bure* — *belo* — where we slept, the eerie scurrying of nocturnal animals on crackling dry leaves around the house, the scrotum-shrivelling stories of swaying lights in the neighbouring hills, soft knocks on doors at odd hours, the mysterious aroma at night of scents usually sprinkled on corpses, streaking stars prophesising death somewhere, wailing noises across the paddy fields and shimmering figures in the nearby mangrove swamps. We dreaded nights.

At Sydney airport, Krishna met us. I gave him my phone number and promised to keep in touch. Kaka had a three-month visa and I told him that I would visit him in Sydney. After we embraced, I headed for Canberra, determined that I would do everything I could to give Kaka a memorable journey to Mr Tom's country. About a month later, Krishna phoned me. Kaka wanted to talk to me. 'Beta, I am going back soon. I would like to see you before I return.' 'But you have a full three-month visa.' 'Something inside tells me that I must return as soon as possible.' A premonition of some sort? His world of magic and sorcery came to mind, and I realised there was no point arguing or trying to persuade him to change his mind. I left for Sydney the following day.

Krishna and his wife had gone to work and the children were at school when I reached the house. It was immediately clear to me that Kaka was a lost

man, uncomfortable and anxious. I reminded him of his promise to tell me the full story about his Australian experience. 'Poora jad pulai' — everything. What he missed most, Kaka said, was his daily routine. In Tabia, he would be up at crack of dawn, feed the cattle and have early breakfast before heading off to the fields. Even at his age. In the evening, after an early shower at the well, he would light the wick lamp — dhibri — and do his puja. He missed his devotional songs on the radio, the death notices in the evening. He would not be able to forgive himself if someone dear to him died while he was away. Kaka often wondered how Lali, his beloved cow, was. He treated her tenderly, almost like a human, a member of the family. For him, not looking after animals, especially a cow [gau-mata, mother], was a crime.

In Fiji, Kaka was connected, was part of a living community. He had a place in the wider scheme of things. But not here. 'I sit here in the lounge most of the day like a deaf and blind man. There is television and radio, but they are of no use to me.' What about a walk in the park, a stroll in the nearby supermarket? I asked. Kaka recalled a particularly hair-raising experience. One day Krishna had left him in the mall of a large supermarket and had gone to get his car repaired. At first Kaka was calm, but as time passed, surrounded by so many white people, he panicked. What if something happened to Krishna? He did not have the home address or the telephone number with him. How would he find his way home? He tried to talk to a young Indian man — who was probably from Fiji — but the man kept walking, muttering to himself. 'He probably thought I was a beggar or something.' From that day on, Kaka preferred to remain at home. For a man fond of the

outdoors, active in the fields, this must have been pain-
ful. 'It is torture, Beta. Sitting, eating, pissing, farting.
That's all I do all day, everyday.' I felt his distress.

Did Krishna and his wife treat him
well, I asked. It was an intrusive question, I know, but I
wanted to be helpful. 'Oh, they both are very nice. Patoh
makes vegetarian dishes and leaves them in the fridge for
me. I have a room to myself. My clothes are washed. On the
weekends, they take me out for drives.' But there was some-
thing missing, I felt. 'Beta, it is not their fault but I
don't see much of them. Babu [Krishna] goes to work in the
morning and Patoh does the evening shift. By the time she
returns, it is time for bed.' The 'ant-like life', as Kaka
aptly put it, was not his cup of tea. 'Getting established
in this society is not easy, Kaka,' I said, 'but things
improve with time.' 'That's true, but by then, half your
life is over. These people would have been millionaires
in Fiji if they worked as hard as they do here.' 'They do
it for the future of their children, Kaka.' He nodded. 'I
know, I know.'

Kaka felt acutely conscious of him-
self whenever he did anything, constantly on the guard.
Back home, he would clear his throat loudly and cough out
the phlegm on the lawn. Everyone did it. Here his grand-
children giggled and covered their mouths with their hands
in embarrassment. In Tabia, Kaka always wore shorts at
home. Here, on several occasions, he felt undressed, half
naked, when Krishna's friends came around. 'I could see
that both Babu and Patoh were sometimes uncomfortable.'
Sometimes, the people he met at *puja* and other ceremonies,
especially people from Viti Levu, laughed in jest at his
rustic Labasa Hindi. 'They find us and our language back-

ward. *"Tum log ke julum bhasa, Kaka"* they would say to me
mockingly — Uncle, you folk [from Labasa] have a wonderful
language: *"awa-gawa* [come and gone, when they say *aya-
gaya*], *dabe* [flood, *baadh*], *bakeda* [crab, *kekda*]."* They
find it funny, but after a while I find the mocking hurtful.
So I don't say much — *ka boli* — not that I have much to say
to these people anyway.' In Tabia, Kaka had his own *kakkus*
[outhouse] where he could wash himself properly with water
after the toilet, but here he would sometimes spill water
on the toilet floor or accidentally leak on it, causing
mustiness and a foul smell. He would then feel guilty and
embarrassed. Kaka found the accumulation of small things
like this making him self-conscious, ill-at-ease in the
house. No one ever said anything, but he felt that he was
a bit of a nuisance for everybody, especially when Krishna's
friends came around.

Kaka was desperate for news from
home, any news. There was nothing about Fiji, let alone
Labasa, on television and only brief snippets on one or two
radio stations, which he often missed because he could not
find the right station. His Fiji radio had only one. 'At
home, I knew what was happening in Fiji and the world, but
here I sit like a frog in a well. It is as if we do not ex-
ist.' I understood his puzzlement. Fiji — Labasa — was all
he knew. His centre of the universe was of no interest and
of no consequence to the rest of the world. 'That is the
way of the world, Kaka,' I tried to assure him. 'We are no-
ticed only when we make a mess of things, or when there is a
natural disaster or when some Australian tourist gets raped
or robbed.' Some of the people he had met, especially the
older ones, hankered for news from Fiji, but the younger
ones were too preoccupied with life and work to bother.

Television both entertained and embarrassed Kaka. He couldn't watch the soaps with the entire family in the room. The scantily clad women, the open display of skin, the kissing, the suggestive bedroom scenes, the crude advertising (for lingerie, skin lotions), had him averting his eyes or uttering muffled coughs. Sometimes, unable to bear the embarrassment, he would just retire to his room on the pretence that he was tired, and then spend much of the night sleepless, wondering about everything. He liked two shows, though, and enjoyed them like a child. One was David Attenborough's nature programmes. He did not understand the language but the antics of the animals and creatures of the sea did not need words to understand. These programmes brought a whole world alive for him. He remembered the animals his *girmitiya* father used to talk about: *sher* [lion], *bhaloo* [bear], *hathi* [elephant], *bandar* [monkey]. He had seen pictures of them in books, but to see live animals on the screen was magical. And he liked cartoons, especially the Bugs Bunny shows. They made no sense to him at all — nor to me — but that was their charm, characters skittering across the screen speaking rapid-fire — '*gitbit gitbit*'. He would laugh out loud when no one was watching.

These were the only programmes Kaka could watch with his small grandchildren. Otherwise there was no communication between them. The children were nice — '*sundar*' is how Kaka described them. They made tea for him and offered him biscuits and cookies, but they had no Hindi at all and Kaka knew no English. He would caress their heads gently and hug them and they would occasionally take him for walks in the park nearby, but no words were exchanged. '*Dil roye, Beta,*' Kaka said to me — the heart

cries — 'that I cannot talk to my own flesh and blood in the only language I know. I hope they will remember me and remember our history.' Krishna was making an effort to introduce his children to Indian religion and culture through the weekend classes held at the local *mandir*, but it was probably a lost cause. History was not taught in many public schools, certainly not Pacific or Fijian history and I wondered how the new generation growing up in Australia, exposed to all the challenges posed by global travel and technology, would learn about their past. I did not have the heart to tell Kaka, but I know that his world would go with him, just as mine will, too. Our past will be a foreign country to children growing up in Australia.

Once or twice, I took Kaka out for a ride through the heart of Sydney, pointing out the monuments — Hyde Park, Circular Quay, the Museum and the Mitchell Library — but Kaka had no understanding and no use for the icons of Australian culture. For him, the city was nothing more than concrete and glass chaos, one damn tall building after another. I took him for a ride in the country, playing devotional Hindi music in the car (which he enjoyed immensely). Kaka had imagined Australia to be clogged with buildings and people, but the long, unending distances between towns both fascinated and terrified him. In Labasa an hour's journey was considered long; the idea of driving for a couple of days to get from one place to another was alien to him. And the geography too fascinated Kaka: the dry barren countryside wheat-brown in December, the bleached bones of dead animals by the roadside, the rusting hulks of discarded machinery and farms stretching for thousands of hectares. 'How can one family manage all this by themselves,' he wondered. 'How can you grow any-

thing in this type of soil?' And he wondered how, living so far apart on their farms, the people kept the community intact. I said little: he was wondering aloud, talking to himself. On our return journey, Kaka said sadly that he wished 'my Kaki', his wife, could have seen all this with him. I wished that too. I could sense that he was missing her. Kaka remained silent for a long time.

I was still unsatisfied that Kaka was happy with all that Krishna and I between us had been able to show him. Then it came to me that Kaka might like to visit the Taronga Zoo. It was an inspired thought. Kaka was like a child in a garden of delights. The animals he had seen on the television screen he saw live with his own eyes: giraffe, rhino, tiger, leopard, lion, cobra, and elephant. I was so glad that he was enjoying himself, pointing out animals to me, saying, 'look, look', with all the excitement of an innocent child. As we approached the monkey section of the zoo, Kaka stopped, joined his palms in prayer and said, '*Jai Hanuman Ji Ki*' — Hail to Lord Hanuman, the monkey god, Lord Rama's brave and loyal general, who had single-handedly rescued Sita from Ravana's clutches. He was excited to see a cobra. '*Nag Baba*,' he said reverentially — the snake god. When I looked at him, Kaka smiled but I couldn't tell whether his display of quiet reverence for the monkeys and cobras was sincere or was it for my entertainment! I knew that the old man certainly had an impish sense of humour.

As we were having a cup of tea at the end of the zoo visit, sweetening it with white sugar, Kaka wondered where that was manufactured. The next day, I took Kaka to the CSR refinery. He was thrilled. As already mentioned, we considered white sugar 'pure' enough to offer it to the gods in our *puja* and *havan*. A supervisor gave

us a good informative tour when he found out that Kaka was from Fiji. Kaka was impressed with how clean the place was and how new the machinery was, nothing remotely like the filthy, stench-producing sugar mills in Fiji. We also visited an IXL jam factory on the way. Jam and bread were a luxury for many poor families in rural areas of Labasa, to be enjoyed on special occasions, such as birthdays. The standard food in most homes was curry, rice and *roti*, with all the vegetables coming from the farm itself.

The visit to the sugar refining factory re-kindled Kaka's interest in the CSR. He wondered whether any of the *kulambar* were still alive. 'We could find out,' I offered. It would mean a lot of research, but I wanted to do it for this man who meant so much to me. I rang the CSR head office in Sydney. There was nothing on the overseers. Evidently, once they finished with the Company, they disappeared off the record books, a bit like the *girmitiya* about whom everything was documented when they were under indenture, and nothing, or very little, when they became free. Was there ever an association or club of former Fiji overseers, I wondered. The lady did not know but promised to find out. She rang an hour or two later to say that I could try Mr Syd Snowsill. He was the leader of the Fiji pack in Sydney. The name seemed vaguely familiar; he was, from memory, the spearhead of the Seaqaqa Cane Expansion project in the early 1970s. A gruff voice greeted me when I rang him. When I explained the purpose of my enquiry, he became relaxed. '*Bahut Accha*' — very good. 'Who are you after? Anyone in particular?' I volunteered three names: Mr Tom, Mr Oxley and Mr Johnson. 'I see,' Mr Snowsill said chuckling and with some affection. 'All the Labasa *badmaash* gang, eh' — the Labasa hooligans. He did

not know the whereabouts of Mr Oxley and Mr Johnson, but Mr Tom — Leslie Duncan Thompson — was living in retirement in Ballina. 'His name will be in the local telephone book,' Mr Snowsill said as he wished me good luck. '*Shukriya ji. Namaste* or should I say *Khuda Hafiz*!' 'Both are fine.'

If you do not know it, Ballina (Bullenah in the local Aboriginal language) is one of the loveliest places in Australia. A rural sugar cane growing community of fewer than twenty thousand in sub-tropical northern New South Wales, by the enchanting bottle-green Richmond River and surrounded by a sea of rippling cane fields for as far as the eye can see, tidal lagoons and surf beaches nearby. It was the kind of place I knew that Kaka would like: a rural cane country since the 1860s, the people friendly and genuine, in the way country folk generally are. And he did, as we drove on the Princess Highway through small, picturesque seaside towns, beaches, thickly-wooded rolling hills along the roadside, across a gently gathering greenness in the distance.

Mr Tom was certainly in the phone book when I checked the next morning. His address was a retirement home on the outskirts of the town, on a small hill overlooking the river. I didn't ring but drove to the place to give Mr Tom a surprise. My mental picture of him remained of a tall thin man, barking orders. Kaka was smiling in anticipation, perspiring slightly. We waited in the wicker chairs in the veranda as the lady at the front desk went to get him from the dining table across the room. As he walked towards us, I knew it was Mr Tom: tall, erect, with a bigger waist now, face creased and hair gone, but not the sense of purposefulness. 'Yeash,' he drawled. When I explained why we had come and told him Kaka's name, he beamed

and hugged him, two old codgers meeting after decades, slapping each other gently on the back. '*Salaam, sahib*,' Kaka muttered. '*Salaam, salaam*,' Mr Tom replied excitedly. '*Chai lao. Jaldi, jaldi*' — bring some tea, quick-fast, he said to no one in particular. Perhaps he wanted us to know that he still had Hindustani after all these years.

'*Tum kaise baitho*,' Mr Tom asked Kaka — how are you? Before Kaka could reply, Mr Tom said, '*Hum to buddha hai ab*' — I am an old man now. I translated for Kaka. After a while, the names came to Mr Tom: Lalta, Nanka, Sundar (he pronounced it Soonda). He especially asked after Udho, the de facto head man of the village, who was one of the few from Labasa to volunteer for the Labour Corps during World War Two. He had died some years back. 'Too bad,' Mr Tom said, 'he was a good man.' He asked after Kaka's family, about the school. 'I haven't been to Labasa since leaving, but hear it is a modern place now, not bush place like it used to be. They tell me the roads have been tarsealed and people have piped water. No longer a *pukka jungali* place, eh. You people deserve every bit of it.'

'*Seaqaqa kaise baitho, Arjun*?' — how is Seaqaqa? Mr Tom asked Kaka. That was the project on which he had worked with Mr Snowsill. It had been launched with great hope of getting Fijians into the sugar industry. Half the leases were reserved for them. When Kaka told him that many Fijians had left their farms or sub-leased them to Indo-Fijian tenants, Mr Tom seemed genuinely sad to learn that all the effort that he and other overseers had put in had gone to pot. 'It was done all too suddenly. They wanted to make political mileage out of it. Win elections. All that *tamasha* [sideshow]. That's no way to run this business. We needed to have proper training for them, prop-

er husbandry practices in place. You can't just pluck them out of the bush and make them successful farmers overnight. Ridiculous.' 'Farming is a profession, son,' Mr Tom said to me, 'just like any other. It is not everyone's cup of tea.' Mr Tom said that the CSR should have remained in Fiji for another five to ten years to effect a good transition, train staff properly, and most importantly to get politicians to see the problems of the industry from a business angle. 'But no, everything had to be done in a rush. You got your independence and you didn't want white men around telling you what to do anymore. Fair enough, I suppose, but look at what a mess you have made of the industry.'

Then Mr Tom asked about the current situation. He had read that the industry was in dire straits. 'I am afraid it is true, Mr Tom,' I said. Most leases in Daku, Naleba, Wainikoro, Laga Laga — places Mr Tom knew so well — had not been renewed, and the former farms were slowly reverting to bush. Mr Tom shook his head. 'Sad. So much promise, shot through so early.' He asked about the farmers. Those evicted were moving out, many to Viti Levu, starting afresh as market gardeners, vegetable growers, general labourers and domestic hands. '*Girmit* again, eh? Unnecessary tragedy. Why? What for? We have all gone mad.'

I asked Mr Tom about something that had been on my mind for many years. 'Why didn't the CSR sell its freehold land to the growers when it decided to leave Fiji? It would have been the right thing to do, the humane thing to do.' Mr Tom acknowledged my question with that characteristic drawl of his, 'Yeash.' And then bluntly, 'We couldn't give a rat's arse about who bought the land. All we wanted was *nagad paisa* [cash]. Fijian leaders understood

very well that land was power and didn't want the CSR to
sell its freehold land to Indians. Over 200,000 bloody
acres or so. Indian leaders in the Alliance went along,
trying to please their masters, hoping for some concessions
elsewhere. The Fijians and the Europeans — Mara, Penaia,
Falvey, Kermode, that crowd — had them by the balls. We in
the Company watched all this in utter incomprehension and
disbelief, but it wasn't our show. We were so pissed off
with the Denning Award.' He was referring to the award by
Lord Denning, Britain's Master of the Roll, which favoured
the growers against the millers and which led eventually
to CSR's departure from Fiji in 1973. 'And then there was
the Gujarati factor, did you know?' I didn't. 'Some of your
leaders feared that if Indian tenants got freehold land,
Gujarati merchants would get their hands on it by hook or
by crook. To some, the Gujarati were a bigger menace than
Fijians and Europeans. Such bloody short-sightedness. Son,
some of your suffering is self-inflicted. Harsh thing to say,
but it's true.'

After a spell of silence, Kaka wanted
to know about Mr Tom's life after Tua Tua. From Tua Tua he had
gone to Lomowai and done the rounds of several Sigatoka sec-
tors (Kavanagasau, Olosara, Cuvu) before moving to Lautoka
mill as a supervisor. Taking early retirement, he returned
to Australia, and after some years of working in Ballina's
sugar industry he 'went fishing', as he put it — travel-
ling, taking up golf and lawn bowling. I vividly recalled
lawn bowling as the game white people, in white uniforms
and white shoes, played at Batanikama. Wife and children?
Kaka wanted to know. The wife had died a few years back,
which is when he moved to this place. The children were
living in Queensland. 'There is nothing for them here.'

Kaka wondered, smiling, if Mr Tom still had that fearsome taste for hot chillies. *'Nahin sako, Arjun'* — can't do it anymore. *'Pet khalas'* — the stomach's gone. 'And what do you do, young man?' Mr Tom asked me. When I told him that I was an academic in Canberra, he smiled. *'Shabaash, Beta, kya baat'* — well done, son. 'Boy from Labasa, eh! Who would have thought! From the cane fields of Fiji to the capital of Australia. You joined the bloody know-all academics! Good onya, son.'

We had been talking like this for an hour or so when the topic of the coups in Fiji came up. Mr Tom had been outraged by what had taken place. There was some support in sections of Australia for the coups, which saw them essentially as the desperate struggle of the indigenous community against the attempted dominance of an immigrant one. But Mr Tom was different. 'I wrote letters to the local papers, gave a few talks and interviews on the radio. No bloody use. Look, I said, you don't know the Indian people. I do. I have worked with them. I understand them. They made Fiji what it is today. They have been the backbone of the sugar industry. You take them out and the whole place will fall apart. Just like that. What wrong have they done? How have they wronged the Fijian people? Their only vices are thrift and industry.' He went on like this for some time. I was not used to hearing this kind of assessment from people in Australia. Mr. Tom was refreshingly adamant, defiant.

'Yours must have been a voice in the wilderness, Mr Tom,' I said. 'Bloody oath, yes. You talk about immigrant people ripping natives apart. Bloody well look at Australia! Look what we have done to the Aborigines. Snatched their land, made them destitute, pushed them into

the bush, robbed them of their rights. Bloody genocide, if you ask me. What have the Indians done to Fiji? They worked hard on the plantations so that the Fijians could survive. What's bad about that? If I had my way, I would bring the whole bang lot here. We need hardworking people like you in this country.' Mr Tom had spoken from the heart. 'Let me not go on, because all this hypocrisy lights me up.' 'Mr Howard would not approve,' I said. 'What would these city slickers know,' Mr Tom said dismissively. 'They don't know their arse from the hole in the ground, if you ask me.' I had heard many a colourful Australian slang — blunt as a pig's arse, knockers, spitting the dummy — but this one was new. I smiled, and appreciated Mr Tom's unvarnished directness.

It was time to go. Once again, Kaka and Mr Tom hugged. 'Well, Arjun, *nahi jaano phir milo ki nahin milo*' — don't know if we will ever meet again. 'Look after yourself and say *salaam* to the old timers.' With that we headed back to Sydney. I told Kaka all that Mr Tom had said. 'Remember, Beta, what I told you: many *kulambar* were tough but fair. We were not completely innocent either: *chori, chandali, chaplusi*' — thievery, stupidity, wanton behaviour. I was impressed, even touched, by Mr Tom's directness and his principled, uncompromising stand on the Fiji coups. I had not expected this sort of humanity in a former *kulambar*, whose general reputation in Fiji is still rotten. Talking to Mr Tom and driving through the cane country brought back many memories of growing up in Tabia more than a half century ago — of swollen brown rivers in the rainy season, the smell of pungent cane fires reddening the ground, cane-carting trains snaking through the countryside, little thatched huts and corrugated iron houses scattered around the dispersed settlements, smoke

from cooking fires rising gently in the distance, little school children in neat uniforms walking Indian-file to school. 'You are a godsend,' Kaka had said to me when I had offered to bring him to Australia with me. In truth, Kaka was a godsend for me. With him, I had re-visited a world of which I was once a part but no longer am.

I dropped Kaka at Krishna's place and returned to Canberra. I was going to Suva for a conference in a couple of months' time and promised to see him then. Tears were rolling down his stubbled cheek as he hugged me. '*Pata nahin, Beta, ab kab miliho*' — don't know, son, when we will meet again. I didn't know it then, but it was the final goodbye. A month after Kaka returned, Krishna rang to say that he had died — of what precisely no one knew. I was speechless for days. The last link to my past was now gone, the last one in the village who had grown up in the shadow of indenture, lived through the Depression, the strikes in the sugar industry, the Second World War. I felt cheated. I still feel his loss. With Kaka gone, one more familiar Tabia signpost had disappeared from my life. After a brief moment of promise, the place once again became a labyrinth of haunting memories.

When I returned to Fiji, I knew that I had to go to Labasa. Perhaps it is the ancient urge to say the final goodbye in person. I wanted to know the exact circumstances of Kaka's death. Only then could I finally come to terms with my grief. Kaka had been happy to return home, back in his own house, back to his daily routine, people told me. Then one day, all of a sudden, Lali, the cow, died. Kaka was distraught; she was like family to him. Lali was his wife's gift to him when their first grandchild was born. He used to talk to her everyday,

caress her forehead, religiously feed her para grass every morning and afternoon, wash her once a week. People said that Kaka talked to Lali as if he was talking to his wife, telling her his doubts and fears, using her as a sounding board for his ideas and plans. Now a loved link to that past was gone. He was heart broken. In fact, he had died from a massive heart attack. The last words Kaka spoke before he collapsed, one of his grandchildren remembered, was *'Dhanraji, taharo, hum aait haye'* — Dhanraji, wait for me. I am coming.

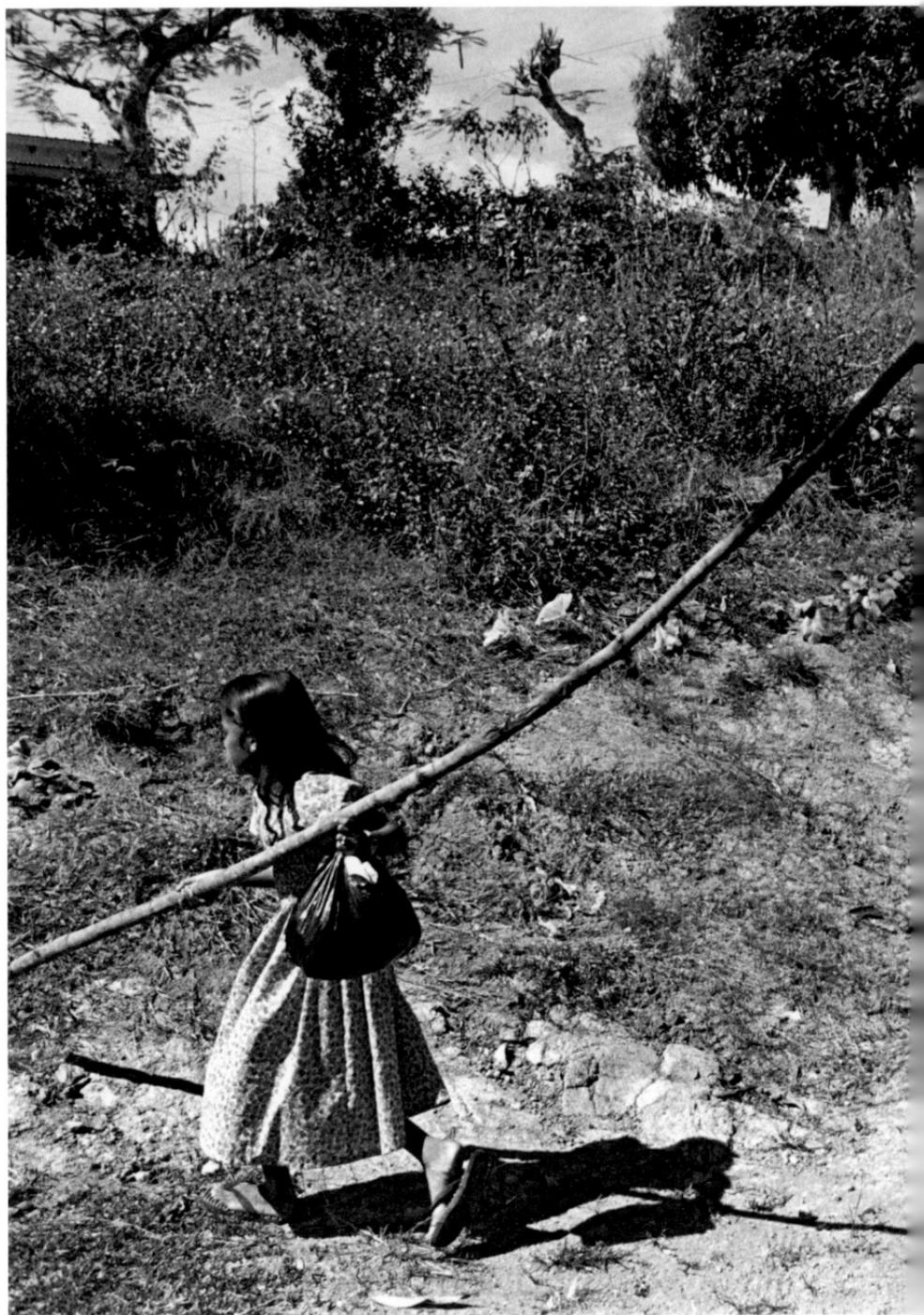

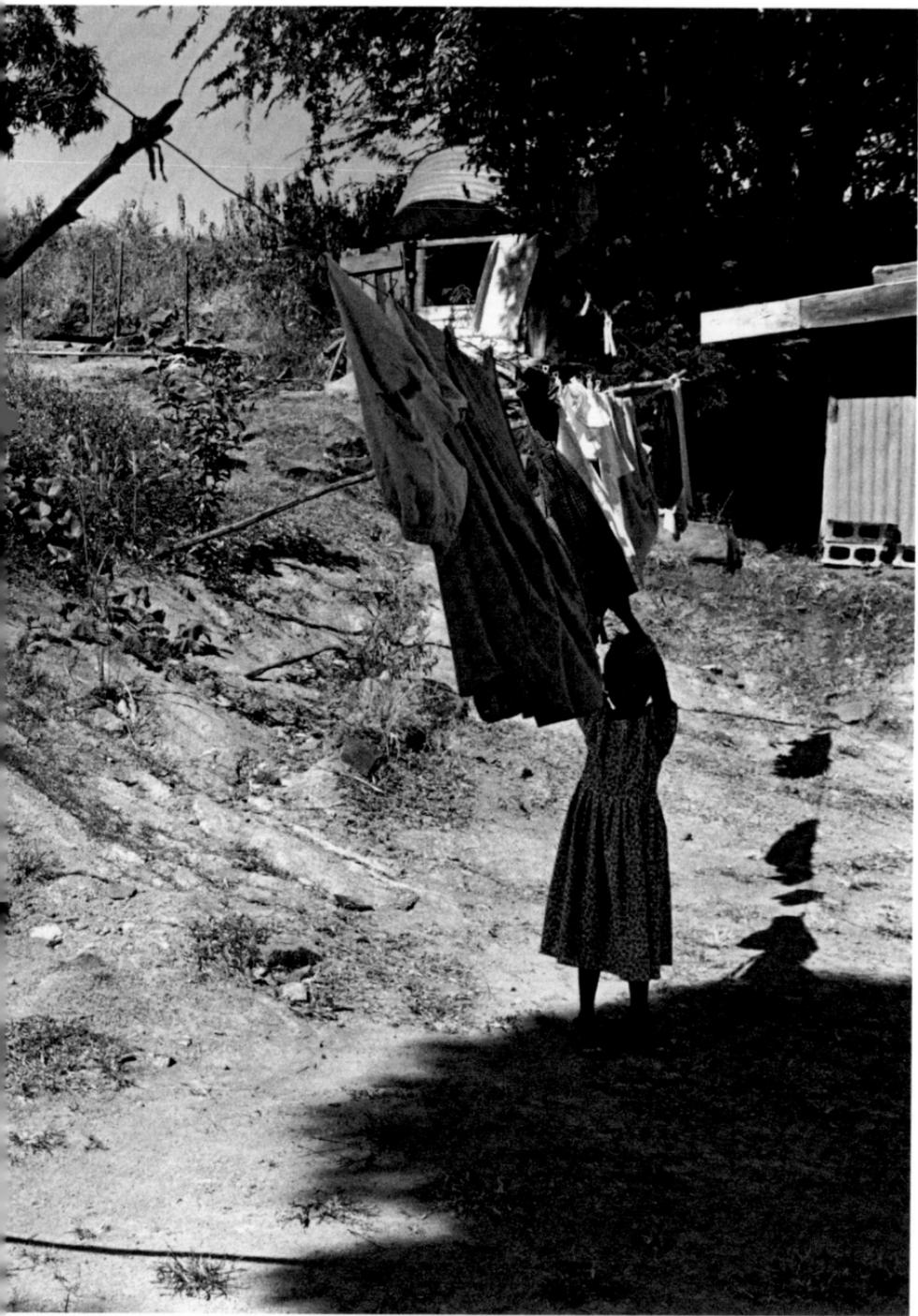

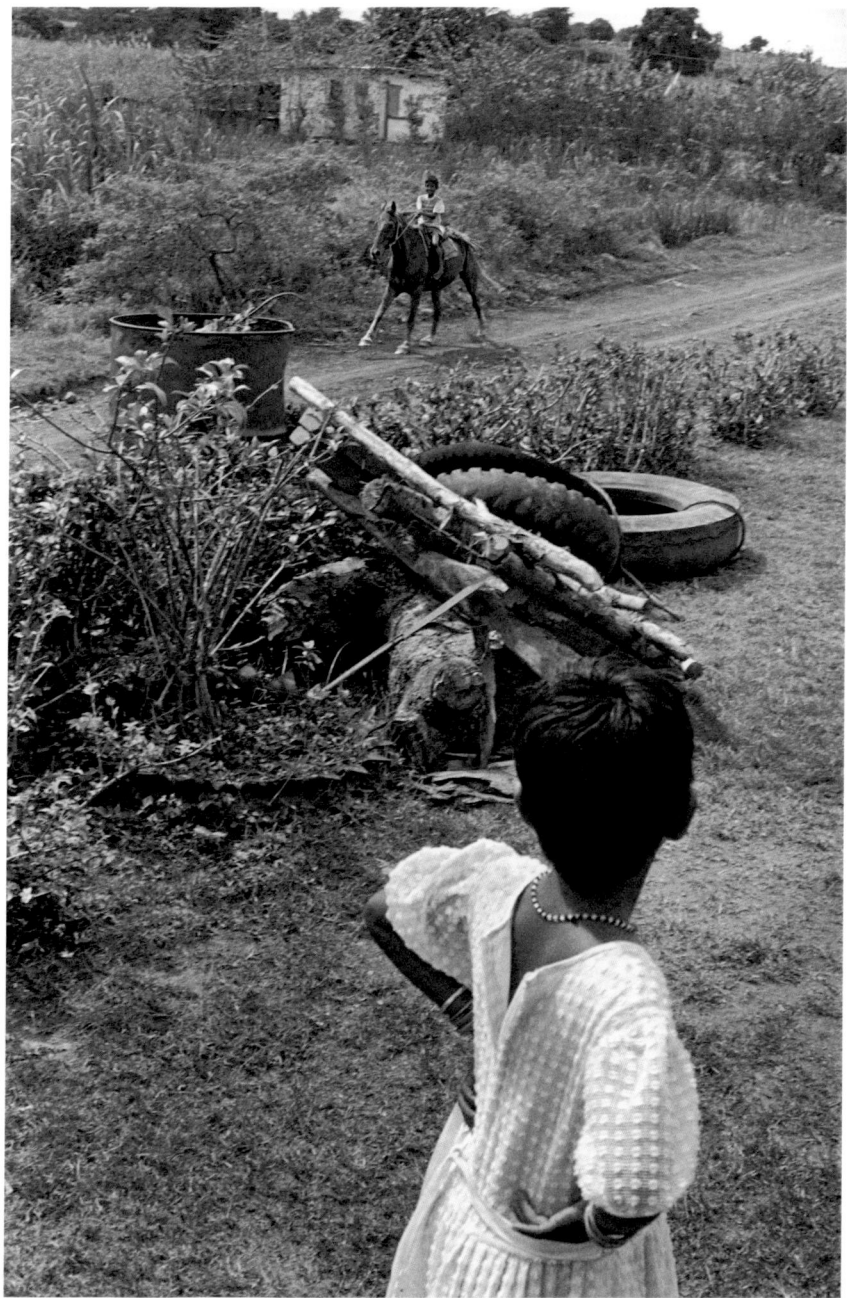

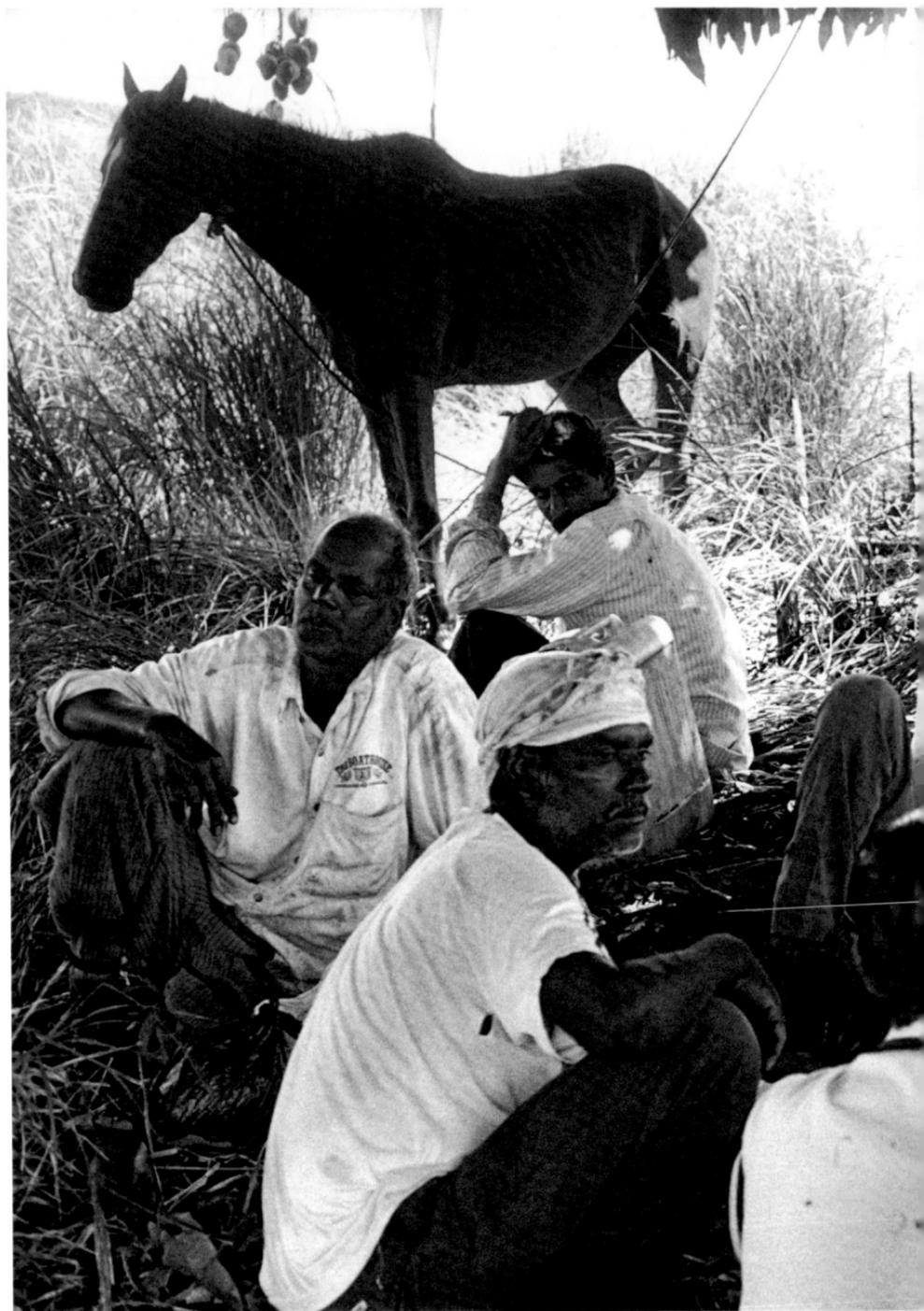

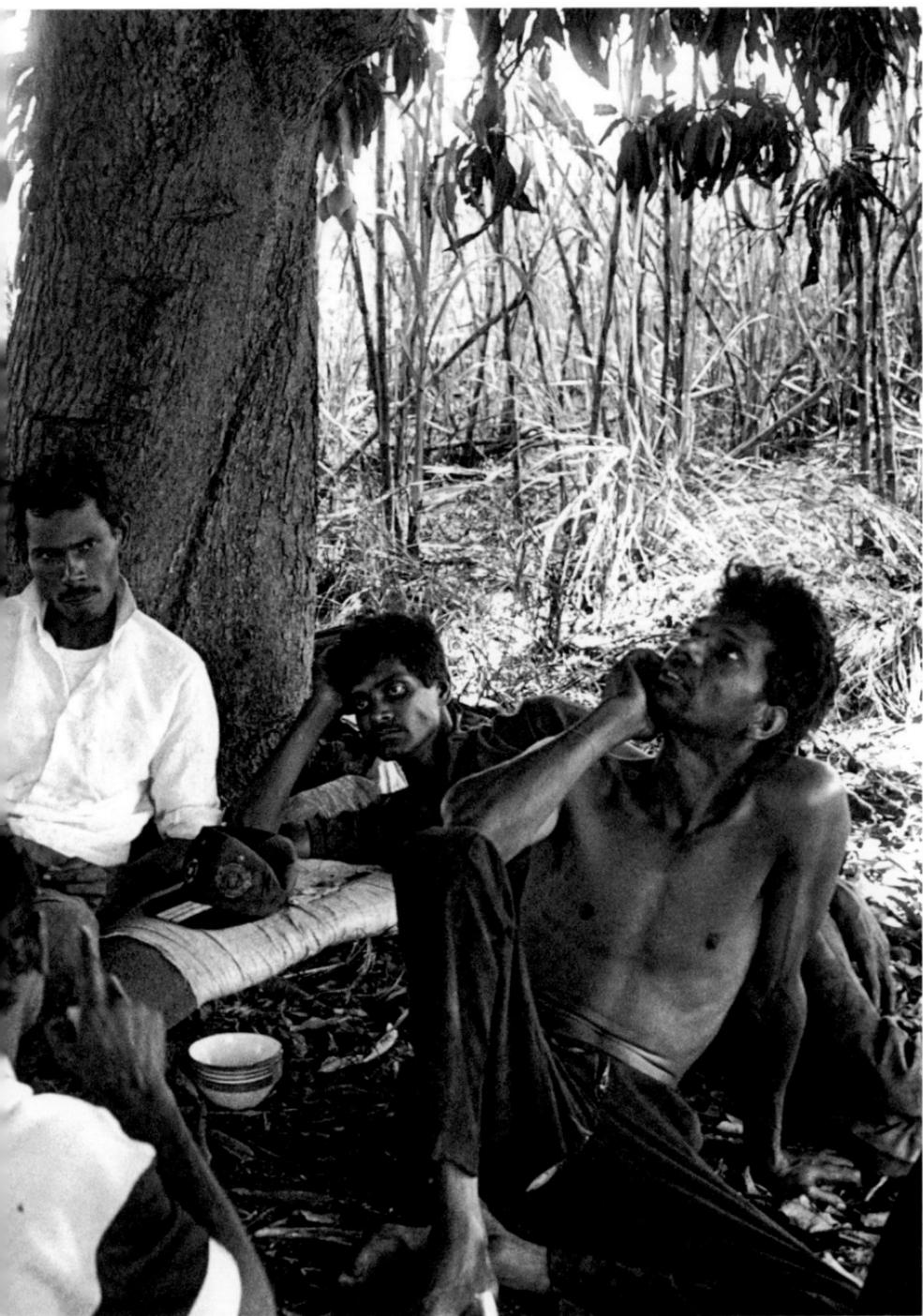

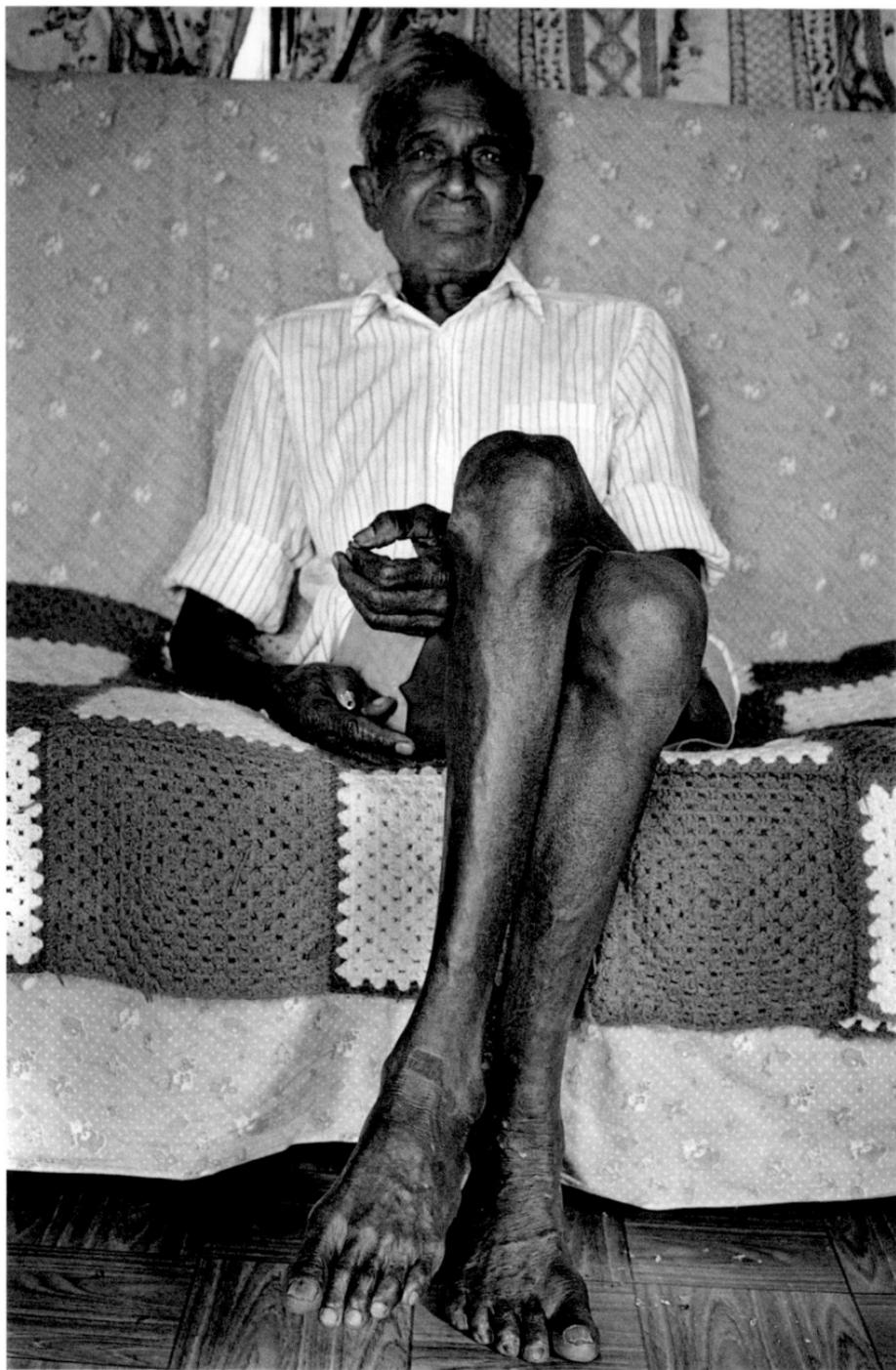

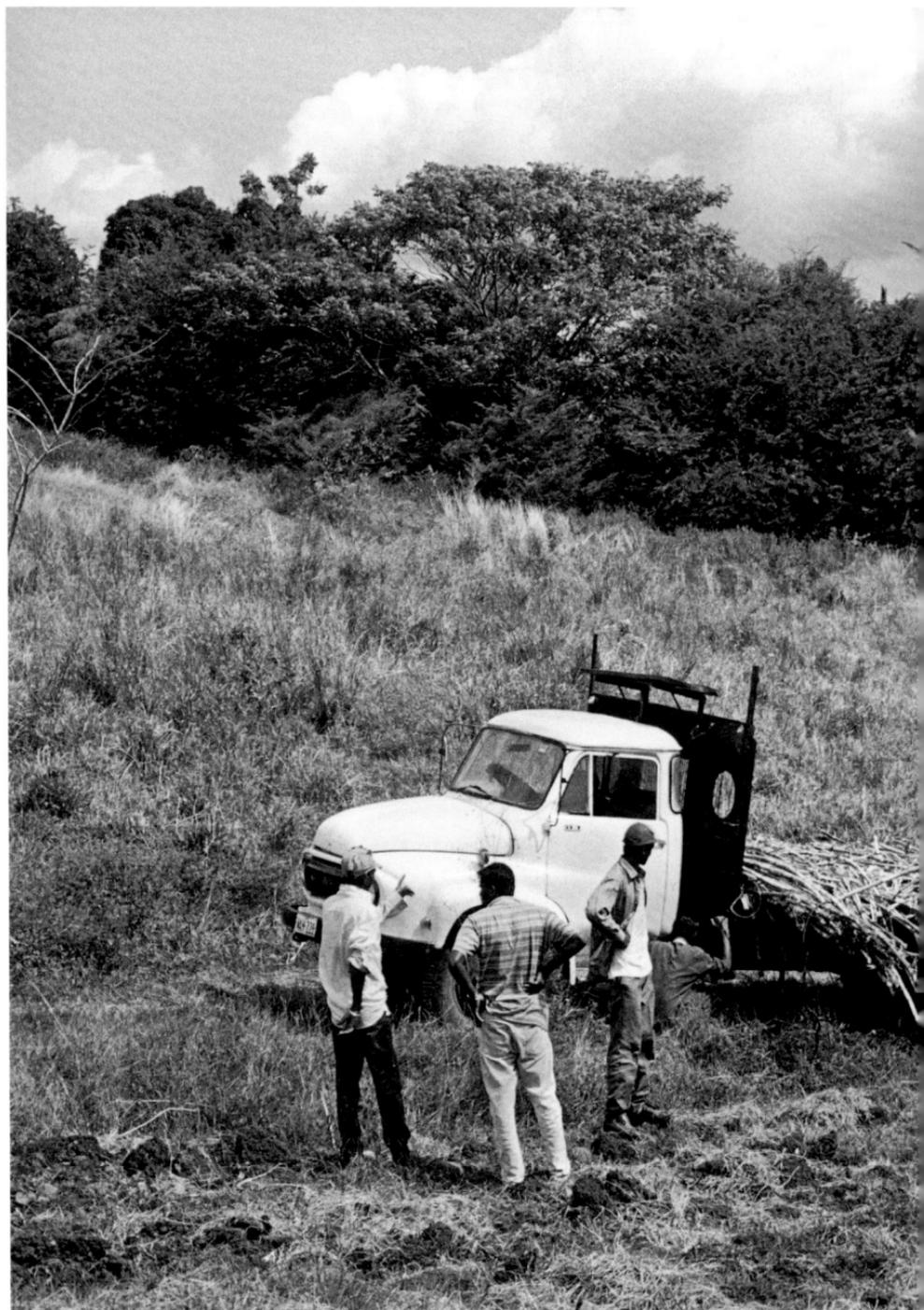

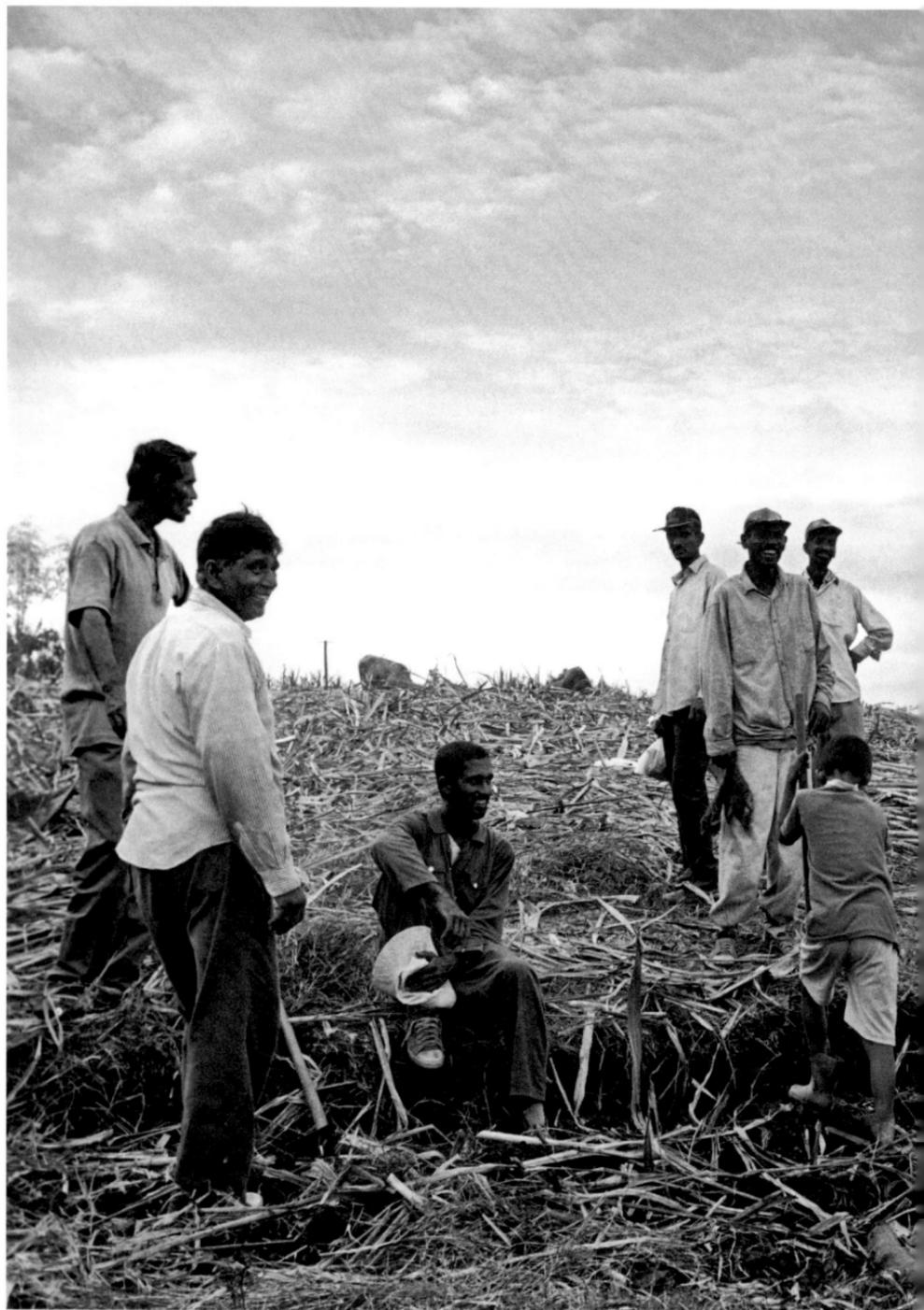

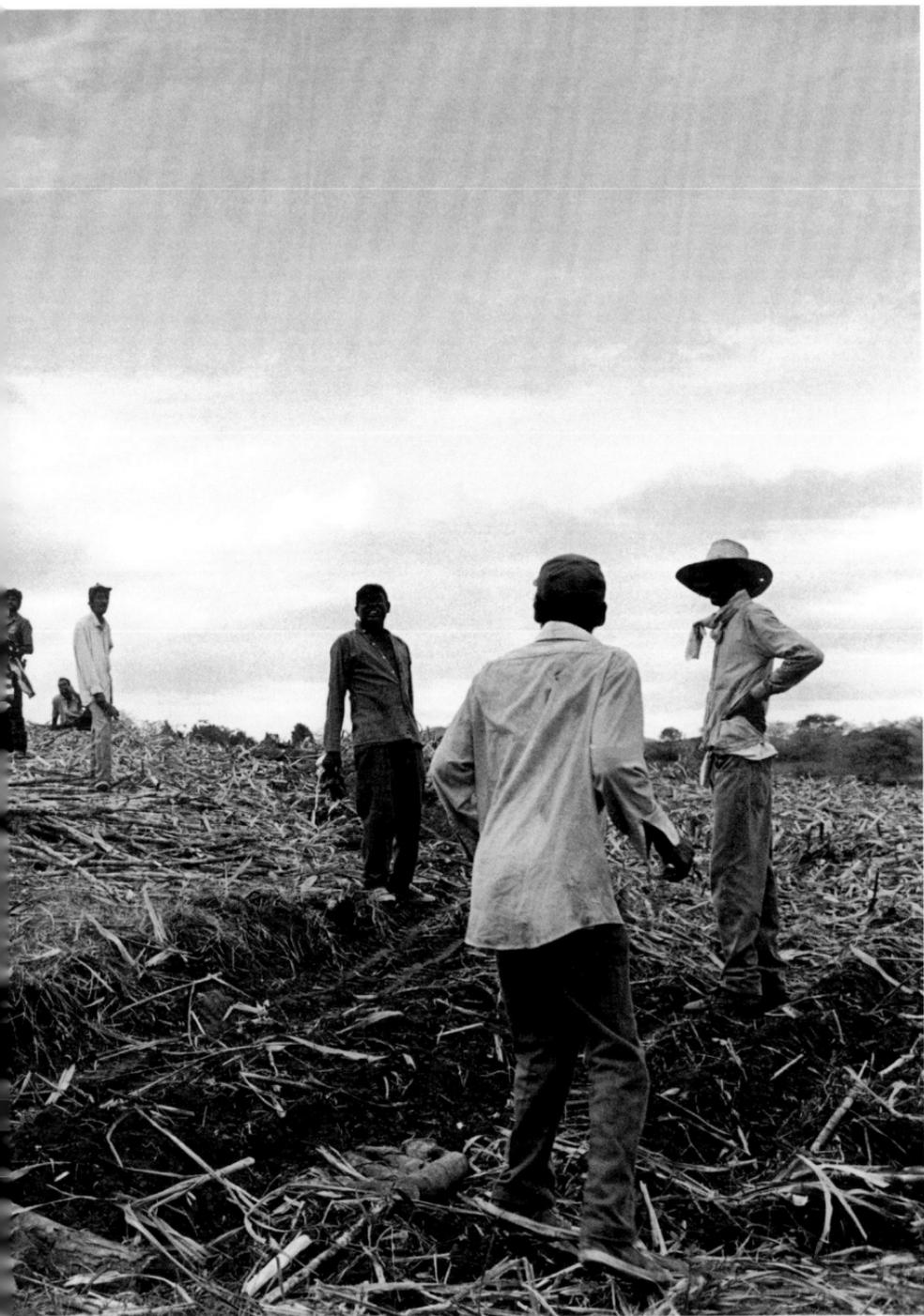

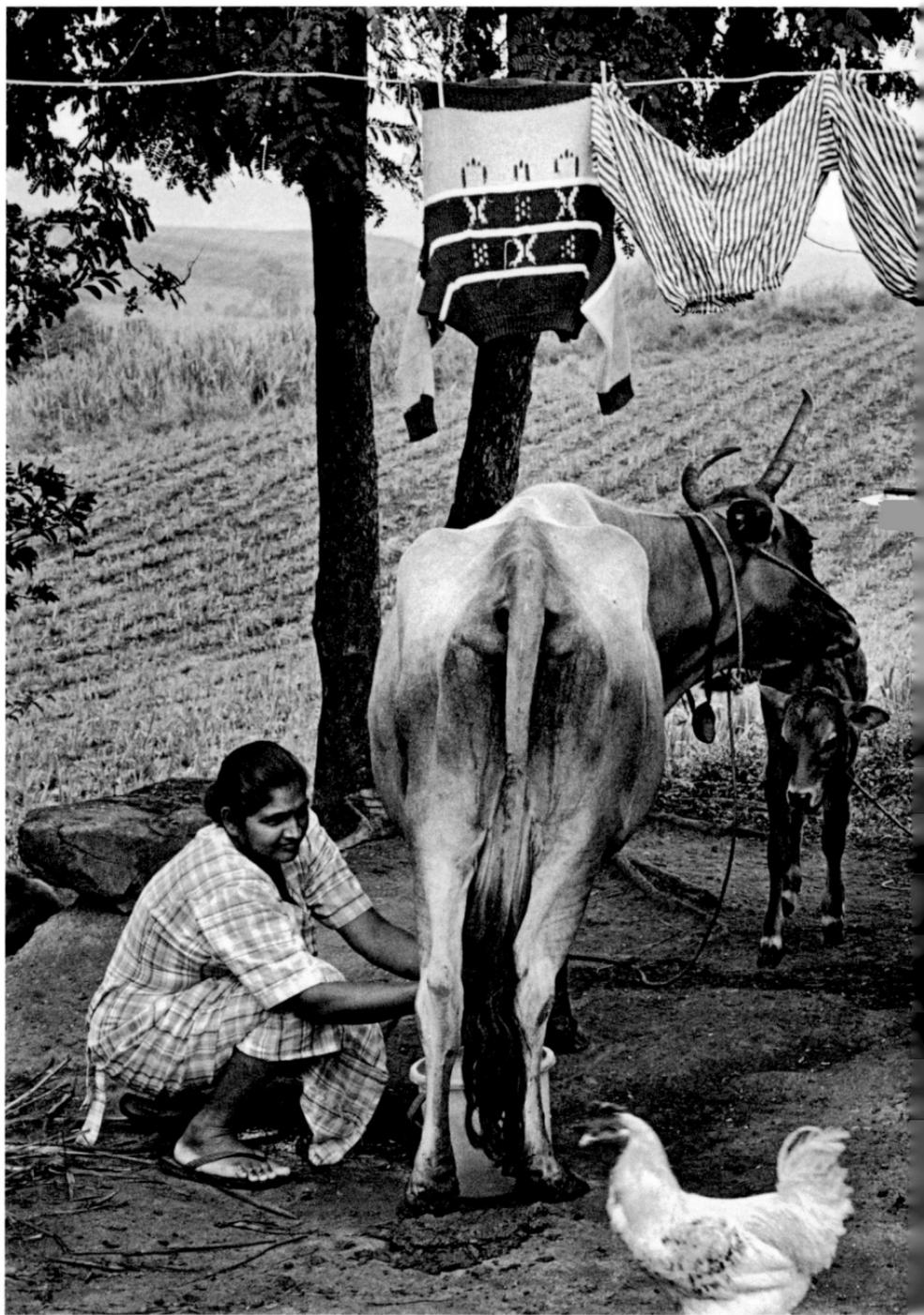

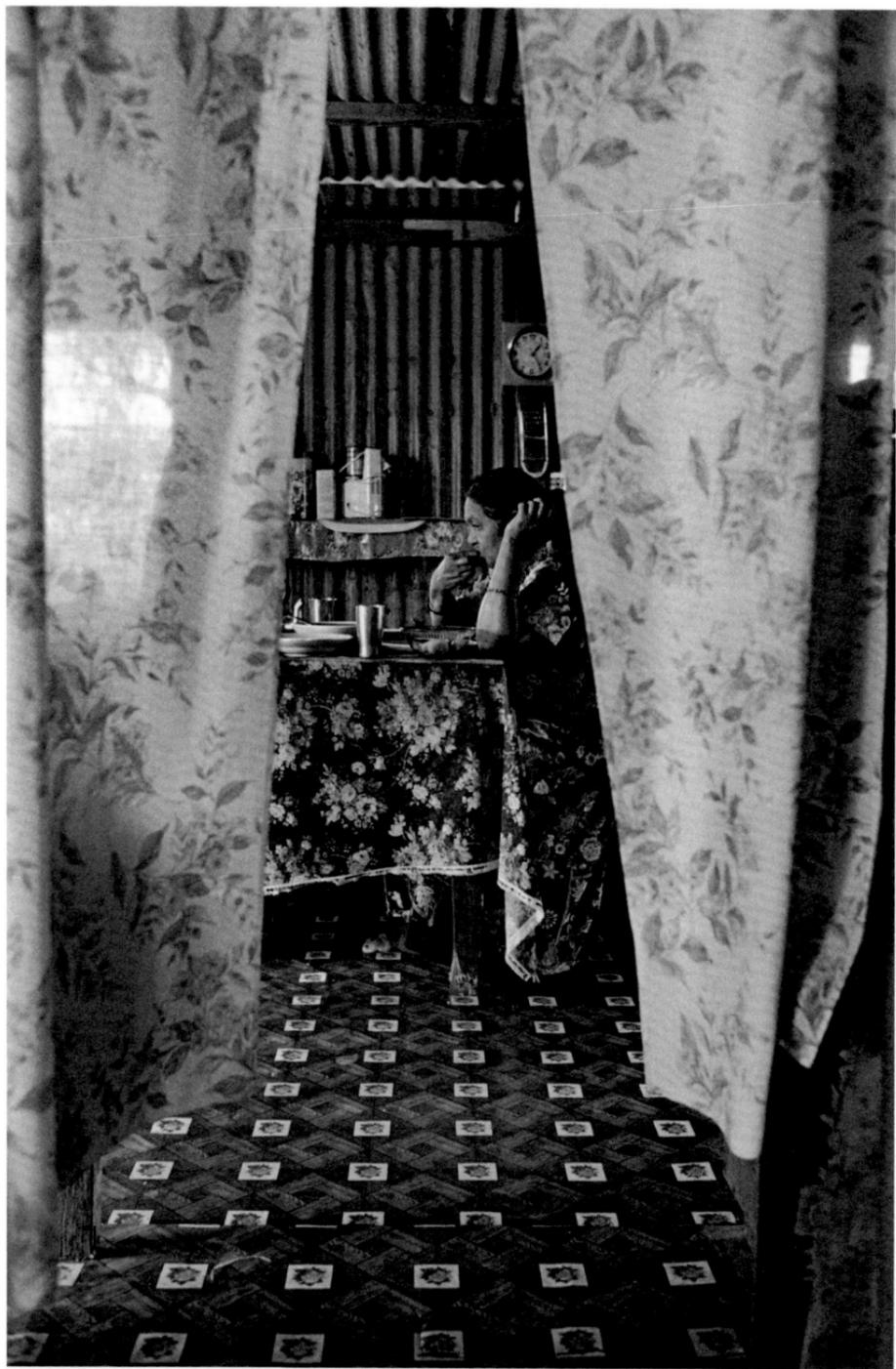

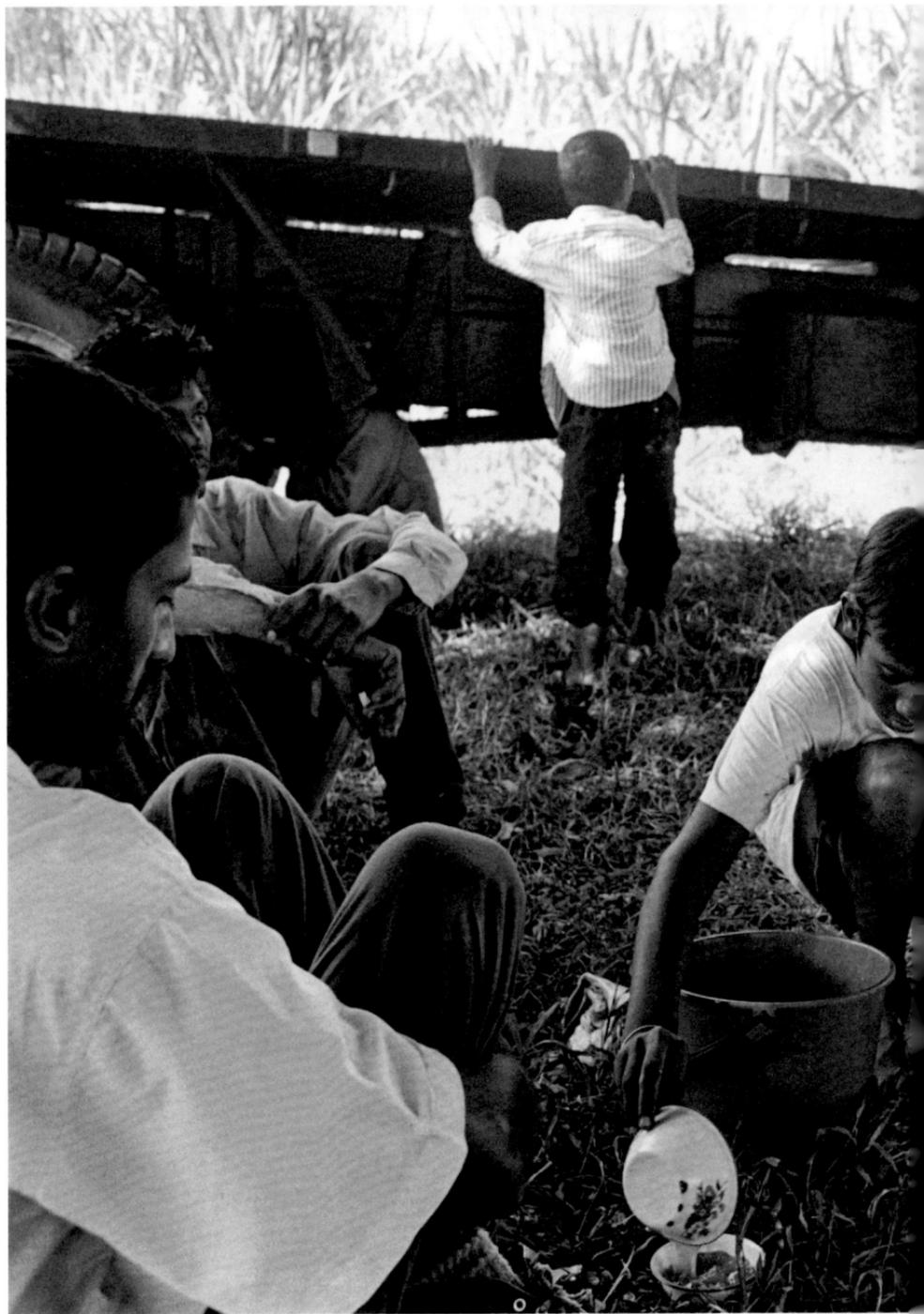

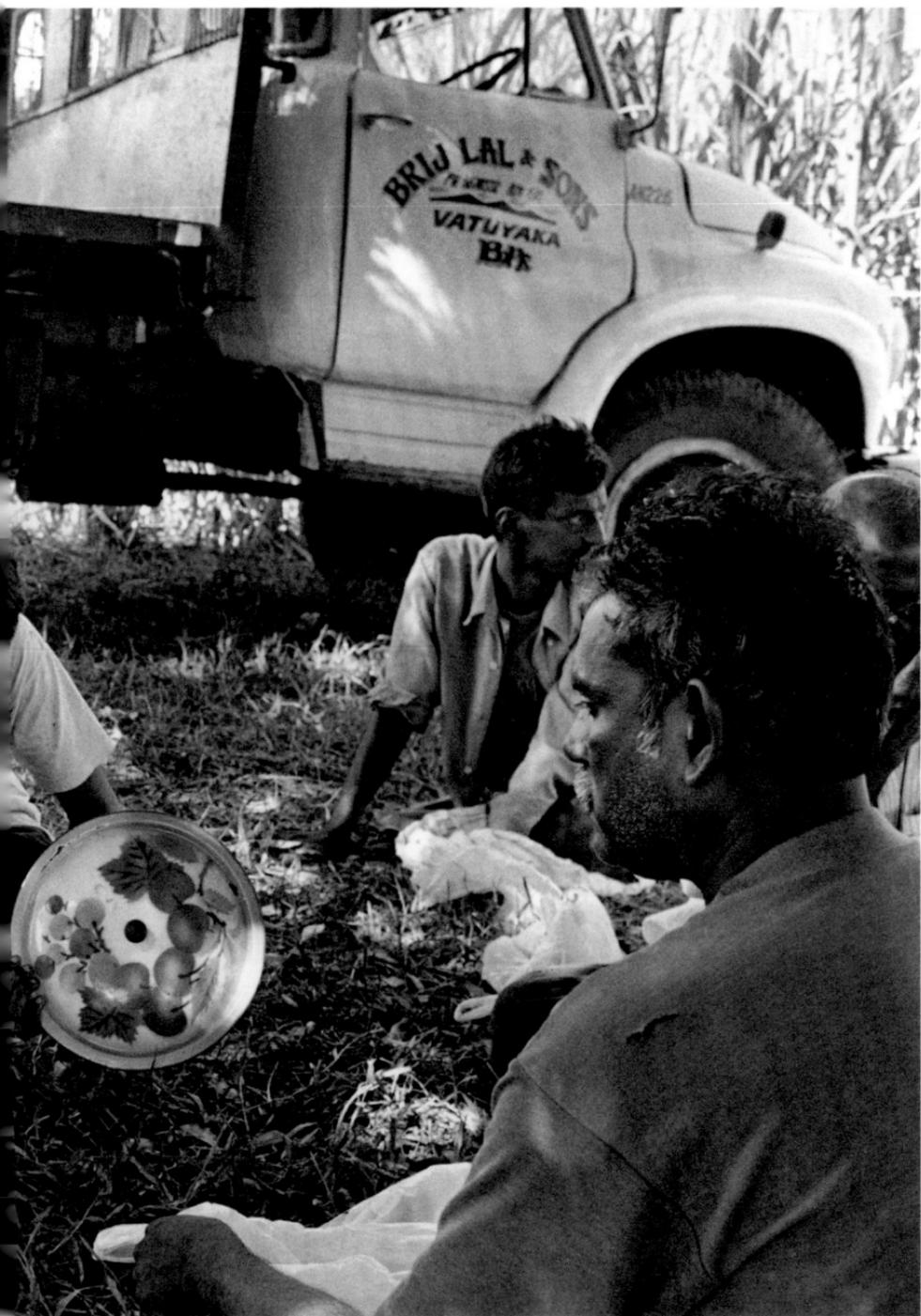

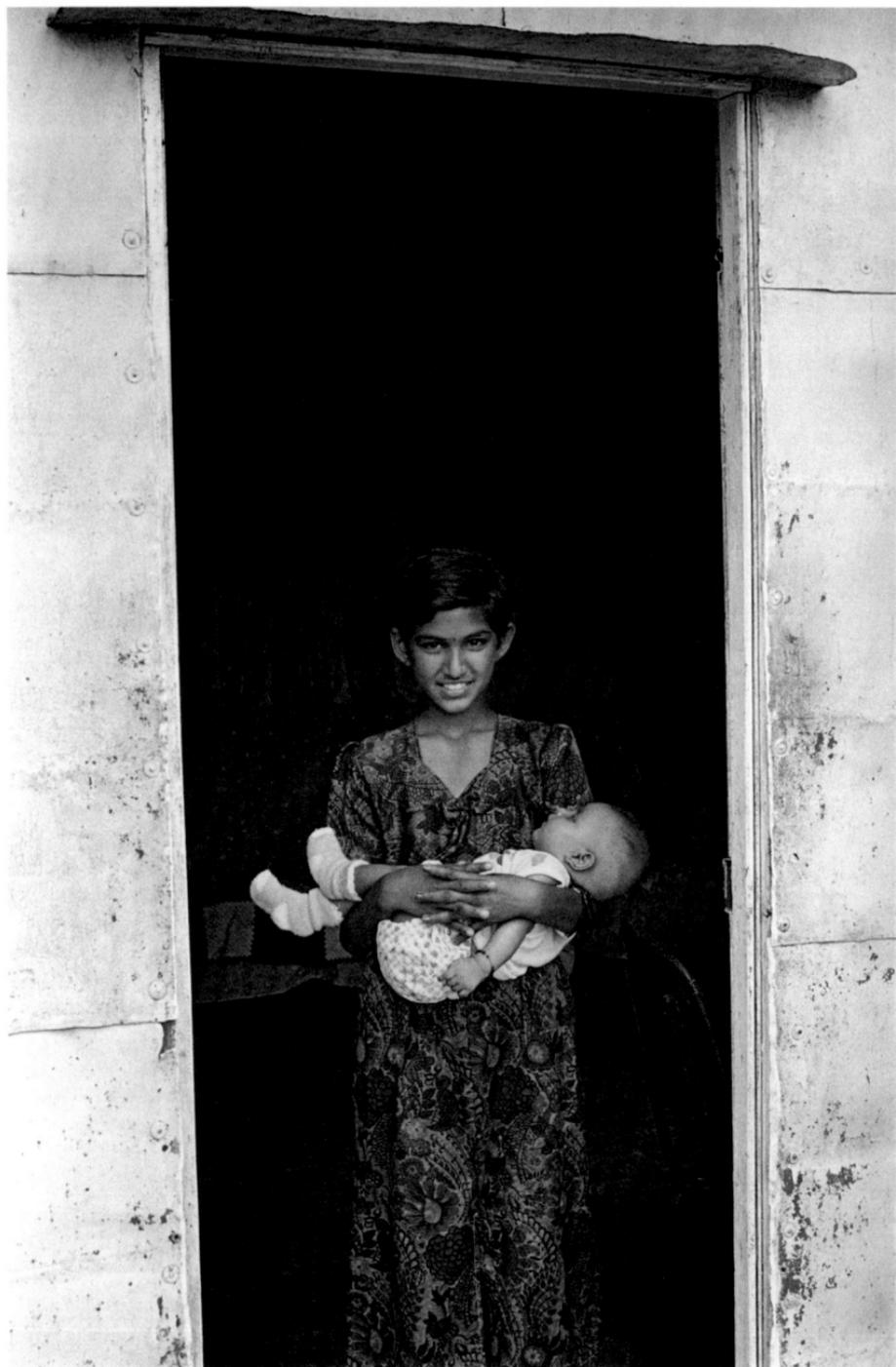

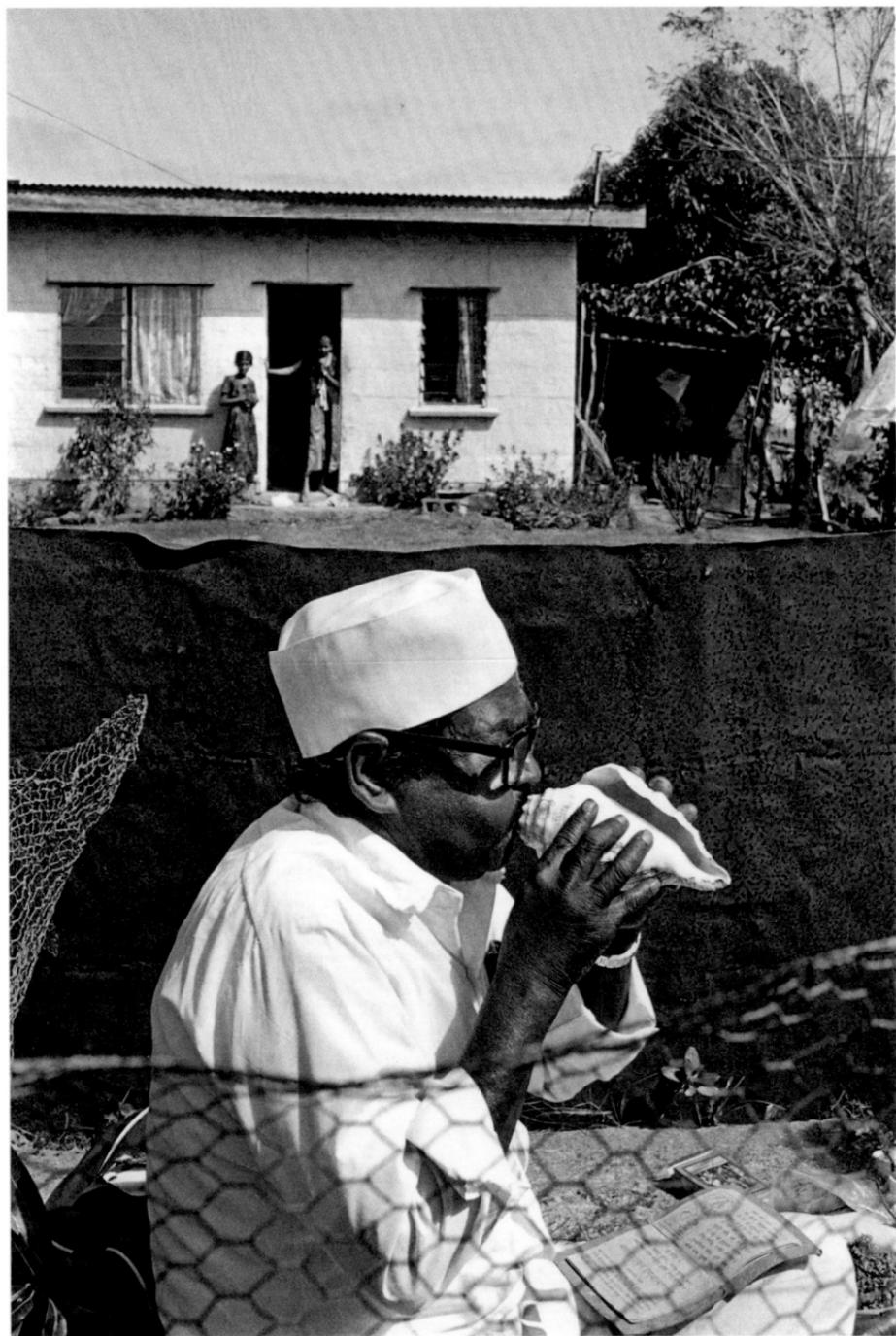

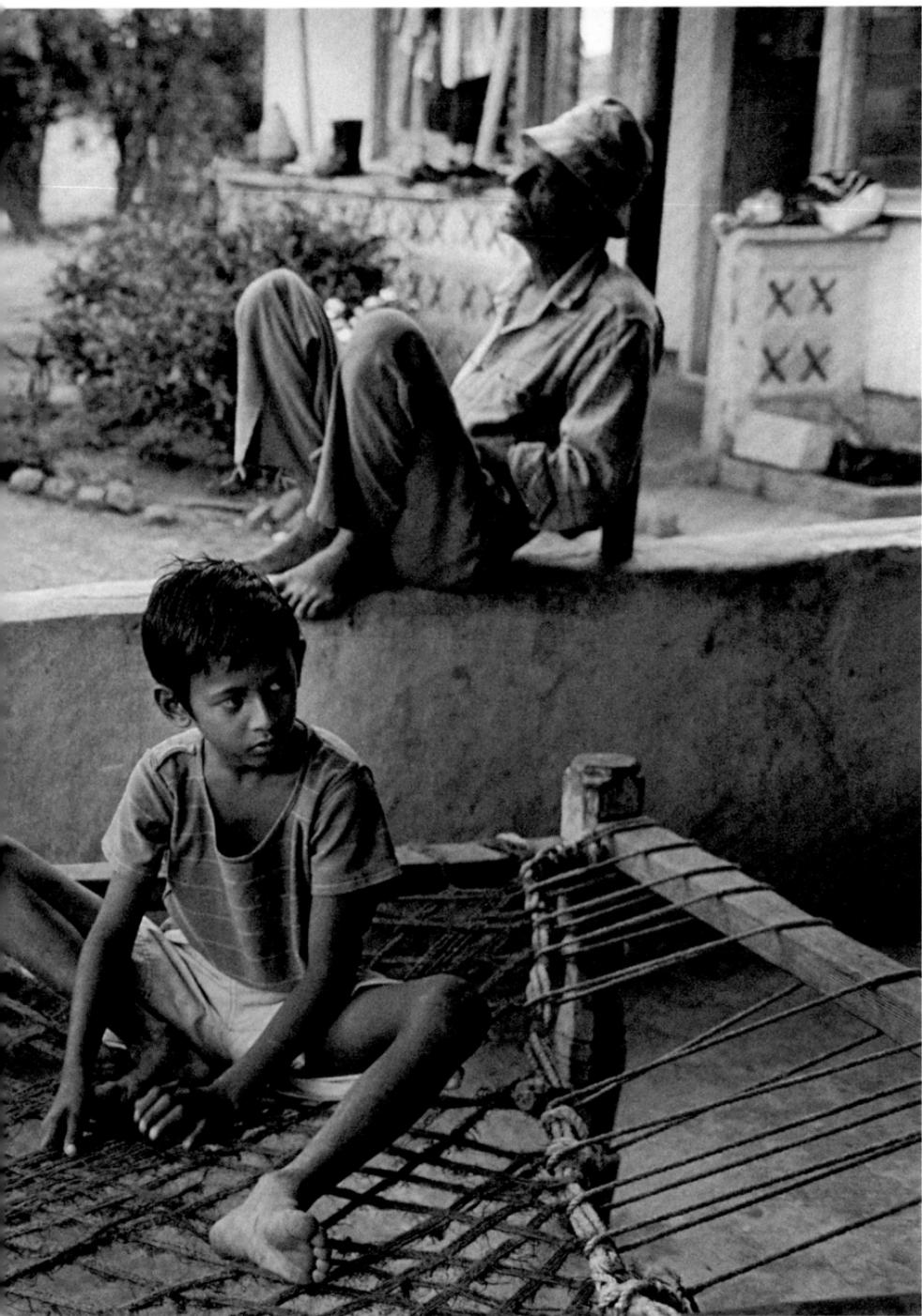

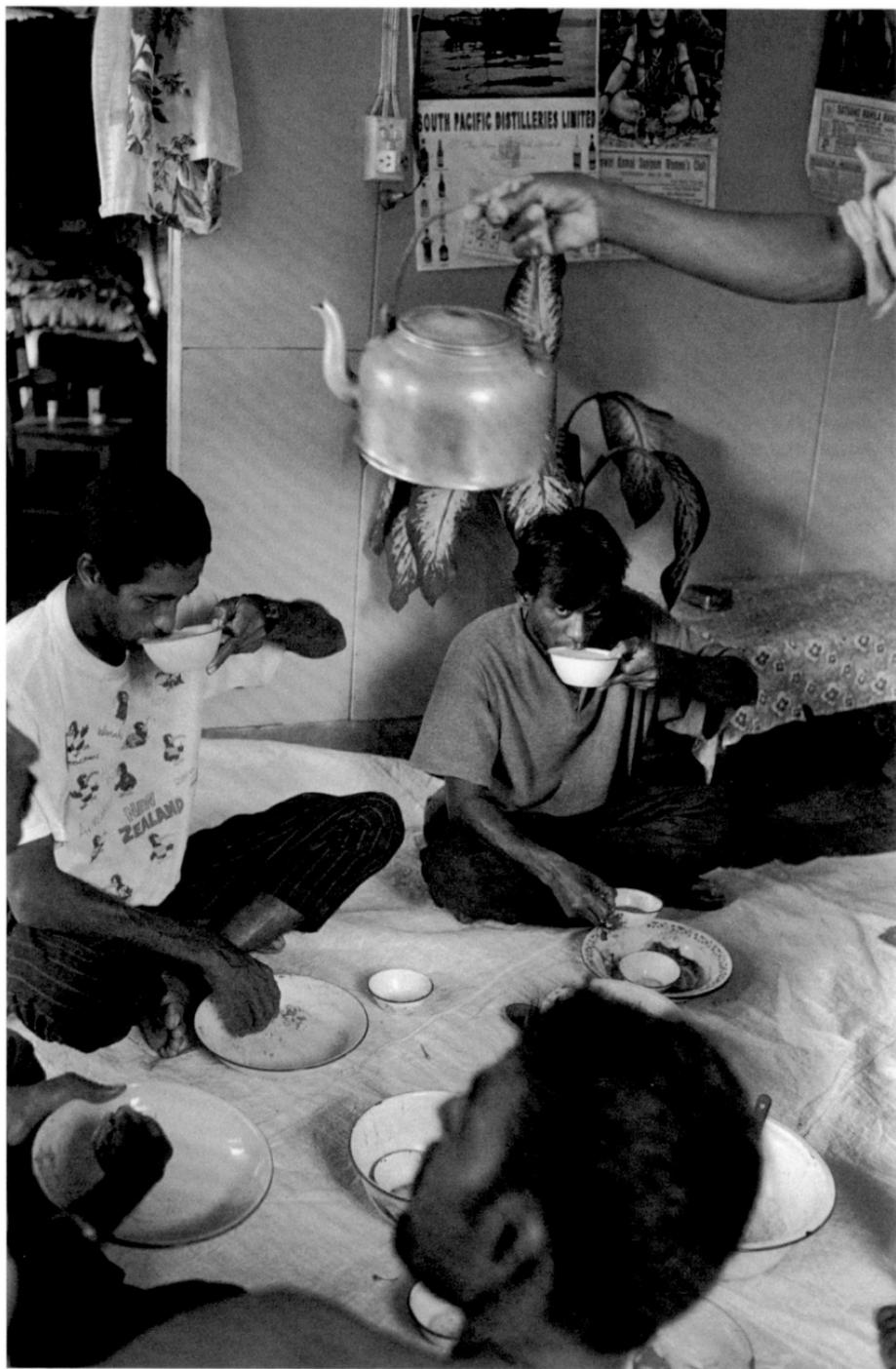

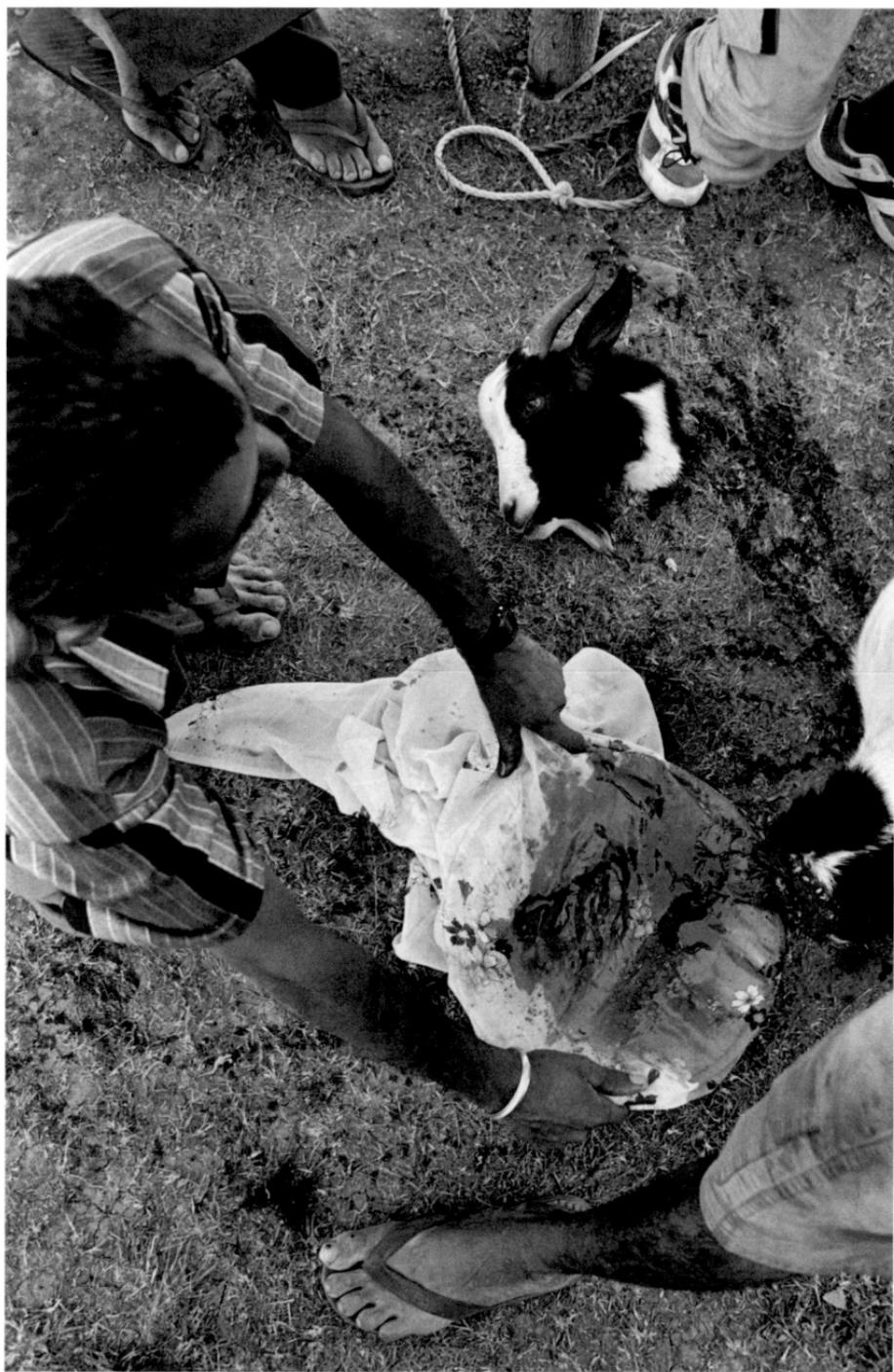

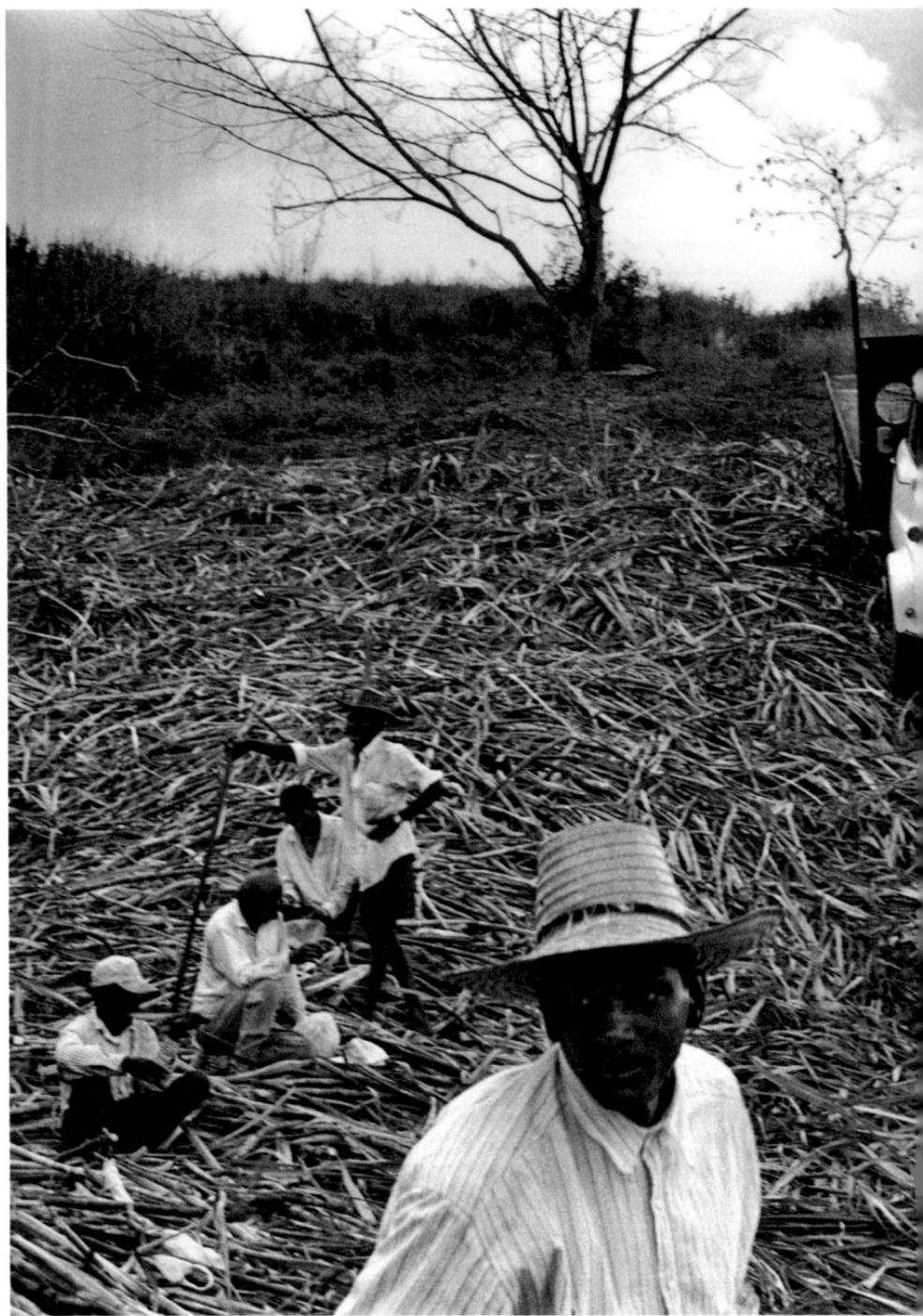

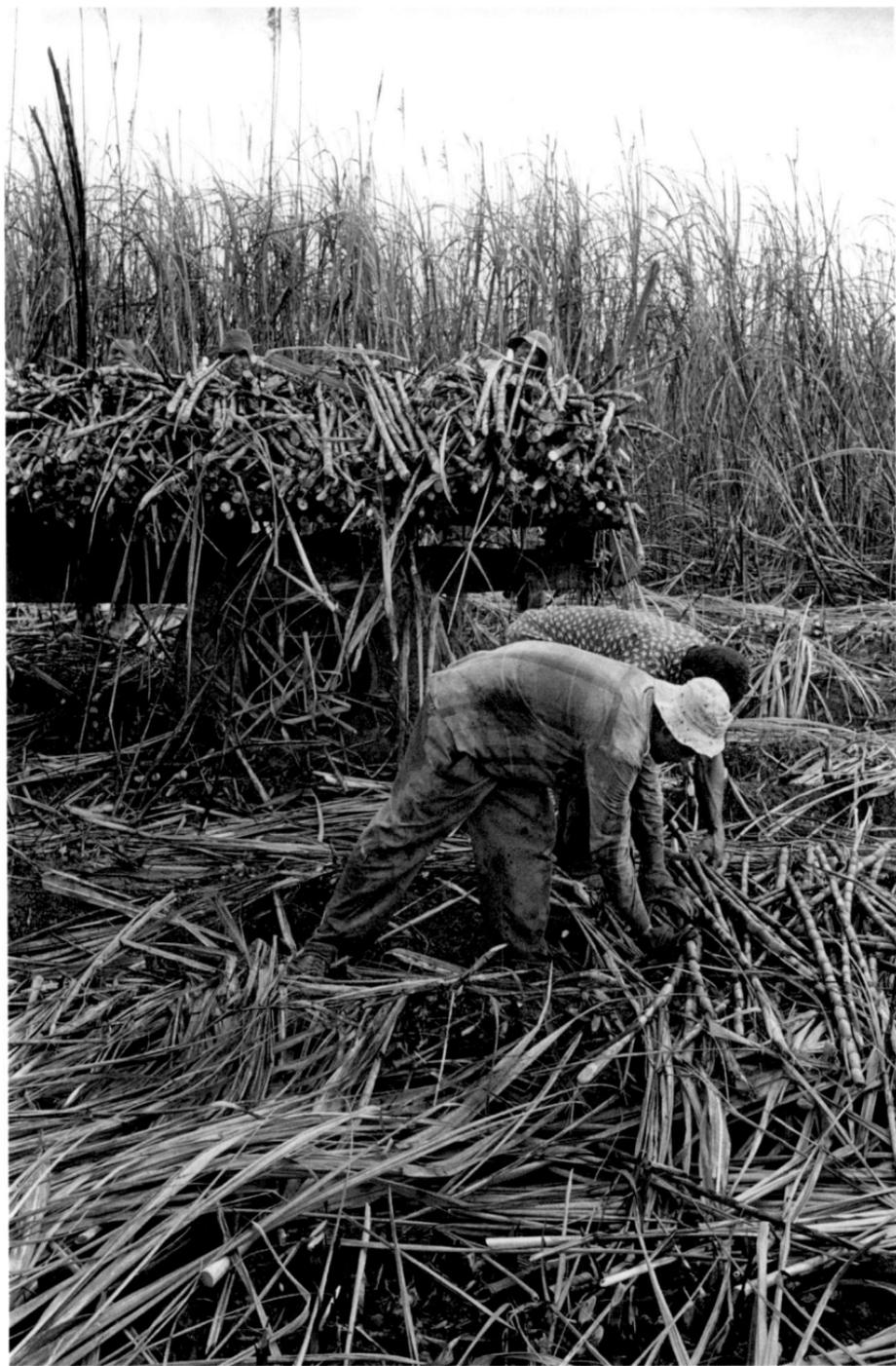

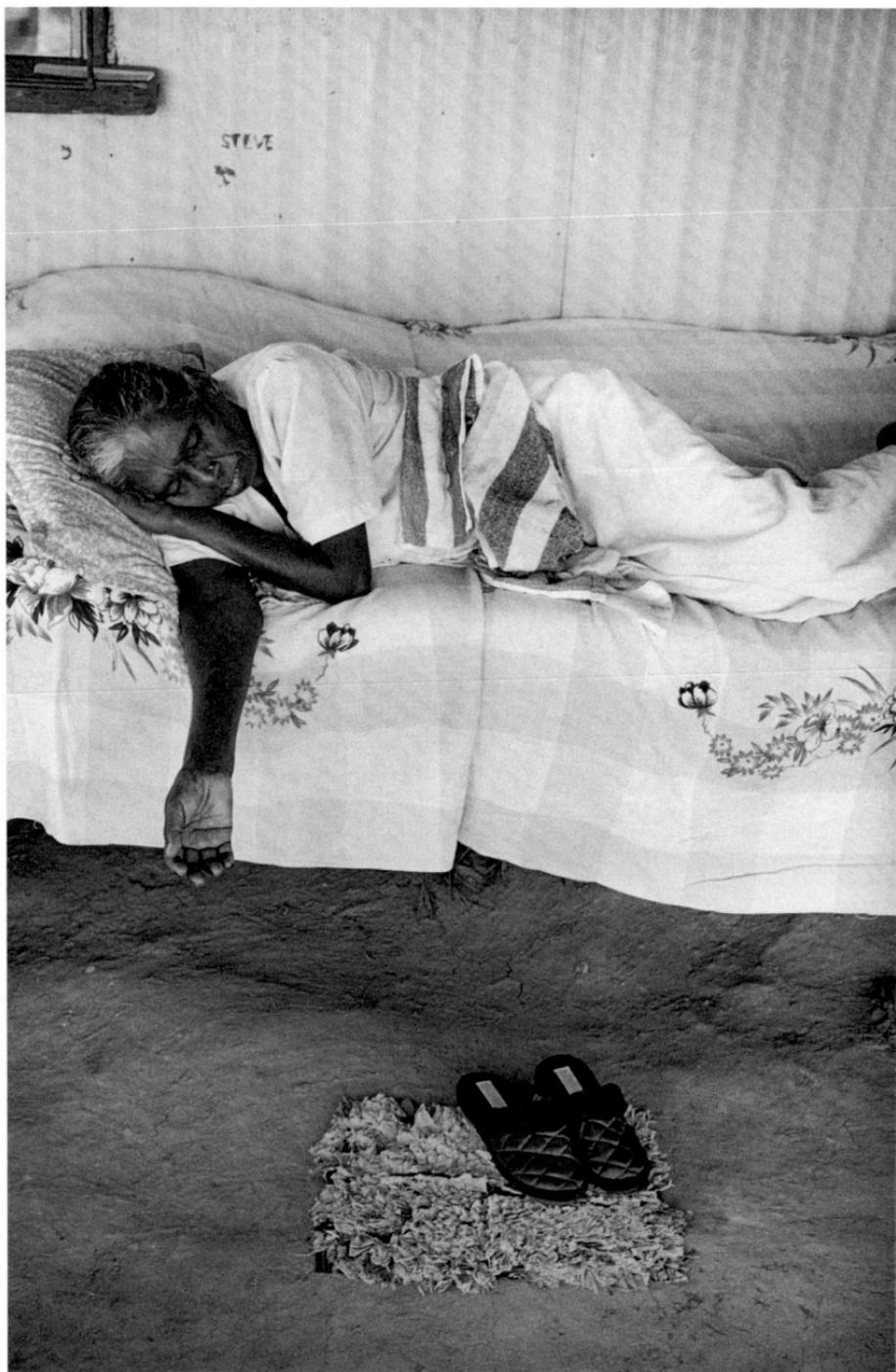

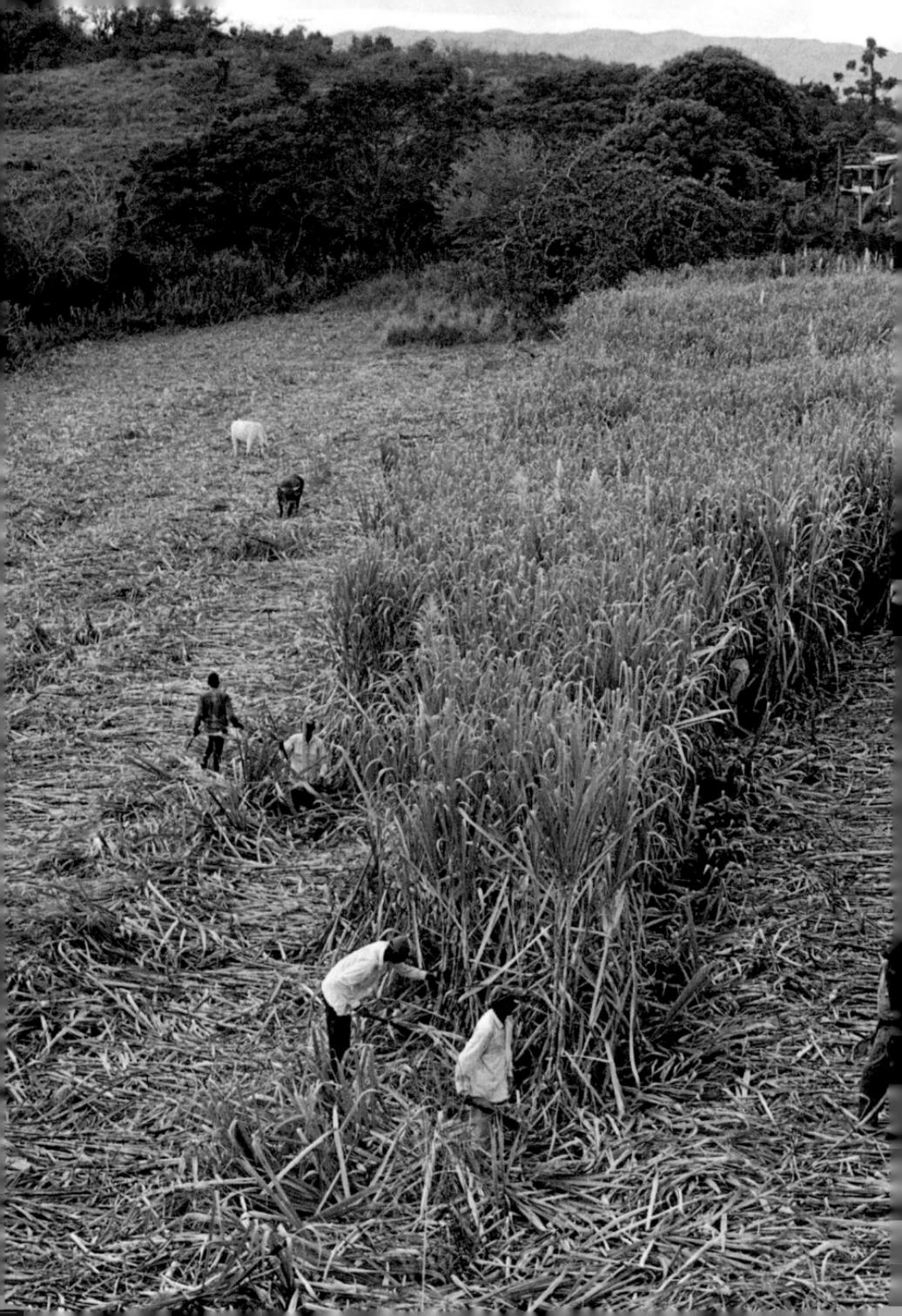

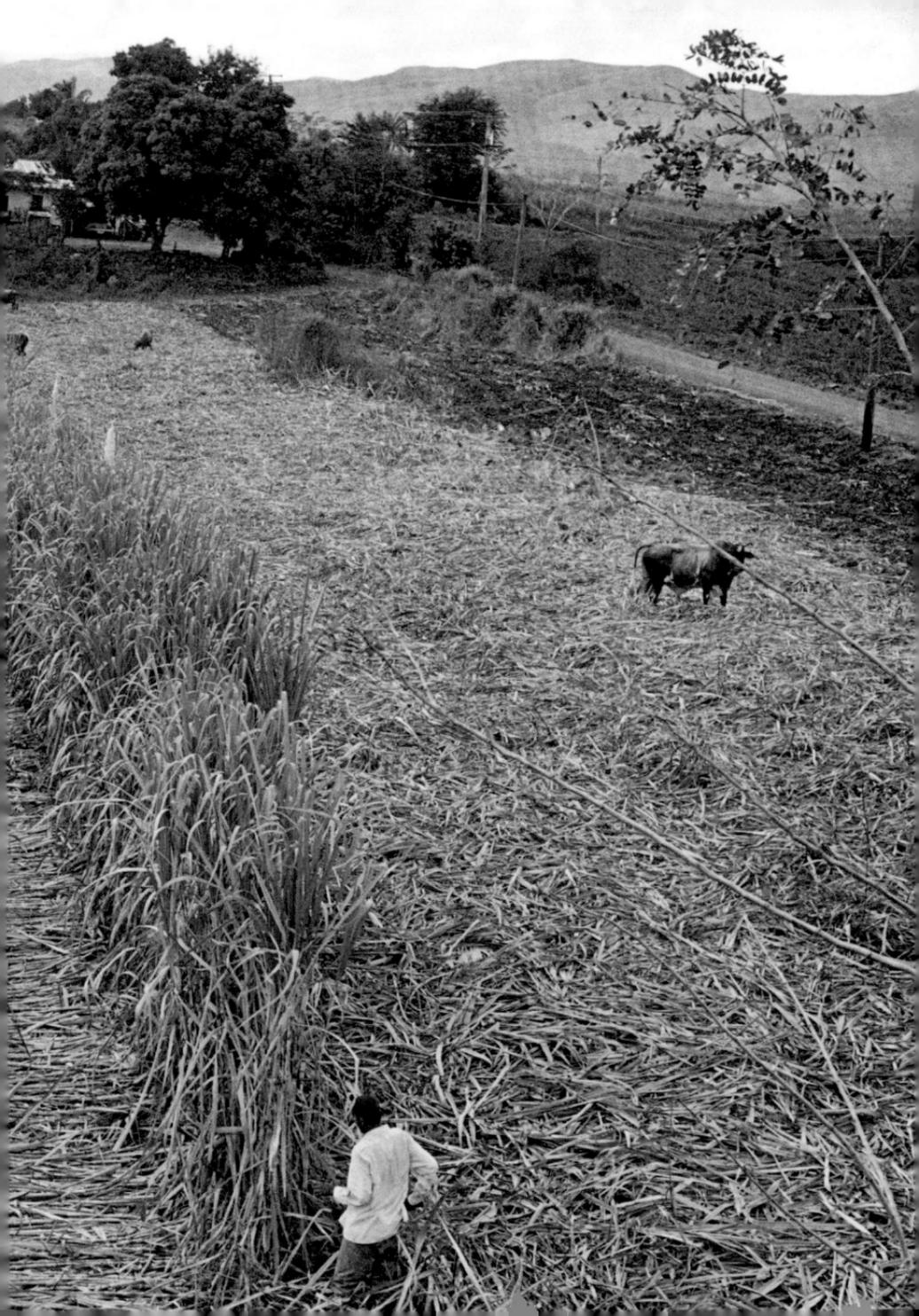

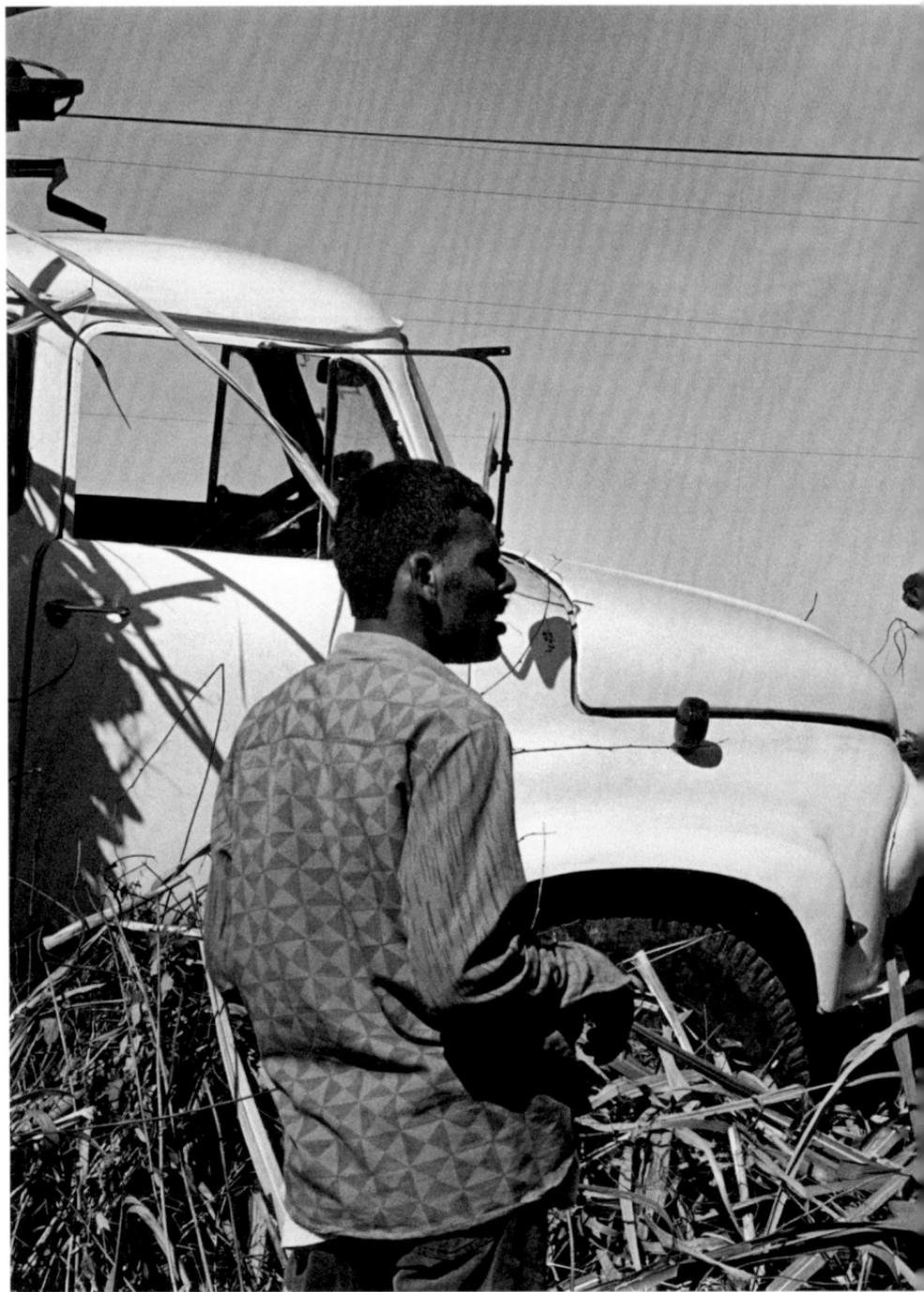

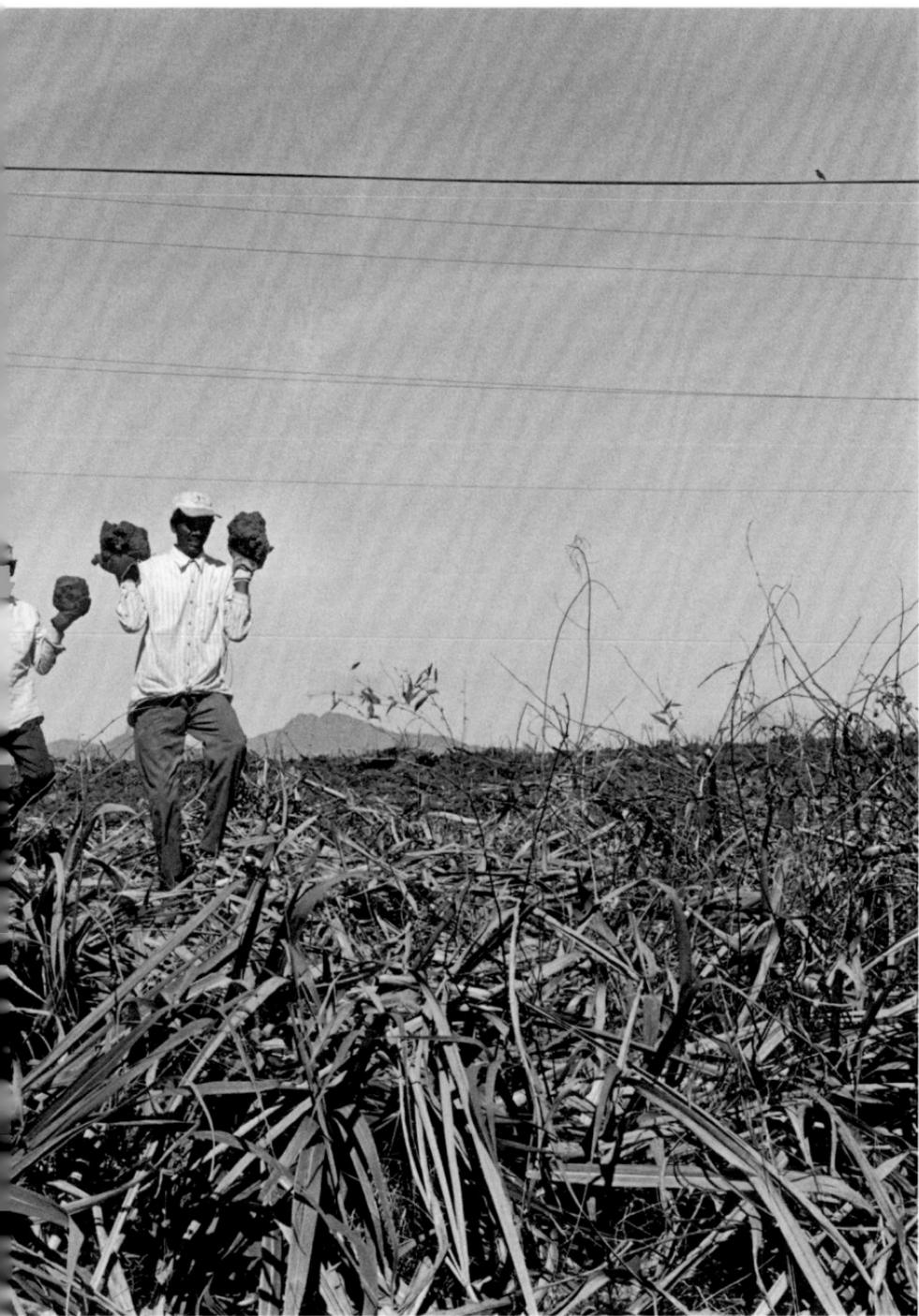

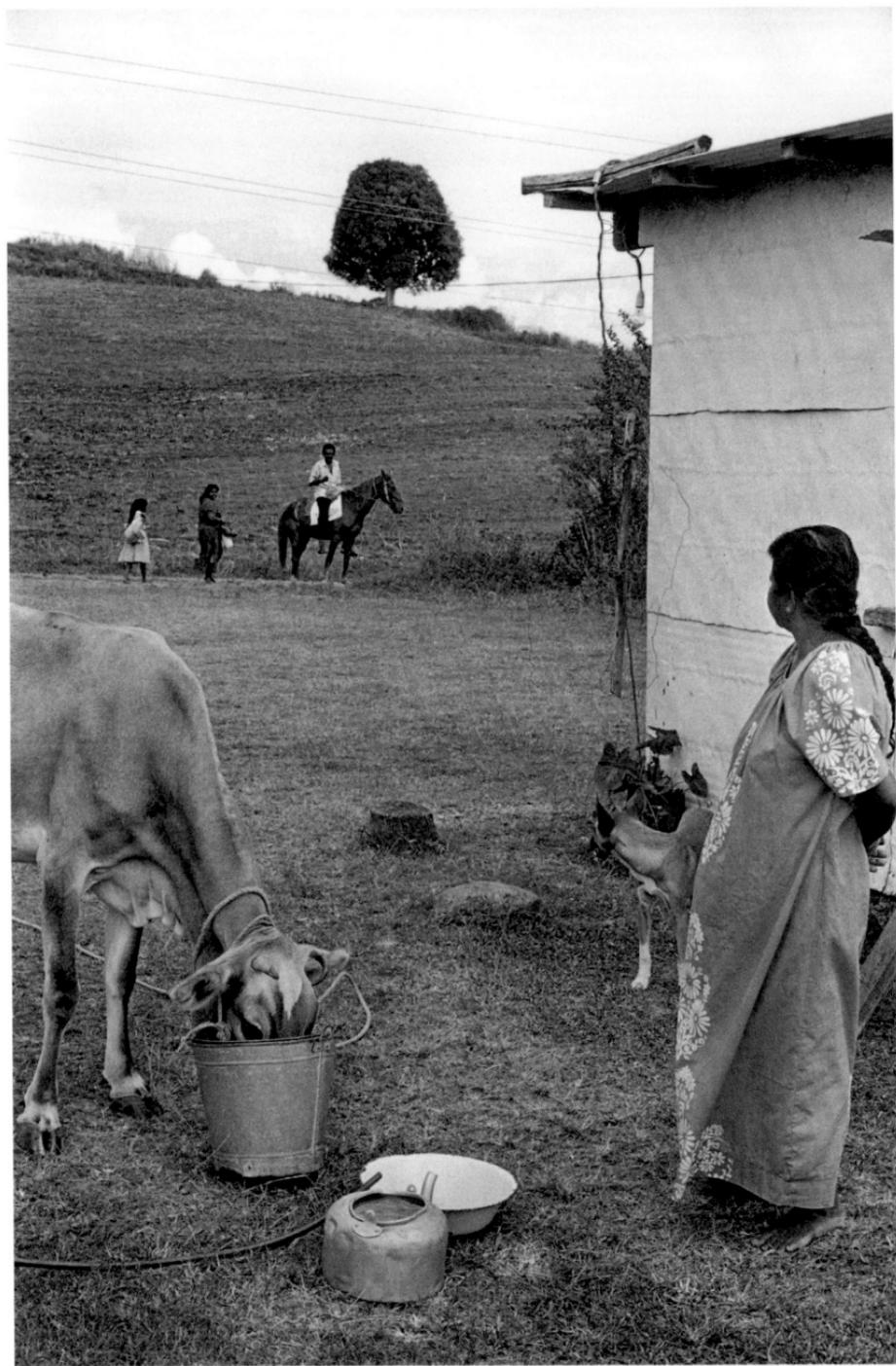

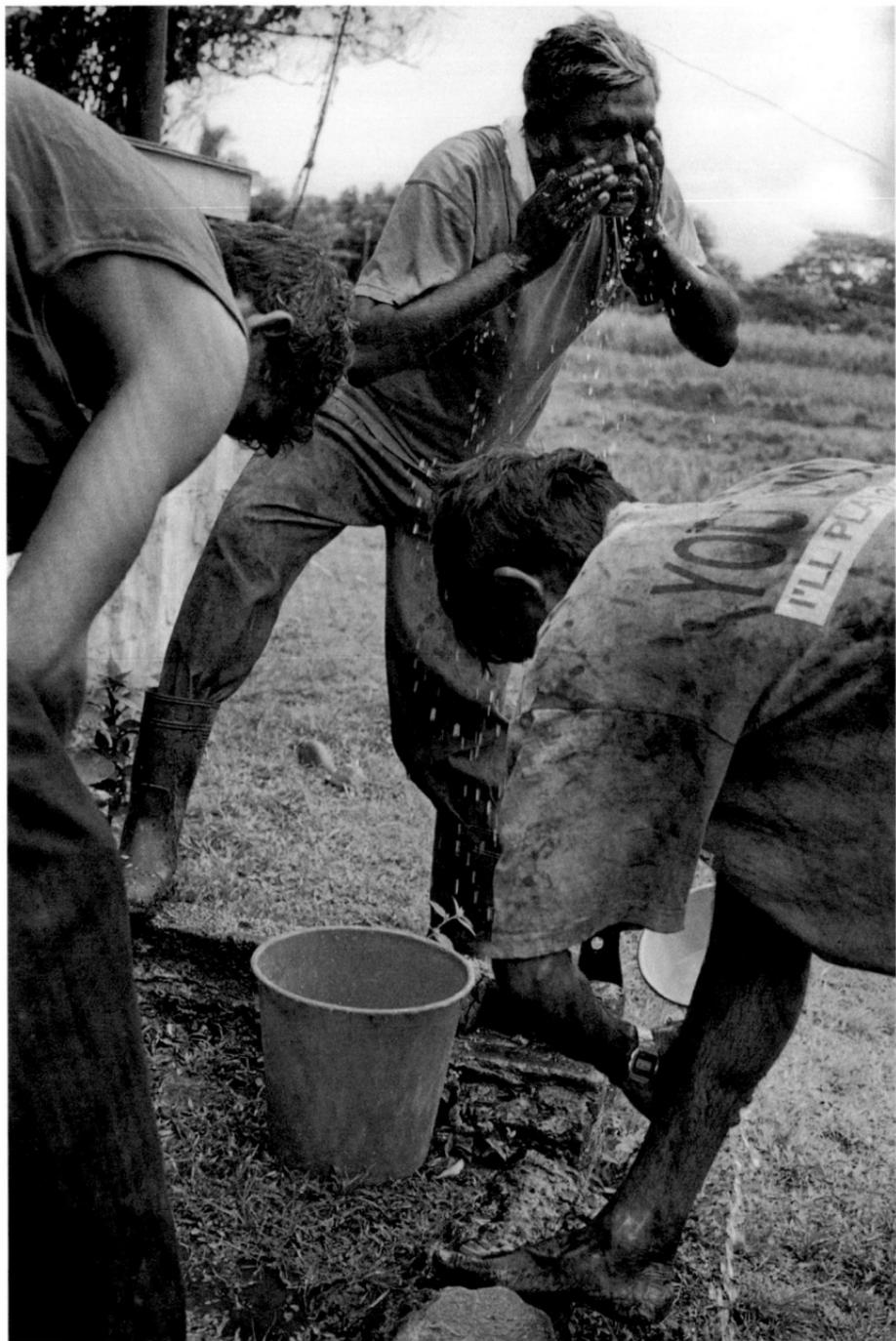

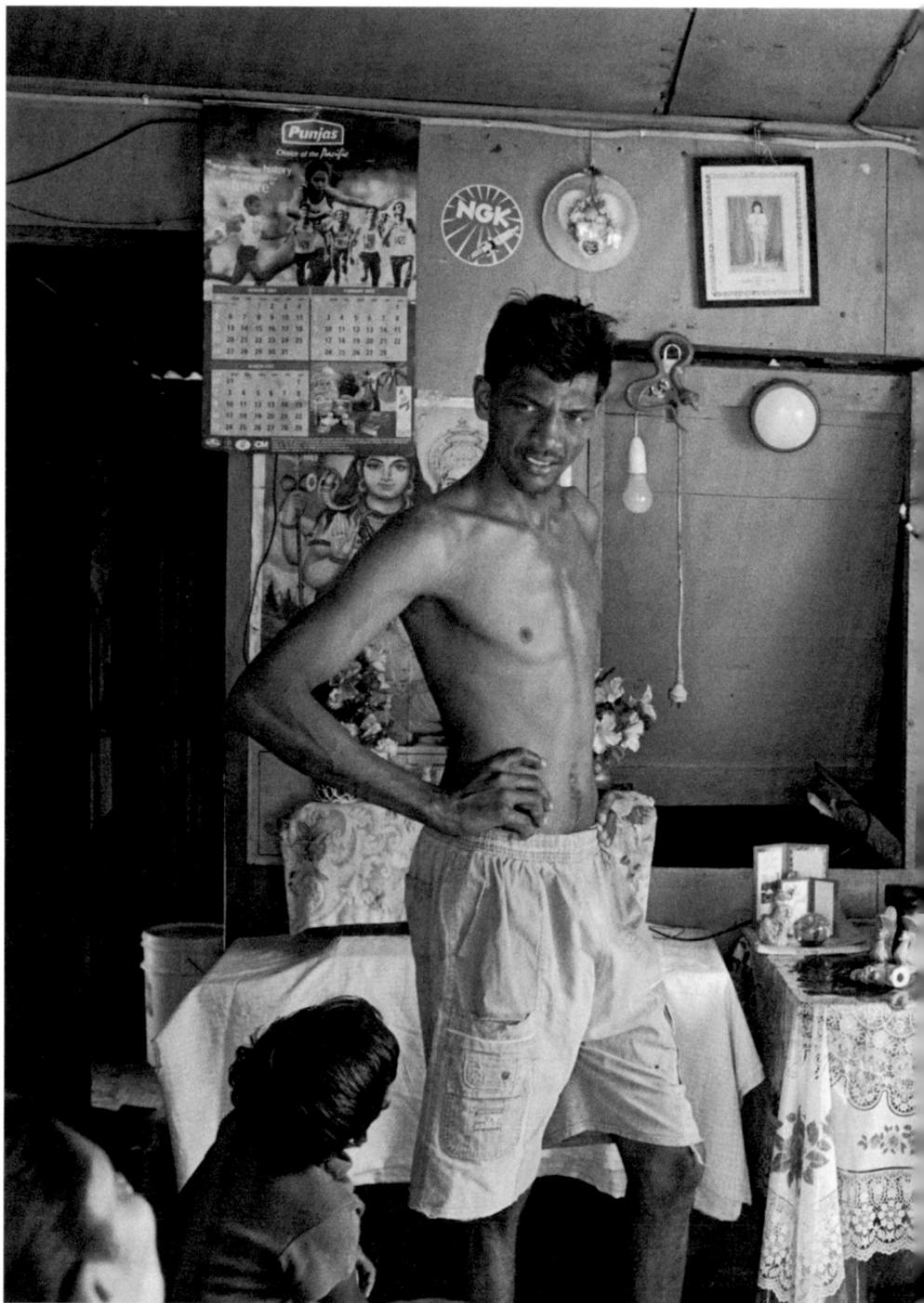

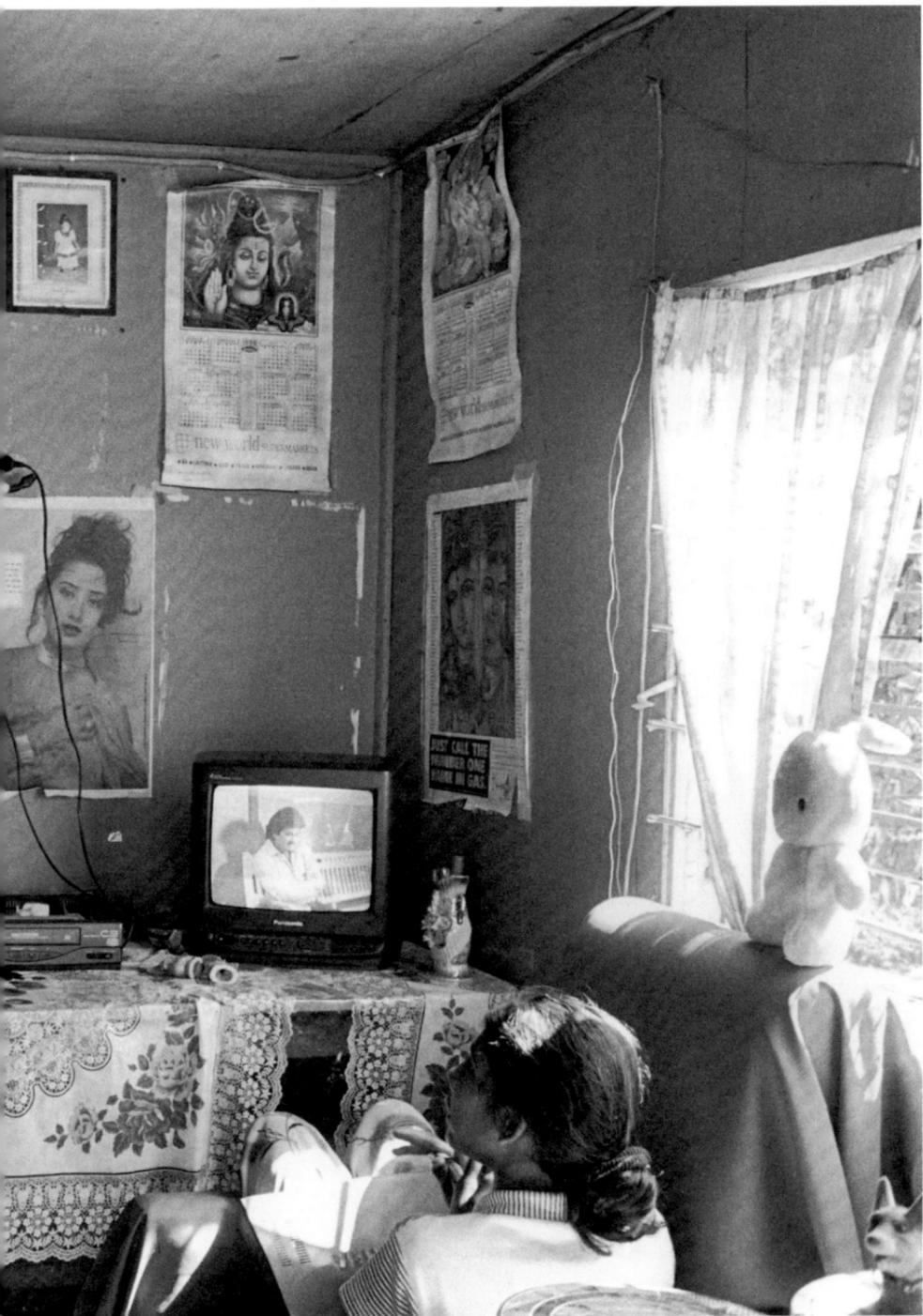

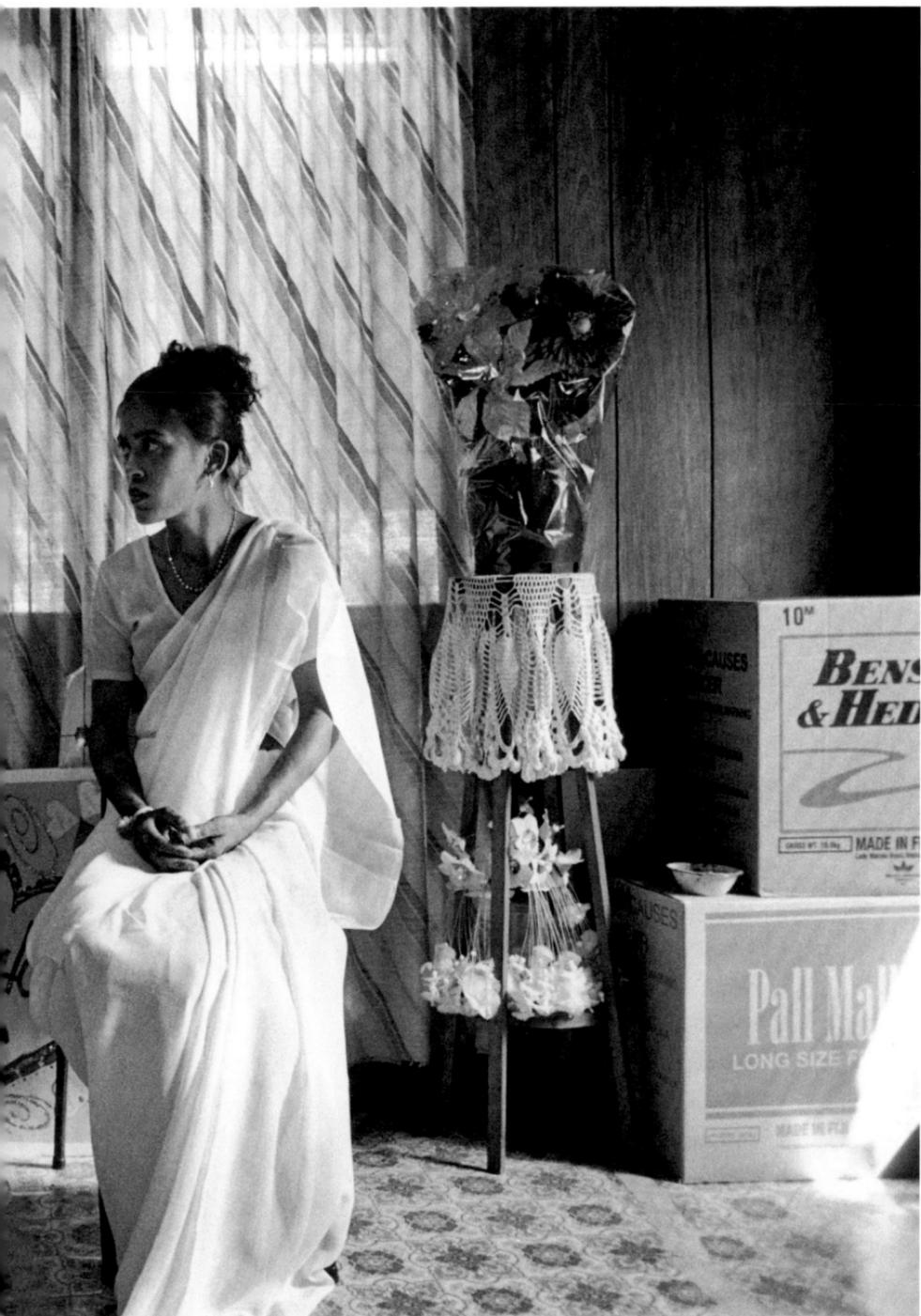

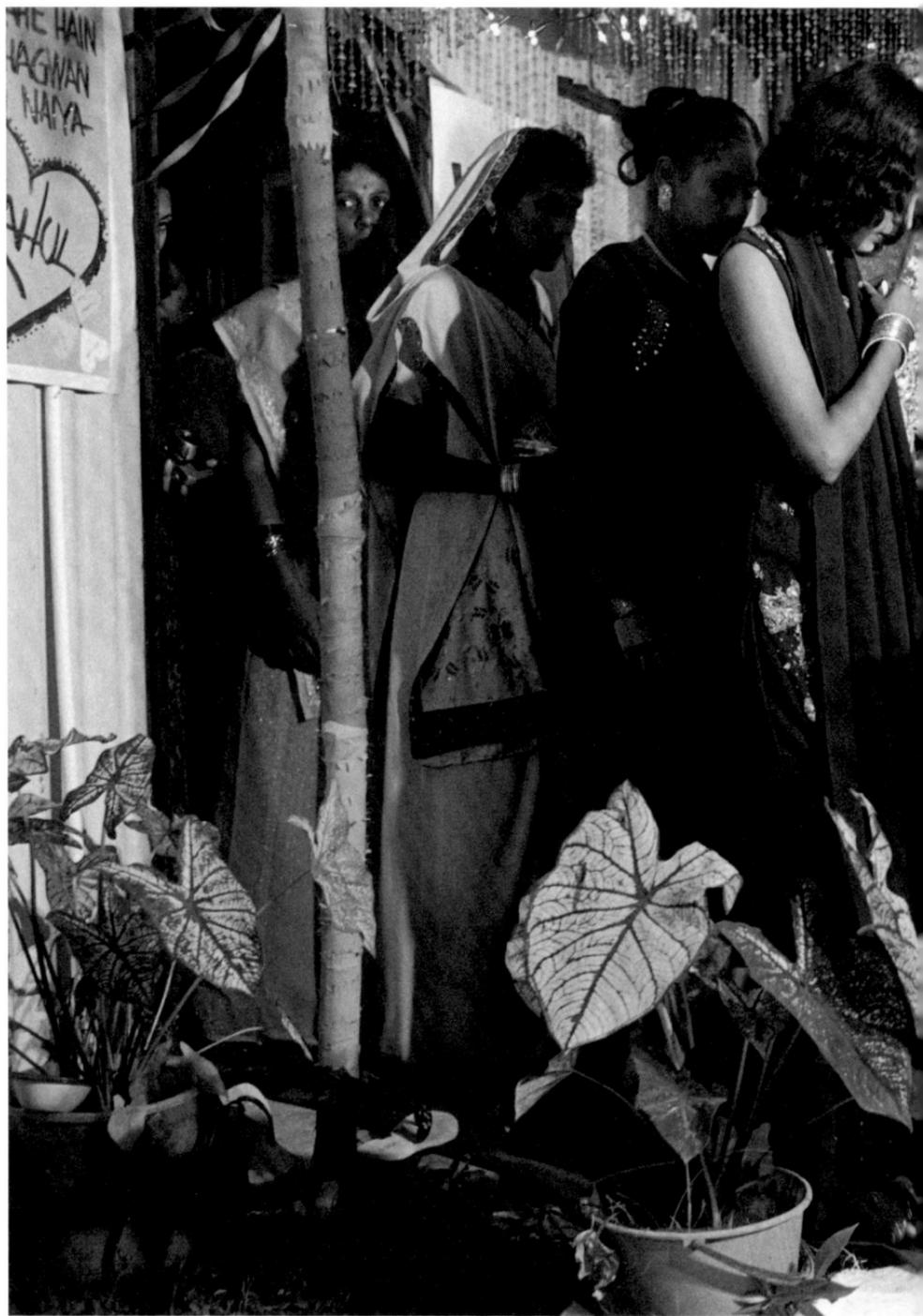

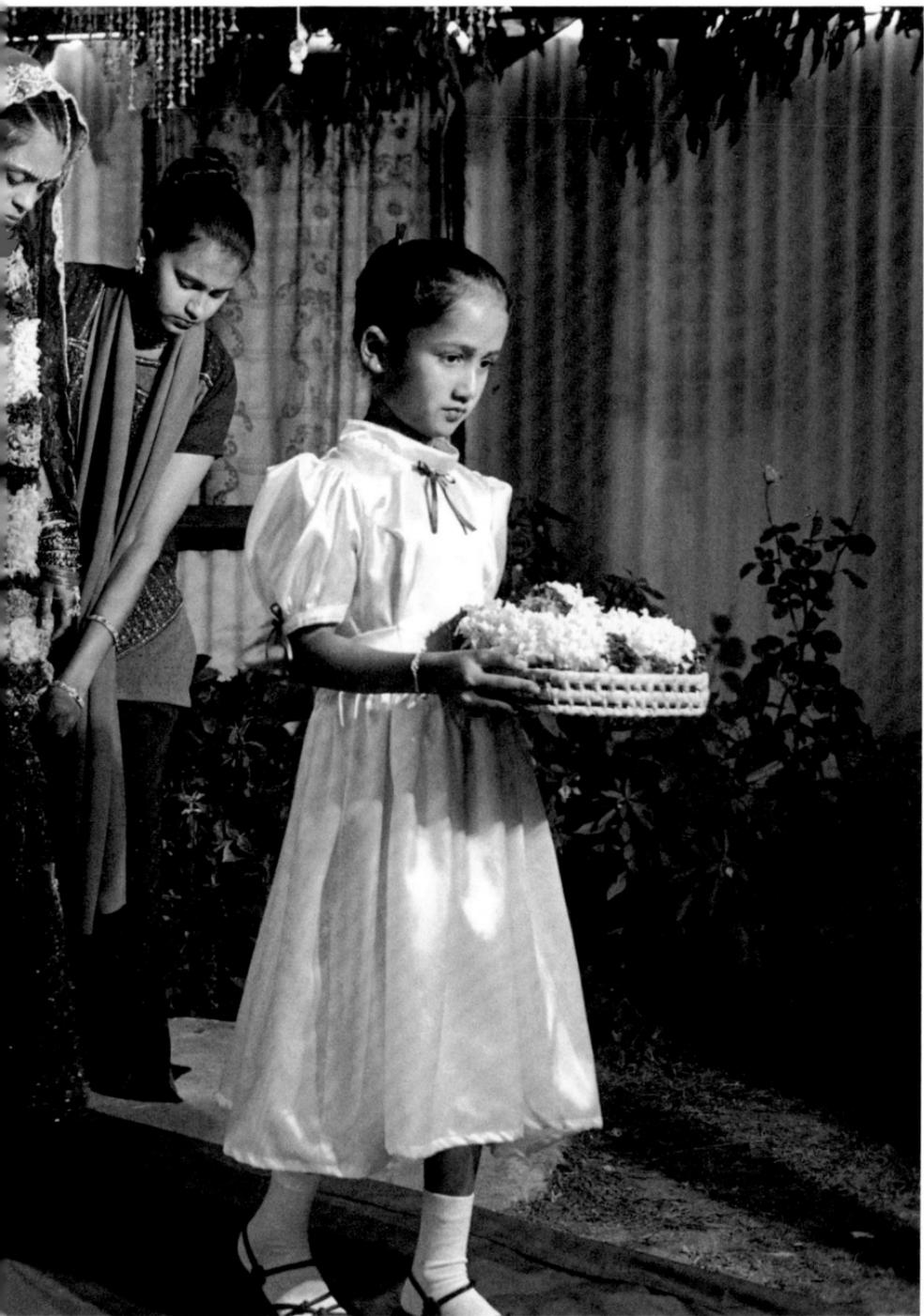

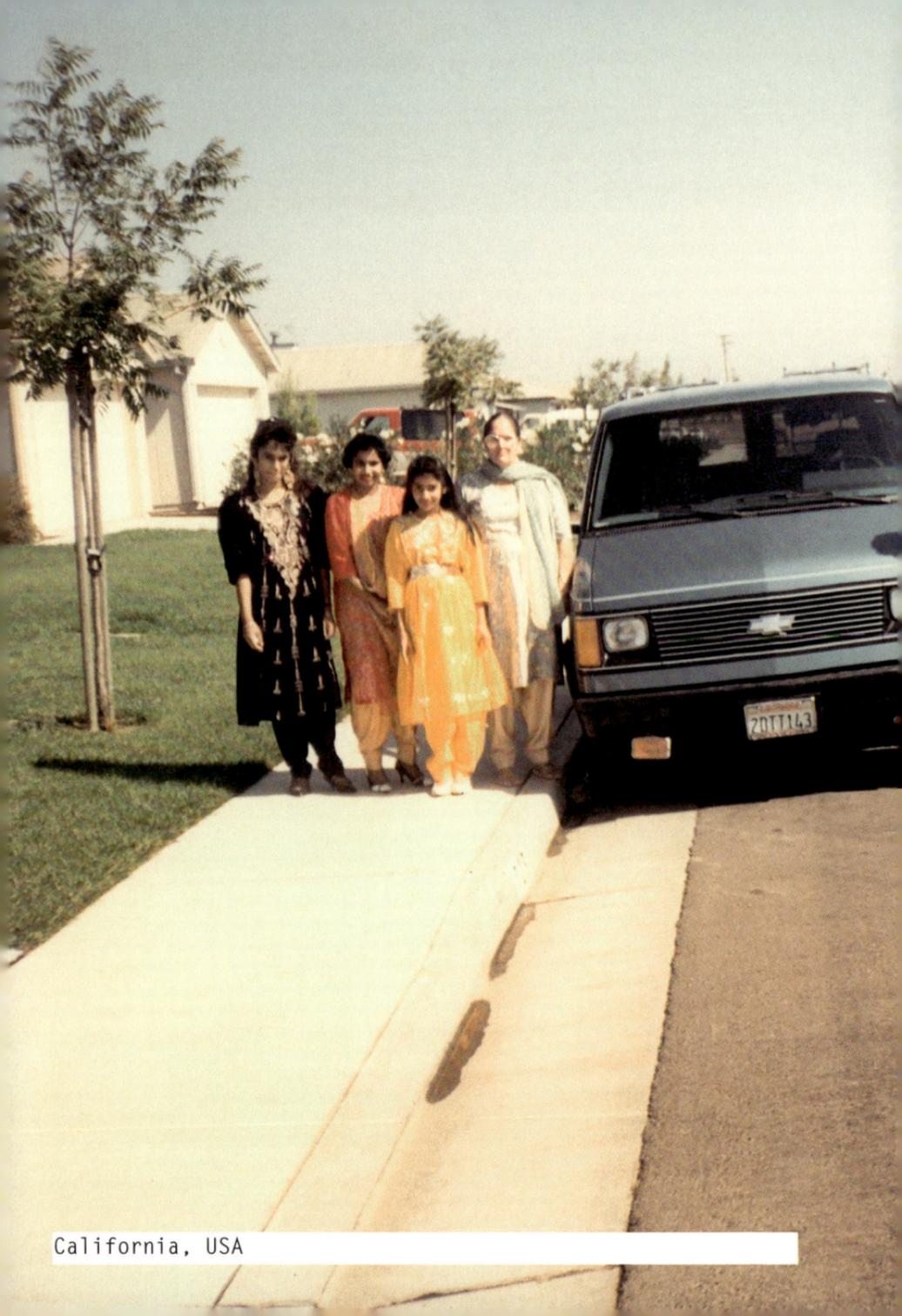

California, USA

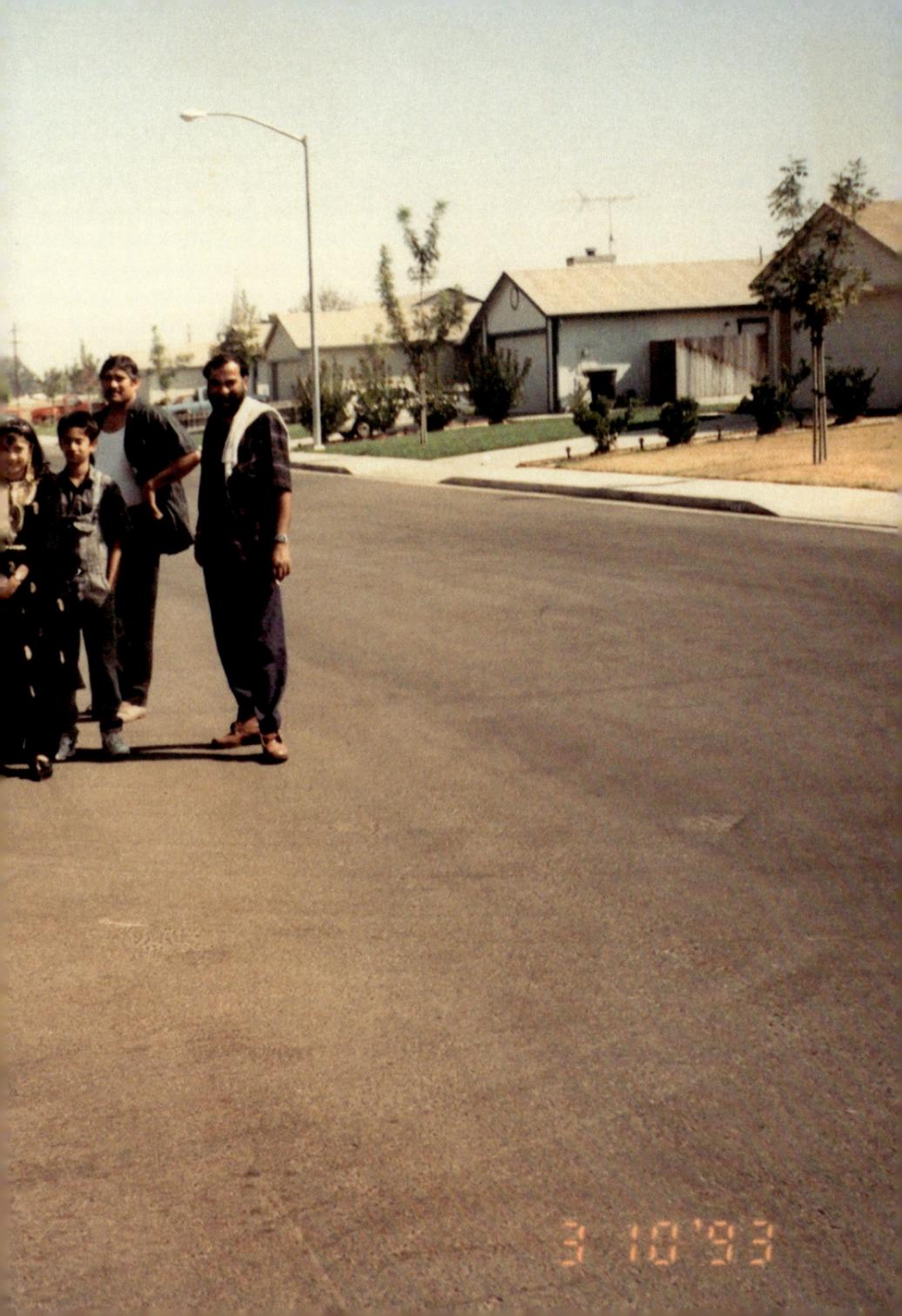

3 10'93

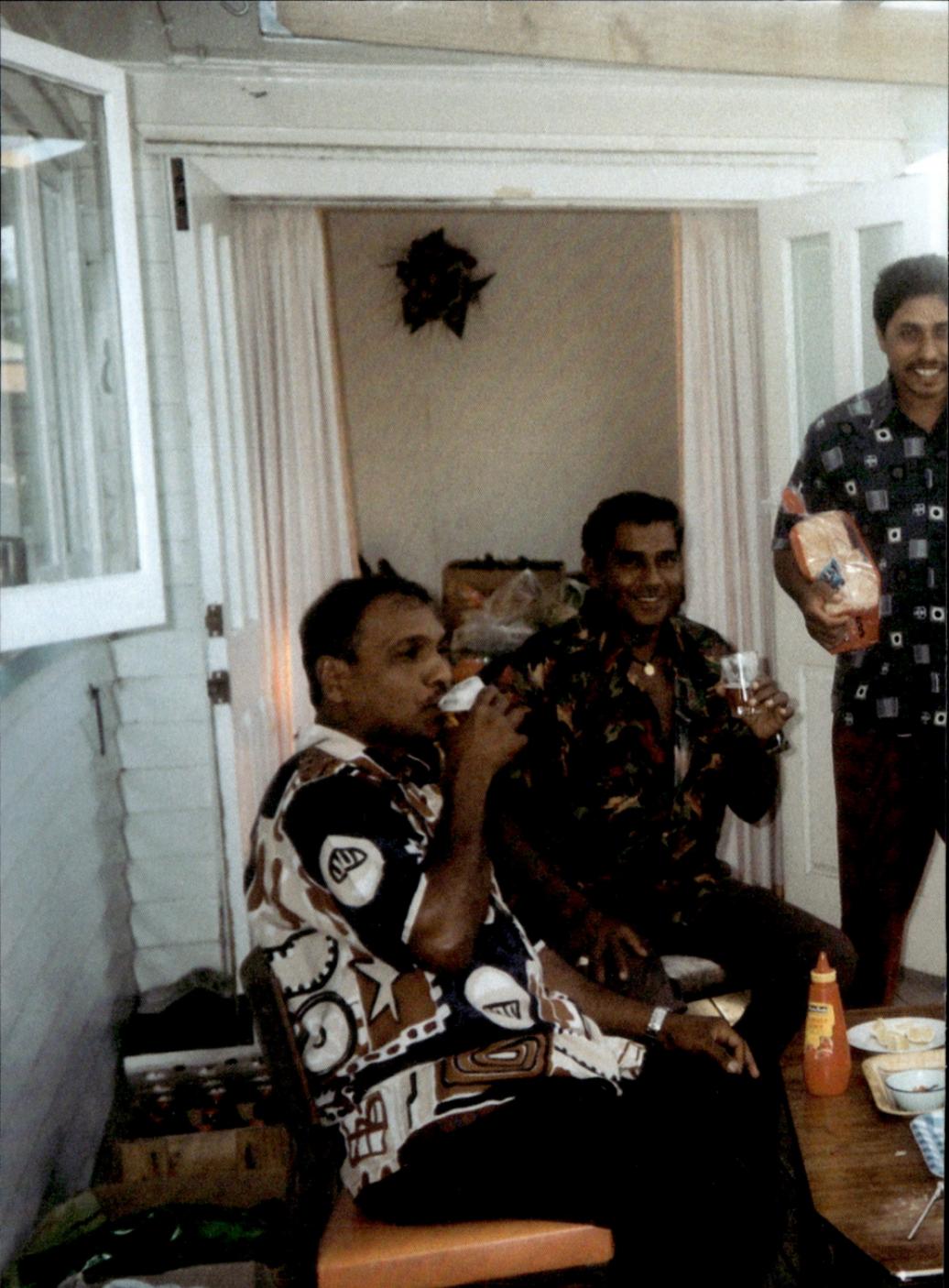

Auckland, New Zealand

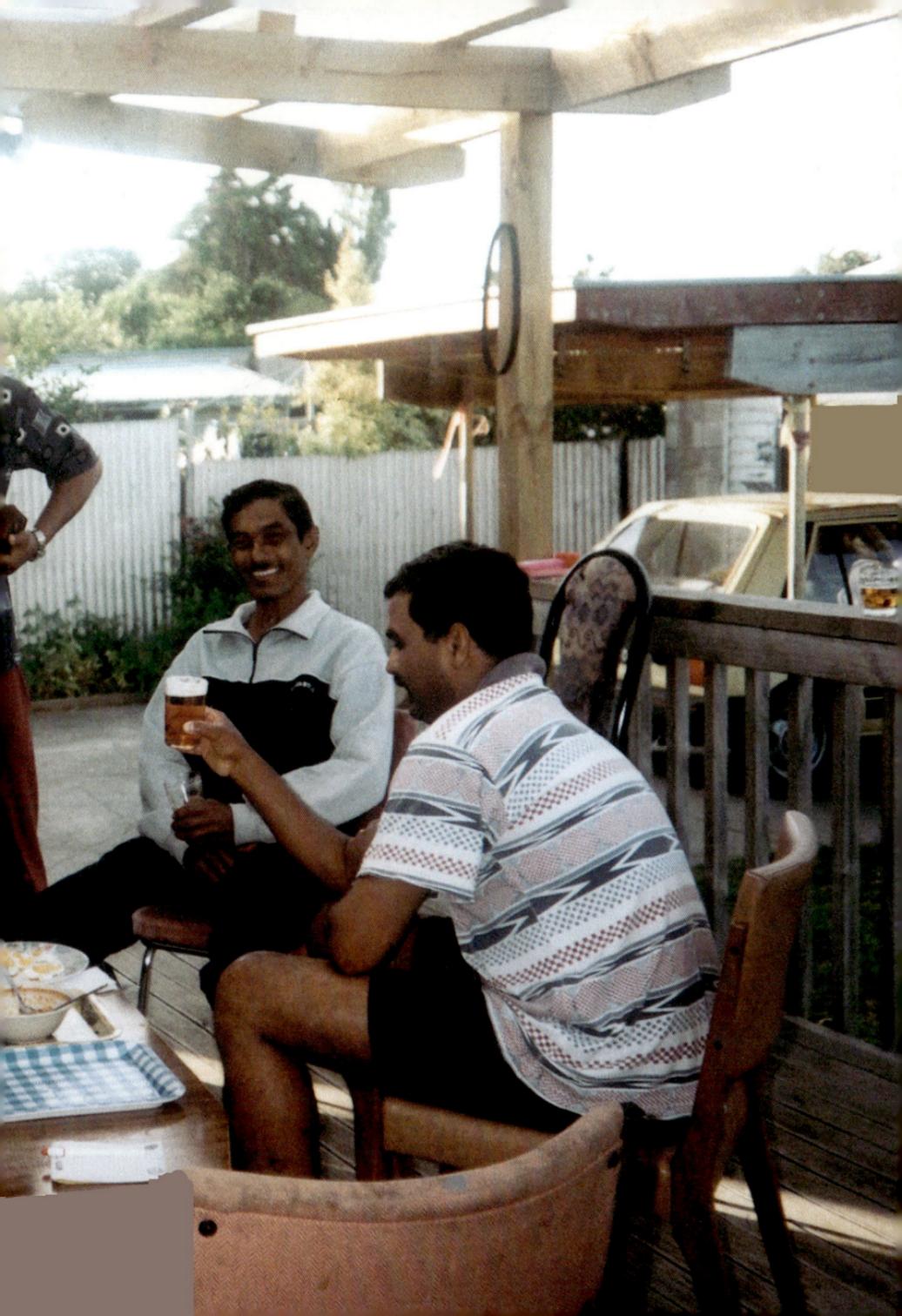

Honolulu, Hawai‘i, USA

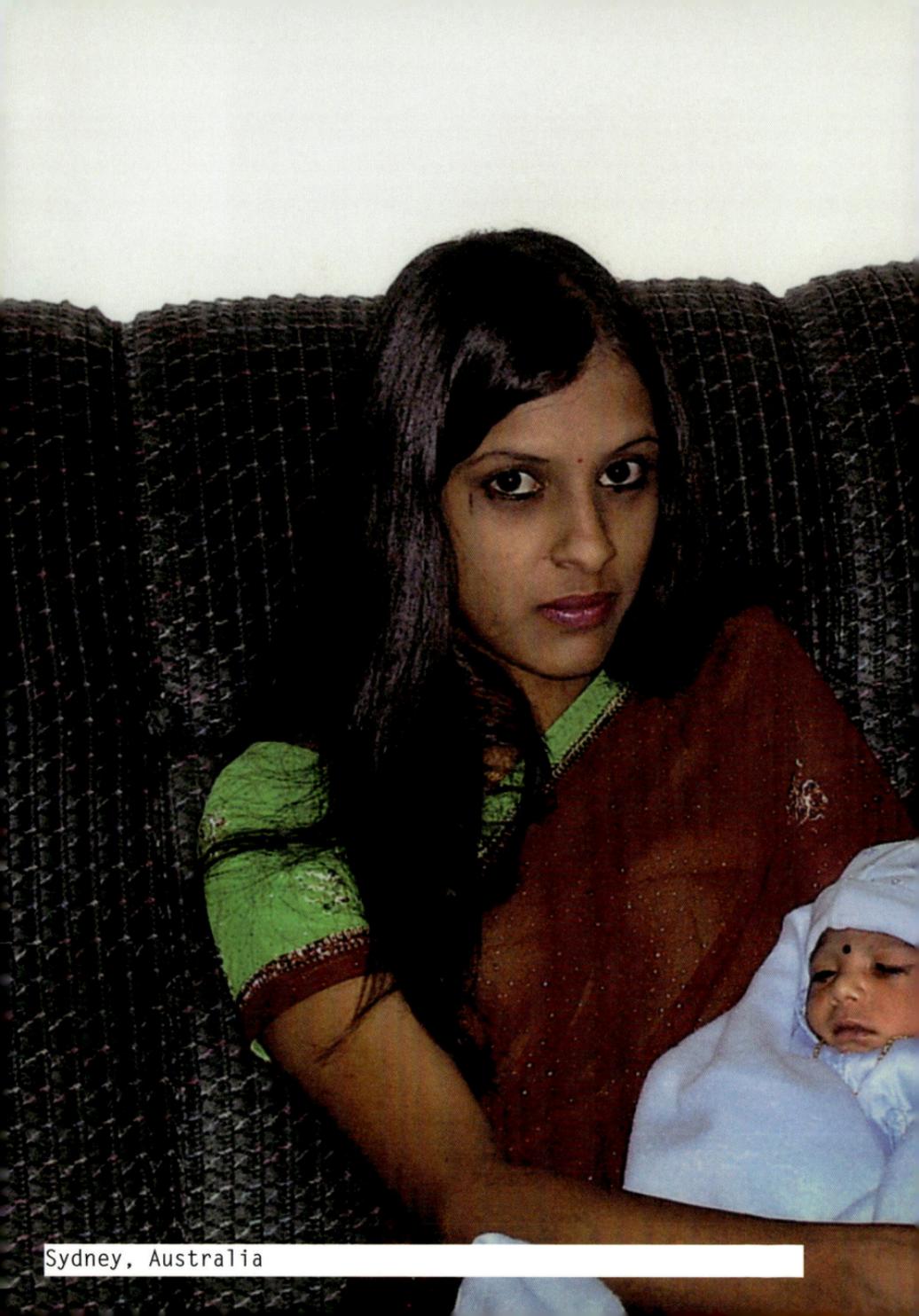

Sydney, Australia

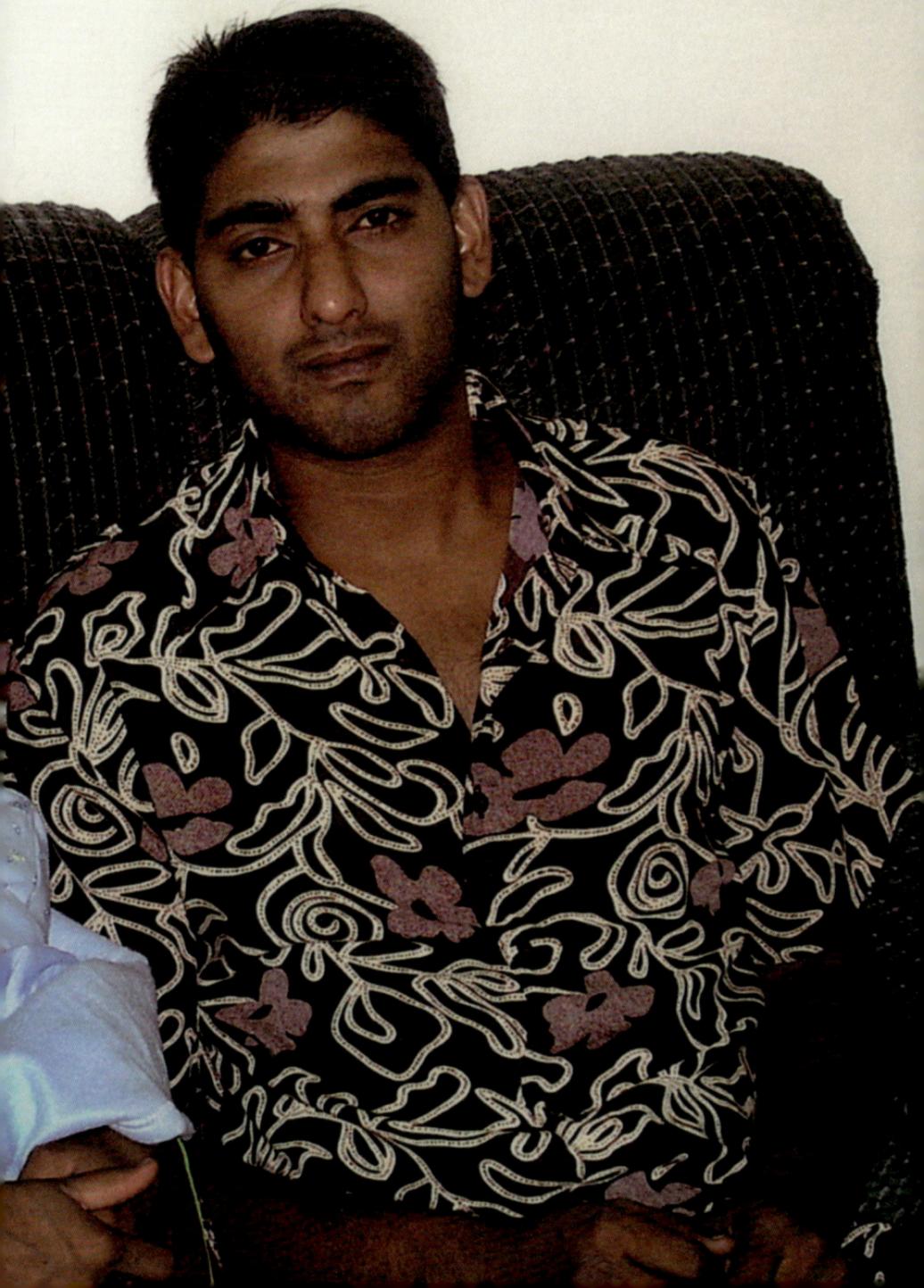

Auckland, New Zealand

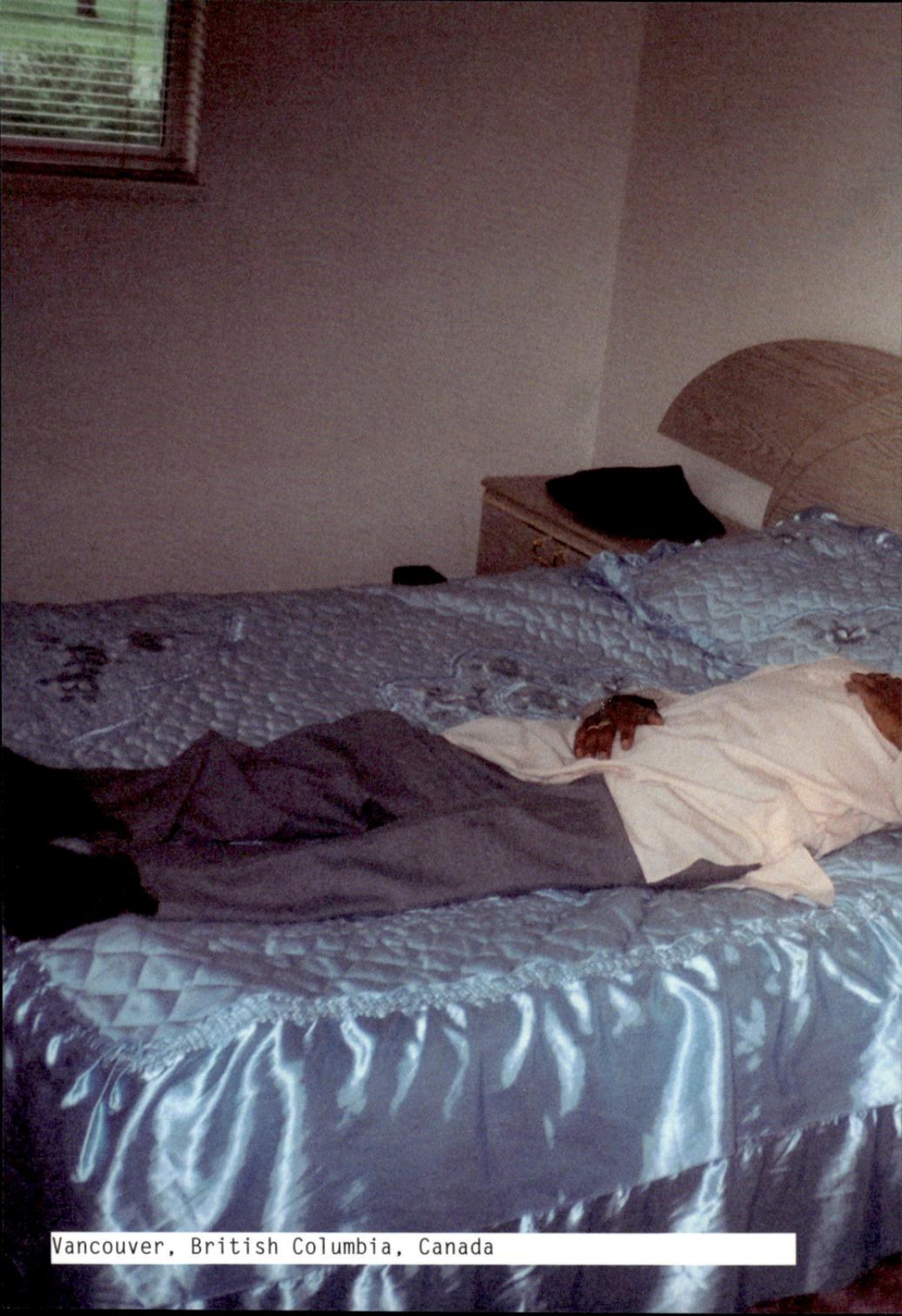
Vancouver, British Columbia, Canada

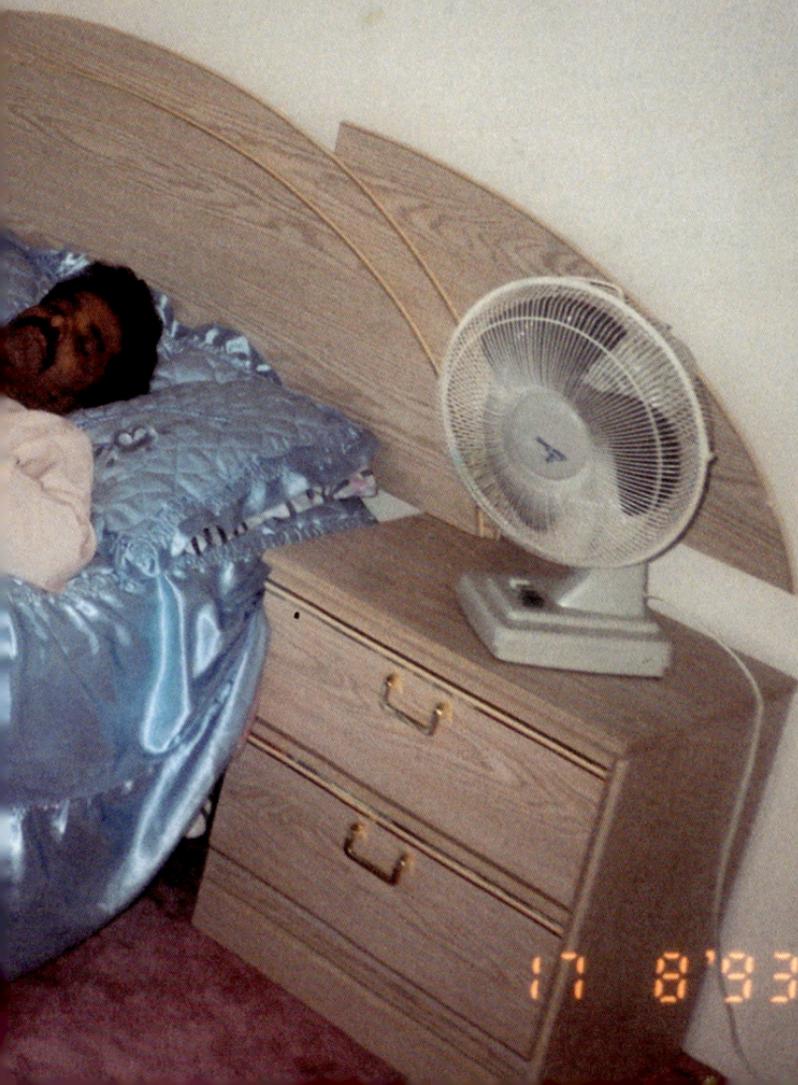

17 8'93

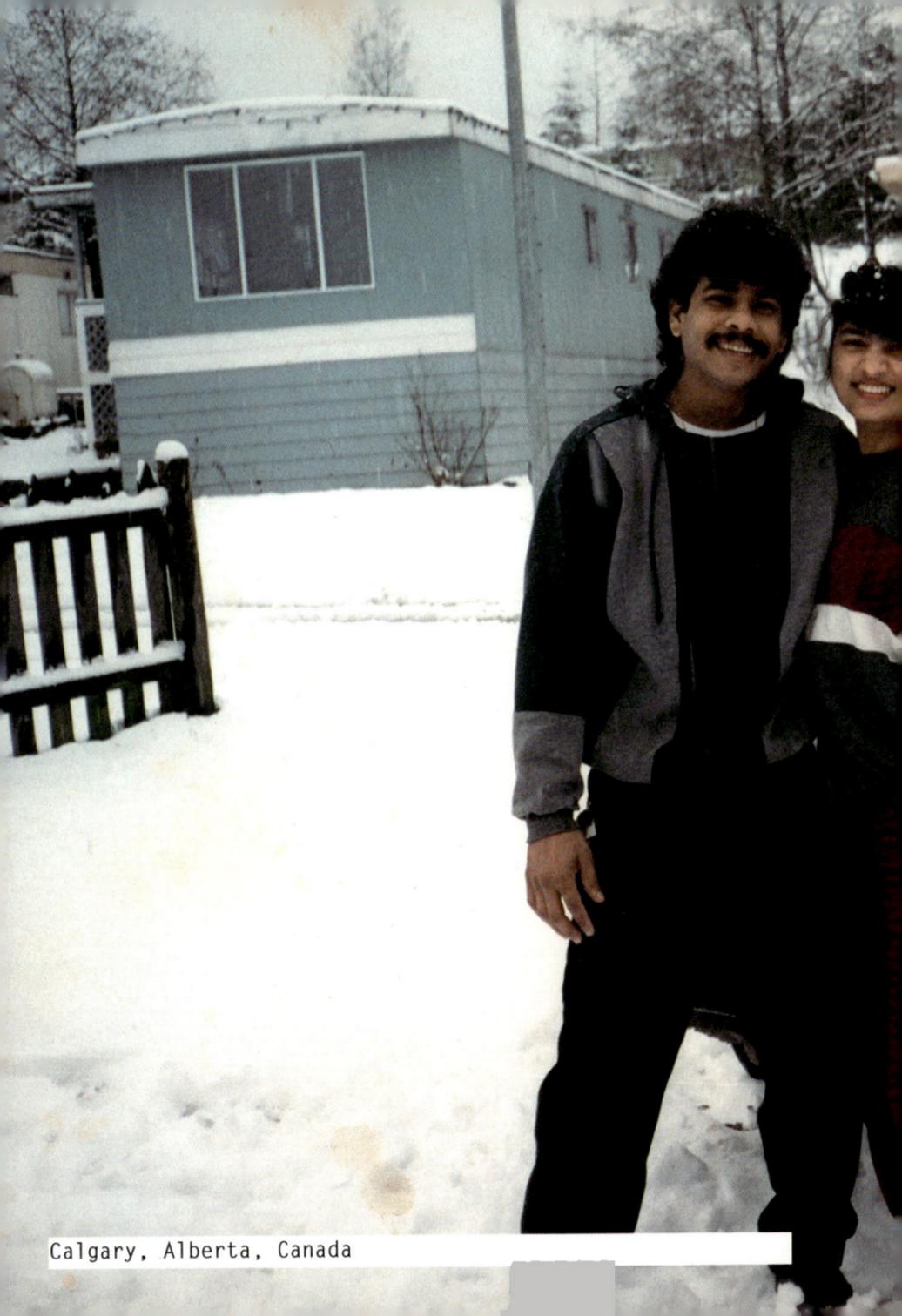

Calgary, Alberta, Canada

THE PHOTOGRAPHS OF INDIAN-FIJIAN SETTLEMENT IN
VATIYAKA WERE TAKEN DURING SEVEN VISITS BETWEEN
JUNE 2000 AND NOVEMBER 2003. THEY ARE OF THE
FAMILIES, AND FRIENDS IN SOME CASES, OF THE
RELATED MEN OF VATIYAKA III CUTTING GANG #18.
ALL HAVE FAMILY WHO HAVE EMIGRATED, AND SOME OF
THOSE I HAVE PHOTOGRAPHED HAVE EMIGRATED SINCE.
AGE- AND DATE-RELATED CAPTION INFORMATION IS
SET AT THE TIME OF EACH PHOTOGRAPH. THE COLOUR
PHOTOGRAPHS ARE A FEW THAT HAVE BEEN POSTED BACK
TO FIJI, THE MOST RECENT IN 2006, FROM THOSE
RELATIVES WHO HAVE EMIGRATED ALREADY. SINCE
THESE PHOTOGRAPHS WERE TAKEN, THERE HAVE BEEN
SOME BIRTHS AND SOME DEATHS.

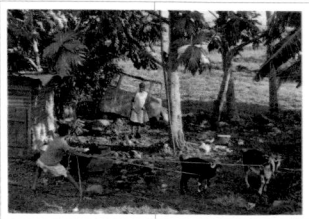

Tuesday, 2 September 2003 When Sashi Devi's children arrived home from school (Sashi is the wife of Aren Kumar who drives the cane lorry for the gang), she at once directed Shayal, her nine-year-old daughter and Shayal's cousin Kushal, who tease each other continually, to gather Sashi's goats from the field and tie them up. Next door, just up the hill, Ravindra Kumar lives with his wife Anjila Devi and their first baby Ashna Devi, and 15 others of his family across three generations.

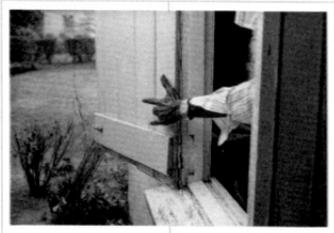

Saturday, 4 August 2001 It is late afternoon and 78-year-old Ram Sundar reaches to close a wooden shutter on the house that he shares with his daughter and a grandson. Rajeshwar Dutt, another grandson, spent time in jail after running with the wrong crowd in Suva. When released, his mother sent him to Vatiyaka, to his grandfather and the cutting gang to straighten him out. He lasted a couple of seasons, but finally, after an argument, he left unannounced.

Sunday, 21 April 2002 *Ram Naumi* is a Hindu festival that runs for eight nights leading to midday on the day of Lord Rama's birth. This year, Dharmen Kumar (38), who on my first visit to Vatiyaka was *sirdar* of the cutting gang, and his wife Padma Wati, each evening hosted readings from the *Ramayan* and offered the *prasad*, the blessed food that is eaten after. This Sunday morning, the music began at 6.45, and others began to arrive an hour later to help prepare food for the gathering to come of the extended family. Nirupa Devi (19) washes dishes with a string of cousins and aunts in Padma's kitchen where the cooking has been done on an open fire and kerosene burner. (Nirupa was married in November 2004 and now lives in Australia. She and her husband have a son Rayner. Her elder sister Anupa was married in August 2003 and now lives in California.)

Saturday, 4 August 2001 Suman Kumar (32) returns from lunch across his cousin Dharmen's recently cut top field. The knives he carries weigh about one pound and produce an elegant arc when swung from above the shoulder to the base of the sugar cane. Some cutters are better than others: quicker, balanced and more focused. Suman and his brother Salance Kumar (33) could claim to be amongst the better skilled.

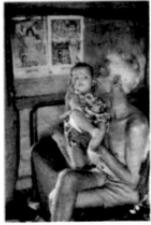

Sunday, 5 August 2001 Ram Khelwan, who even now puts in a full day of cane cutting, embraces his granddaughter Sarina, the daughter of Salance Kumar and Saveena Devi. It is unlikely that Ram Khelwan will live outside Fiji, while, equally, given the trouble in his country of birth, it is expected that the granddaughter he holds will be encouraged to another life in a first world country.

Tuesday, 31 July 2001 Sashi leads her calf and freshly milked cow to her brother-in-law Dharmen's cane field, where they will graze on cane leaves removed and discarded at harvest. Most of the cane cutters wear a single leather glove on the hand they use to clutch the cane as they lean in to cut. Cane leaves have imperceptible serrated edges that are enough to tear at your hands.

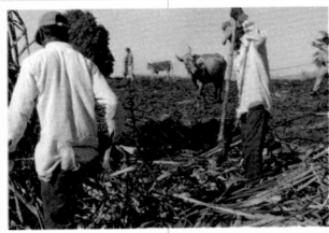

Monday, 1 September 2003 Kushal offers his mother Padma a bite of his ninth birthday cake. It is a small party between the families of Dharmen and his brother Aren. Earlier in the day, after a visit to Ba, I had been at Satish Kumar (43) and Sujila Devi's house off Khalsa Road for a goat curry. Their elder daughter Anupa was married two days before to a young Indian-Fijian man who lives in Hayward, California. In the next few days, she will leave Fiji for the first time to live abroad.

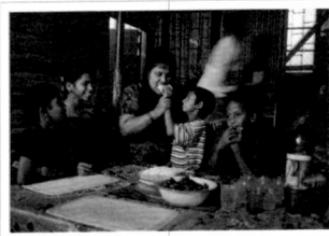

Tuesday, 2 September 2003 Shayal spreads her wings across the makeshift football field outside her parent's house on Vatiyaka Road. Football is the sport of choice amongst the Indian Fijians, and more than once the Ba football team has won the Fiji-wide football competition. Along with her younger brother and followed by her cousin Kushal, Shayal chases after her father who wants to talk with a group of Fijians cutting cane on the land they own across from Dharmen's top field. Indian-Fijians can only lease the land they farm.

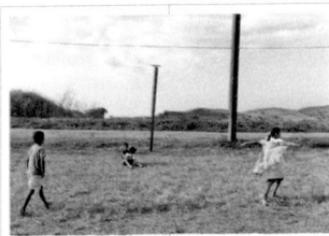

Sunday, 6 July 2003 From day to day, the cutting gang can fluctuate in number depending on health and circumstance. There are never less than 10 men and sometimes up to 13. Between seasons, the make-up of the gang can vary for one reason or another. For example, this year one young cutter had an argument with his family and left the district; another was jailed for a short while for failing to pay child support; the first year I came, a cutter sliced his hand while cutting cane. I saw that only once in the five years I returned to Vatiyaka.

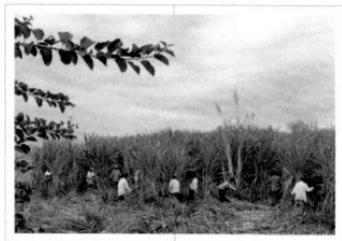

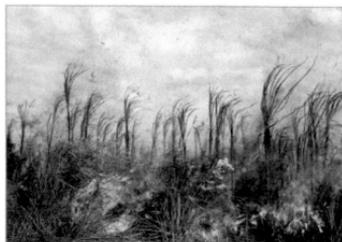

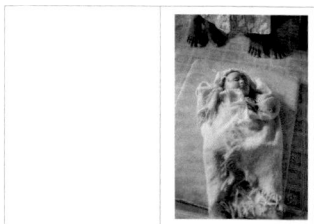

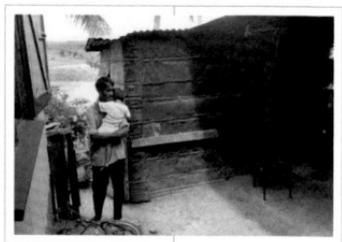

Thursday, 8 November 2001 Balgeet Singh's father planted this sugar cane. Balgeet, a Sikh, is not part of Dharmen's extended family, but lives on Khalsa Road and sometimes joins the Kumar cutting gang. He says he has mixed with Hindus for so long that now he seldom wears a turban. In the land lease disorder encouraged by those who came to power following the 2000 coup, his father lost the lease on half the land he had worked and lived on for 30 years. He lost too the crop he had planted and, consequently, the income from it. There were 80 acres, altogether, of which the Fijian owners kept 40 and renewed the lease on the other 40. The Fijian owners have put a fire through the cane to clear weeds before cutting. After burning the cane, the mill insists that the cane be cut within seven days or they will not accept it. Normally, weed clearing would be part of regular farm management, but in the transition between a farmer losing his lease and the Fijian owners taking back the land, crop management can fall away. It turned out that the Fijian owners employed Dharmen's gang, including Balgeet, to harvest the cane.

Wednesday, 1 August 2001 Sharina Kumar (two months) lies swaddled on the floor of her parents' home. The toes behind her belong to her mother Saveena and Shelin (13), Saveena's niece from next door. Sharina's father Salance, this season works with his father Ram Khelawan, as part of another gang. He and his father joined Dharmen's gang the following year. Earlier in the day, I had been privy to a tense discussion between Dharmen, *sirdar* of the cutting gang, and the gang's president Narend Prasad, who has since immigrated with his immediate family to New Zealand, concerning the size of loads the lorry was taking to the mill. The lorry owner Aren, Dharmen's brother, is paid by the tonne and complained that the loads had been too small to offset the running costs of his lorry. The matter was resolved.

Tuesday, 22 September 2003 Ravindra Kumar (31) calms his first-born Ashna Devi during a lunch-break from cutting. The kitchen out-building to his left has been constructed typically using flattened 44-gallon drums. Two years before, Ravindra's milking cow fell into a ditch and died before it was discovered. He cried that day. Ravindra's twenty-year-old niece Jotika is to be married to a young Indian-Fijian man who has lived in Surry near Vancouver, Canada since he was nine. Joti is very excited: 'He is a nice boy, a nice photo.' He has sent her an album of photographs of their first meeting and engagement. He wants a photograph of her for his wallet which she will select from those she had taken at a

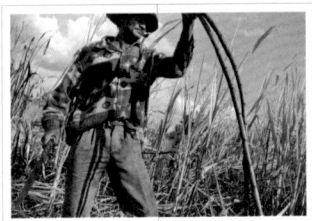

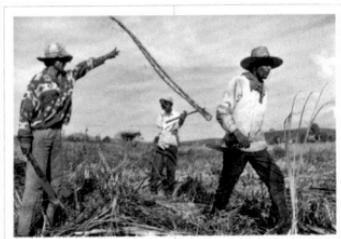

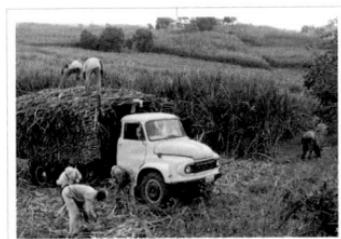

photographer's studio in Ba, the nearest town, in different clothes: jeans, a sari and other clothes.

Thursday, 8 November 2001 Salance along with Suman is amongst the best cutters in the gang. He often wears a red, white and blue, stars and stripes shirt sent to him by relatives living in the USA. The blade of his knife, as with those of the other cutters, is razor sharp. At each water break, you see the cutters resolutely running the small flat files they carry in their back trouser pockets along either side of their knife blades.

Thursday, 8 November 2001 Suman (right) and Salance often work a strip of cane together because they are consistently the quickest cutters in the gang. They are tall, slim, agile, strong and experienced and have an ability to focus as if they reset goals several times a day. Ravindra wipes sweat from his face. Depending on whose cane is being harvested and the current mill price, with a few exceptions, each cutter receives about F$7.50 per tonne and will cut and load about two tonnes per day. However, most members of the gang lease land and will receive, when their land is cut by the gang, around F$25.50 tonne less lorry cartage at F$3.60 a tonne and the various farm management expenses through the year. Each acre in a favourable growing year, if well managed, will produce about 30 tonnes of sugar cane. Most farmers lease about 10 acres. It is a small living.

Friday, 4 July 2003 Jagdish Prasad repairs his cane lorry, an old Ford that has motored around the irregular roads of Fiji for much of its 170,000 miles. Jagdesh's father Bineshri Prasad and Dharmen's father Brij Lal [no relation of the writer, Brij V Lal], both dead now, were brothers. Jagdish's wife Maan Kumari suffered a stroke in 2002, but is now much recovered. Their three daughters all want to leave Fiji.

Tuesday, 31 July 2001 Aren's lorry, loaded here with around 11 to 12 tonnes of cane, is of the same vintage as his cousin Jagish's. This is his second of two loads today. It's almost impossible to get Ford spare parts for these lorries, and when they are available out of New Zealand or Australia, they are expensive. Chinese parts are more readily available, and consistently cheaper.

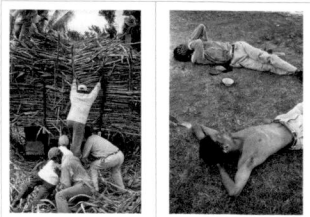

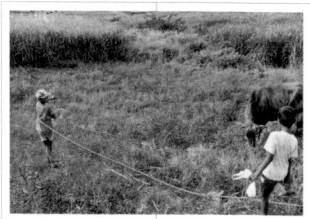

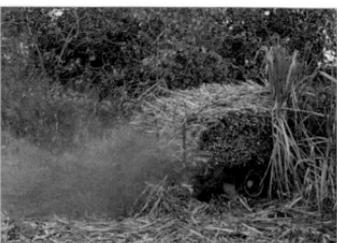

Tuesday, 31 July 2001 Once the lorry is loaded with sugar cane, it must be well-secured for its eight-kilometre journey to the mill on the outskirts of Ba. A wire rope connected at the front of the lorry near the cab is drawn over the load to a hand ratchet where as many cutters as can manage get around it, pull, push and stand to lever the rope as tight as possible.

Thursday, 2 August 2001 Suman rests during a water break with his cousin Salen Kumar. Salen is one of three brothers in the gang. The other two are Anup (35) and Bobby (24) who live together with their immediate family off Vatiyaka Road near Ram Sundar's home. (Salen died unexpectedly in 2006.)

Saturday, 28 June 2003 On school holidays, cousins Kushal and Annal Kumar lead Dharmen and Padma's milking cow down to where the gang is cutting on Ram Dayal's leased land off Khalsa Road. Even during the school break, Dharmen and Padma insist that Kushal and his brother Koonal spend time with homework and improve their English. Education and competence with the English language are recognised ways out of Fiji for Indian-Fijian children. It will be these children who will reach back after immigration to extract their parents from the country of their birth.

Friday, 3 August 2001 Aren's lorry labours out of Dharmen's lower paddock bound for the mill near Ba.

Tuesday, 2 September 2003 Shayal, still in her school uniform, and Kushal, after tying up Shayal's mother's goats, romp about in an abandoned car up the road at Ravindra's house on Vatiyaka Road overlooking the valley to Khalsa Road. Ravindra's house has a water bore. Not everyone in the valley has one as they cost about F$4,000. If you do not have a bore, you buy water from those who do. Every day, you will see one or two of the older children with a two-bullock team hauling 44-gallon drums of water astride old car tyres.

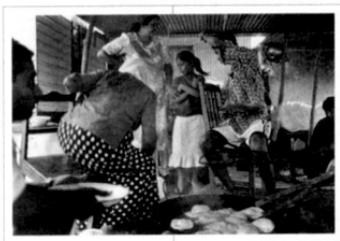

Saturday, 20 April 2002 Chandra Wati, in the polka dot skirt, is Dharmen's mother. She is visiting from Vancouver where she has lived with Dharmen's brother Munen since the death of her husband and Dharmen and Aren's father Brij Lal. Along with others of the extended family, she helps cook over an open fire during the Hindu *Ram Naumi* festival at what was once her home. Shayal is remonstrated with yet again, this time by her older cousin Avinesh Prasad, whose father Ramesh is in the cutting gang.

Thursday, 2 August 2001 Anup Kumar's wife Chandra Wati (not to be confused with Dharmen's mother of the same name) strides across a cane field down the hill from Ravindra's home. Ravindra's family leases 22 acres in two leases surrounding the house off Vatiyaka Road where they have lived for more than 30 years. They successfully renegotiated both expired 30-year leases this year. After the coup, there was an initial burst of refusals amongst Fijian tribal owners to renew leases. When it was realised that this crucial rental income for both government and Fijians was at risk, so successful had the non-renewal programme been, common sense prevailed and Fijian owners were persuaded to renew.

Sunday, 5 August 2001 Ram Khelawan, the father of Salance (foreground), Suman and Arvin, shaves on the stoop of his *bure* after an early finish to the cutting day. The family has just leased a further 11 acres nearby that had previously been leased by last year's headman of the cutting gang Vishnu Deo (52). Vishnu and his immediate family, distressed at what had come to pass, pulled down their home of 30 years, leaving only the concrete pad, loaded it onto a lorry, and relocated away from the extended family to the outskirts of Nadi, where he has a small plot on which to rebuild. He now sells roasted peanuts door-to-door in Fijian villages.

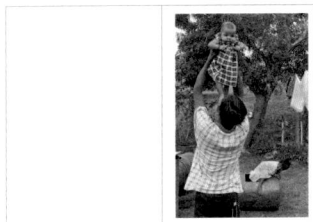

Sunday, 5 August 2001 Salance plays with his two-year-old daughter while the eldest and the most mischievous straddles a water drum. Salance has been married to Saveena for five years. Neither has been out of Fiji even though others of their extended family have emigrated. Their three daughters each with a nickname — Pooja, Xena (after the television heroine) and Daizy — will certainly join their cousins, uncles and aunts overseas as part of the inexorable migration of Indian-Fijians.

Friday, 29 August 2003 Aren's youngest son Annal
on the way to Ba with his father, visits Shree
Vishnu Mandir, the first Hindu temple in Fiji.

Friday, 4 July 2003 While Jagdesh Prasad repairs
his lorry outside, two of his nephews on school
holidays watch an old black-and-white Bombay
movie, *Do Phool* (*Two Flowers*), a story that was
adapted, according to the video case, from *Heidi*.

Sunday, 21 April 2002 At the midday conclusion
of *Ram Naumi*, the women collect the garlands that
decorated the temporary shrine at Dharmen and
Padma's home, and then, along with some of the
young men and boys and with much laughter and
commotion, hoist themselves aboard Aren's lorry
to be delivered to a stream a couple of kilometres
down Vatiyaka Road. There, amidst singing and
cheerful celebration, the flowers are set adrift
upon the stream releasing spirits to calmly float
to the open sea. At this point, pandemonium
overtakes the occasion as buckets are produced and
gallons of water are thrown over everyone at hand
in a ritual purification.

Sunday, 21 April 2002 Dharmen's mother Chanadra
Wati (right) and his wife Padma set the garlands
adrift.

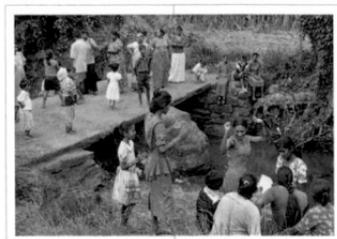

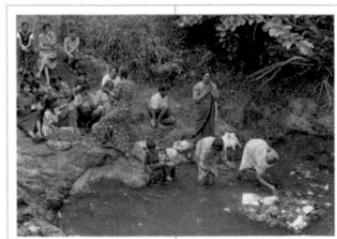

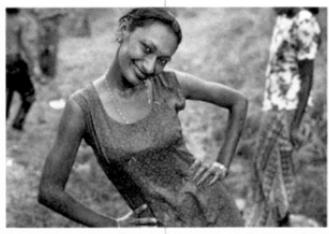

Sunday, 21 April 2002 A drenched and well-purified Anila Prasad (23). Anila's father has a heart condition and is unable to cut cane. They moved this year from Vatiyaka to Vatilolo, a suburb of Ba.

Monday, 6 August 2001 After a field of cane has been cut and the gang has loaded the lorry ready for the mill, a few of them will neatly set fire to the littered cane leaves as the first part of preparation for the next crop. During the cutting season, these fires can be seen throughout the cane growing areas of Fiji warming the deep blue of the evening sky.

Tuesday, 1 July 2003 Aten Kumar's two children Artika (6) and Arishna (4) hang out the household washing while their father is in the field with the gang cutting cane. Aten's elder brother Satish, who farms leased land nearby off Khalsa Road, has come by horse to collect them for the day. Aten and his wife Binita have separated and she has gone to live in another town.

Sunday, 5 August 2001 Beyond the horse that Pooja Kumar (4) tracks along Khalsa Road is the tin home of Vijendra Kumar (51), the cutting gang's headman this year, and his wife Sharma Wati. Sharma spent the previous year with her brother and sister-in-law in Rancho Cordova, California where they have lived for the past six years. They built the house 10 years ago with 30 44-gallon drums cut down and straightened to form the walls. They have no children. (Vijendra died unexpectedly in 2005.)

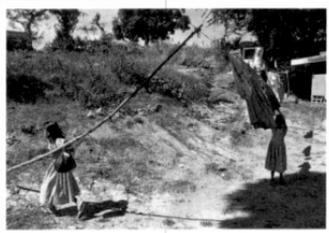

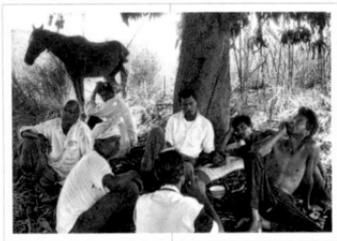

Friday, 9 November 2001 Some of the cutting gang take a water break beneath a mango tree. Left to right: Vijendra Kumar, Ramesh Prasad (with bandanna), Bobby Kumar (at rear), Aren Kumar (making a point), Aten Kumar (the horse is his), Salance Kumar, and his brother Suman.

Saturday, 4 August 2001 Ram Sundar (78), despite his age, still ploughs his leased land with two aging bullocks, but must hire the cutting gang to harvest his crop and clear the road for Aren's cane lorry.

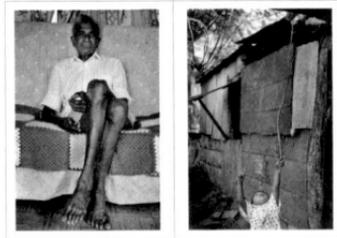

Sunday, 5 August 2001 Two-year-old Devina, Salance and Saveena's second daughter, plays with a thong at the end of a stick outside her mother's kitchen. Devina's spry grandfather Ram Khelawan has been cutting cane for over 45 years and says if he rests now he will become ill. He's never been to hospital and he's never been out of Fiji. His father Ganga Prasad was born in Fiji, but his grandfather was born in India at a place he does not know, and came to Fiji as an indentured labourer, a *girmitiya*, to cut sugar cane.

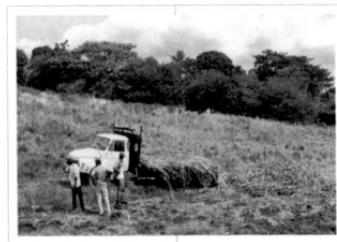

Tuesday, 31 July 2001 While negotiating the uneven track out of Dharmen's lower paddock, Aren's lorry tipped more than it should have and, as if in slow motion, smoothly shed its load. This calamity happens rarely, if only because the men know that the cane must be reloaded with the usual sweat and grind. Everyone makes certain that the load is well strapped and any potholes in the track are filled. Not so this day. When asked who was to blame, Dharmen replied, 'No one to blame' — even if the shouting and body language suggested otherwise — 'Just bad luck — but no one died, nothing broken.'

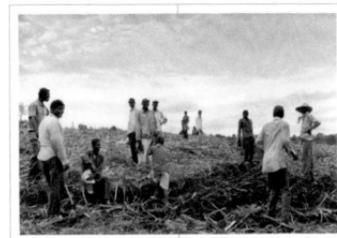

Sunday, 6 July 2003 By late afternoon, the gang has completed the harvest of Ram Dayal's crop and the lorry is loaded ready for Aren's evening drive to the mill. The cutters will now idle up the hill to Ram Dayal's house where his wife has made aluminium pots of sweet tea. Left to right: Aren Kumar, Ram Dayal, Dharmen Kumar, Bobby Kumar, Aten Kumar, Salendra Kumar, Kushal Kumar (Dharmen's eldest son), Salance Kumar (clutching his US flag shirt), Ravindra Kumar, Ram Khelawan (at rear obscured), Arvind Kumar (sitting at rear), Ramesh Prasad, Salesh Karan, Suman Kumar.

Tuesday, 31 July 2001 One member of the gang, generally the least experienced, will be tagged to be the water-boy. He will stop cutting and take a welcome walk to the nearest house to collect water-filled aluminium teapots — sometimes, plastic buckets — and carry them with universal enamelled bowls to the cutters ready for their break. The cutters have been working since 6.30 and their first break is about 9.00 when they will sit in the field, in the shade if they can, swap roti and curry, smoke *suki* (strong tobacco wrapped very thinly in newsprint), drink water, and sometimes drink *yaqona*, or grog, as it is commonly termed.

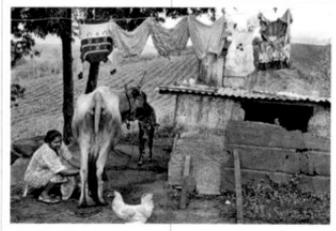

Saturday, 4 August 2001 Anup's wife Chandra milks her cow after organising her four children to the school bus that comes at 6.30. Besides the children's school lunches, she will have made a roti and curry lunch parcel for Anup and his two younger brothers in the cutting gang, Salendra and Bobby, who live in the same house near Ram Sundar with their grandmother and grandfather.

Sunday, 29 June 2003 Swaran Lata eats lunch after she has seen her husband Ram Dayal back to the cane field. Some cutters walk home for lunch if they are working nearby. Their elder daughter Neelam Ashika (24) went to Vancouver on a student visa, and now has Canadian permanent residency. Her twenty-two-year-old sister Nalini Ashika still lives at home, but is engaged to a Punjabi who lives in Sacramento, California. Padma's brother has arranged the marriage, but Nalini first requires a US visa. If she doesn't have a response to her application in six months to a year, she will apply again. Swaran's parents went to Sacramento the year after the 1987 Fiji coups.

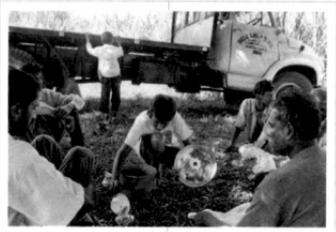

Tuesday, 1 July 2003 During a lunch break, Aren's elder son Nilesh (14) dispenses *yaqona*, or grog. Indian-Fijians have taken to grog, a traditional and ceremonial drink of the indigenous Fijian, with such eagerness that it is now considered a social problem. Groups of men — very seldom women — will drink grog, a mild narcotic, into the early hours of the morning, as well as partake most days in breaks from cutting cane. Dharmen and Padma sell grog powder from a small, income-supplementing shop they run out of their home, and find it hard to keep pace with demand. Padma buys bundles of *yaqona* root at the market in Ba, and spends hours pounding it to powder before spooning it into small, white paper bags for sale at F$2.00 each.

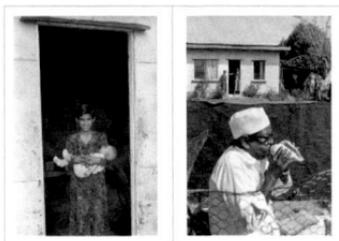

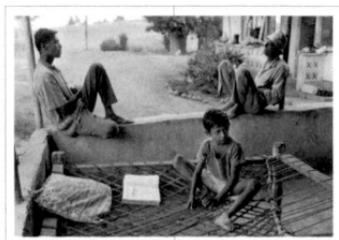

Saturday, 4 August 2001 In the doorway of Ram Sundar's home, Anup's daughter Sangeeta Kumar (12) proudly cradles her cousin Ashna. Ashna is the first child of Ravindra Kumar and Anjila Devi.

Saturday, 4 August 2001 Ram Sundar's grandnieces Roshni Lata (18) and her cousin Sangeeta Kumar look across to Pandit Genda Maharaj who blows a *sunkh* during Ram's regular Saturday morning *puja* convened to pray for the well-being of his family. Family groups within the extended family have *puja* at the home of one of the group either on a Tuesday evening or Saturday. These *puja* are held in addition to celebrating other Hindu festivals dotted through the calendar. Each group will have its regular *puja* pandit who will lead the reading of the *Ramayan* punctuated with the group's zestful singing with music often played by members of the cutting gang.

Thursday, 8 November 2001 Cousins Aren Kumar and Ramesh Prasad rest while waiting to negotiate a contract for ploughing and planting sugar cane with a Fijian owner who is in the field next to them burning out weeds. This was Bhaget Singh's father's leased land, until the lease ran out this year. The Fijian owners have decided to keep half and renew the lease on the remainder for 30 years. Aren and Ramesh will help organise the contract to plough and plant after the harvest: F$8.00 per day to plant, and the tractor at F$110.00 per hectare for ploughing. 'We are going to help him because he is a nice man, eh,' says Aren.

Tuesday, 2 September 2003 On the hill across from Dharmen's house, Aren and his nephew Kushal visited Harbindar Singh and his wife, a Punjabi couple in their 50s. They had immigrated to the US a little over two years ago to be with their elder son, who is a lawyer and studying part-time for a Masters degree, and their daughter-in-law, who is an accountant. Harbindar found employment in the kitchen of a Japanese restaurant where he remained for five months until he could endure it no longer. He opted to return to 'the freedom and lifestyle' of his leased sugar cane farm in Vatiyaka, leaving his wife to work on the grill at a McDonald's restaurant. She now visits their home in Vatiyaka once a year.

Saturday, 4 August 2001 The cutting gang has been harvesting on contract some of Ram Sundar's sugar cane. In appreciation, he has invited the gang to lunch after his morning prayers. The men sat outside, first, on a mat of cut-down jute fertiliser bags to drink grog beneath a sizeable tamarind tree heavy with long, finger-thick pods of seed.

Sunday, 31 August 2003 A goat is butchered to feed guests the day after the arranged wedding of Anupa Devi (20) and Sandeep Rahul Sharma (22). Rahul, an Indian-Fijian who has just completed a university science degree in the US, has lived with his parents and two sisters in Hayward, California since they emigrated in 1991. Anupa is the elder of three daughters of Satish and his wife Sujila. Satish is not in the cutting gang, but is the brother of Aten who this year is the joint headman of the gang with Suman. Satish and Aten have a brother in Vancouver while Sujila has four brothers and a sister in New Zealand. Two of her brothers married two sisters a few years apart.

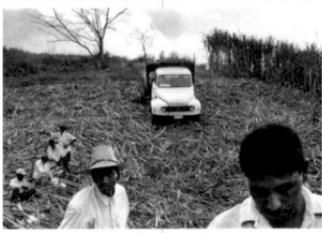

Wednesday, 8 August 2001 Ram Sundar stands in the background with Bobby, Vijendra and Aten during a water-break while harvesting Ram's sugar cane. The man in the foreground to the right of Suman is to immigrate soon to New Zealand to marry a young Samoan woman. 'She is very beautiful,' he repeated through the day.

Wednesday, 5 July 2000 Down the road from Vatiyaka near Kings Road, the main north road across Viti Levu, an Indian-Fijian leaseholder — not of the Kumar extended family — has hired a group of Fijians to harvest his crop. Most young Indian-Fijian men have no desire to cut sugar cane. They want to leave the country. This has produced a labour shortage where some leaseholders find it necessary to hire labour other than Indian. On Fiji television news at 10.00 tonight, it is reported that George Speight, the front man of the coup, has been given 48 hours to release the prime minister Mahendra Chaudhry and the other hostages and then leave the parliament buildings, or lose an offered amnesty. Speight is currently serving a life sentence for treason.

Tuesday, 1 July 2003 Sumintra Devi (90) was married to the late Binesri Prasad who was the eldest of Dharmen's uncles on his father's side. She is living with her son-in-law and daughter, Ramesh Prasad and his wife Manjula Devi and their four children. They moved to their current home in Vatiyaka after Ramesh's nephew Narend (who was

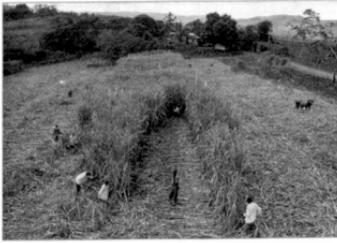

president of the cutting gang in 2001) vacated the house to immigrate to New Zealand with his wife and two children.

Thursday, 2 August 2001 Dharmen and Padma's house stands amongst trees at the end of their field of sugar cane being harvested by the cutting gang. Vatiyaka Road is to the right. Within this gang, the cutters mostly work in pairs. Everyone will cut the same amount of cane, just at different speeds. For instance, brothers Salance and Suman steam ahead, strip cutting, and, as with everyone else, neatly laying the cane in rows a lorry width apart ready for loading from both sides.

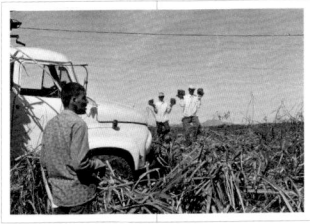

Wednesday, 1 August 2001 Suman and Aten carry rocks from the side of the road nearby that they and the others in the gang will use to hammer at the stacked cane on one side of the lorry to even up the load by the stretch of the hand. If they do not attend to this, there is an increased chance that the lorry will spill its load on the bumpy exit from the field. Salesh (at left) is the grandson of Ram Sundar.

Friday, 3 August 2001 Sharma Wati's husband Vijendra Kumar (51) is headman of the gang, having taken over from Vishnu Deo (52) who lost his lease last year and moved with his family to the outskirts of Nadi. The headman is the organiser of the gang and must have, Vijendra explains, 'Good manners and respect — you must not get angry. Some other gangs throw knives and cut off hands, quarrel and fight — but we are family.'

Thursday, 8 November 2001 For some reason, Aren's younger brother Sanjay, at right, washing his legs and feet, is always to be seen cutting cane while barefoot when everyone else will have some sort of footwear. (Sanjay has since immigrated to New Zealand.)

Saturday, 5 July 2003 Shayal leans against her father Aren on a clammy evening at home — it is her ninth birthday party. Her brother Annal and cousin Kushal play fight on the top bunk in the children's bedroom until Aren cautions them to be calm. Earlier in the day, in a well-appointed house in Ba, I met the poet and novelist Jogindar Singh Kanwal who wrote *The Morning*, an affecting and beautiful novel of triumph based on the indenture system in Fiji at the turn of the century before last. He is a retired principal of local Khalsa College, and much of his material for the story came from conversations over many years with the people of greater Vatiyaka.

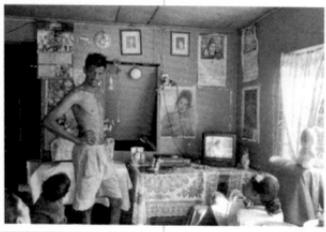

Thursday, 3 July 2003 Suman, this year's joint headman of the cutting gang, deliberates with his wife Sarita Devi over a list of errands before taking the bus into Ba. It is school holidays and his daughter Shalin (11), her cousin Sanjini (6) and Sarita have been absorbed in a Bollywood video. Suman has finished cutting earlier than usual. Sometimes the mill in Ba has more sugar cane than it can process and halts deliveries. As well, every Tuesday during the season, the mill closes for cleaning and cannot receive cane. The various cutting gangs in the region harvest and load their lorries, but it will be a short day. Early the next morning at the mill, scores of lorries wait uncomplainingly in line for hours before sliding their loads into the crusher.

Friday, 29 August 2003 Anupa Devi is to marry Sandeep Rahul Sharma tomorrow at the Vatiyaka home of Anupa's parents Satish Kumar and Sujila Devi. The second day of the three-day wedding custom is punctuated with deep ritual, high spirits and preparation for this evening's distractions for the collected family and friends of Anupa and her parents. The entertainment will focus on two astonishingly enthusiastic singing and dancing transvestites who have been hired for the night. Rahul's family will not be there. They are in Nadi and will arrive tomorrow morning.

Saturday, 30 August 2003 Her young cousin Artika Bandna pilots Anupa to her wedding closely attended by her two sisters Anupa (left) and Kartik. Anupa's mother and an entourage of aunts follow. Seven days after this moment, Anupa will leave Fiji for the first time to live with her husband and his parents in Hayward, California. Marriage can be a way out of Fiji.

BRUCE CONNEW

FOR CATHERINE, SALLY, JANE, TIM,
ALICE, OLIVER AND QUINN, AND THE GOOD
PEOPLE OF VATIYAKA

The good Fiji citizens
of Vatiyaka, many of whom
are represented here in the
photographs and by name, must
be acknowledged and thanked
for their kindness, gener-
osity and welcome, even at
times of stress and change;
particularly Dharmen Kumar,
his wife Padma, and their
two fine boys Kushal and
Koonal, who gave me a roof
and cared for me, all the
while managing my time and
progress in Vatiyaka. At
the outset, Satendra Singh
knowingly led me to Dharmen.
I thank Catherine, my wife,
who encouraged this work and
enthusiastically took charge
of our house building in my
absences. She applied her
love, mind and talent to the
design and typography of the
book, to its look and feel;
and my children, Sally, Jane,
Tim, Alice and Oliver, and
grandson, Quinn, who fill me
with gladness. Quinn's Fiji
family offered me direction
and warmth. There are those
of my friends who fiddled
with the selection and
sequence of my photographs
and texts to improve their
meaning and expression.
Brij V Lal, a scholar and
fine writer whose company
and knowledge I have been
fortunate enough to enjoy,
was introduced to me by
Shyam and Pearl Murti after
I had read *Chalo Jahaji*,
Brij's important book on
Indian indenture in Fiji.
There are those who have
lent their valuable support:
Teresia Teaiwa, David Hanlon,
Fergus Barrowman, William
Hamilton, Michael Gifkins,
Glenn Busch, Trish Allen,
Jason Busch, John B Turner,
Bridget Parrott, Vijay Mishra
and Elizabeth DeLoughrey.

BRUCE CONNEW IS A NEW ZEALAND-BORN
DOCUMENTARY PHOTOGRAPHER. HE HAS PUBLISHED
A NUMBER OF BOOKS AND HAS EXHIBITED WIDELY.
HIS PHOTOGRAPHS ARE IN PUBLIC AND PRIVATE
COLLECTIONS.

BRIJ V LAL IS PROFESSOR OF PACIFIC AND
ASIAN HISTORY IN THE RESEARCH SCHOOL OF
PACIFIC AND ASIAN STUDIES AT THE AUSTRALIAN
NATIONAL UNIVERSITY. FIJI-BORN, HE HAS
PUBLISHED WIDELY ON FIJIAN AND PACIFIC
HISTORY AND WRITTEN ON THE HISTORY OF THE
INDIAN INDENTURED DIASPORA. HE WAS A MEMBER
OF THE FIJI CONSTITUTION REVIEW COMMISSION,
WHOSE REPORT FORMS THE BASIS OF FIJI'S
CONSTITUTION.

UNIVERSITY OF HAWAI'I PRESS
2840 Kolowalu Street
Honolulu, Hawai'i 96822-1888, USA
www.uhpress.hawaii.edu

ISBN 978-0-8248-3198-1

First published in 2007

With the support of
CENTER FOR PACIFIC ISLANDS STUDIES
UNIVERSITY OF HAWAI'I AT MĀNOA,
ASIA NEW ZEALAND FOUNDATION,
CREATIVE NEW ZEALAND

creative
nz

Design and typography
CATHERINE GRIFFITHS
www.catherinegriffiths.co.nz

Printed by EBS, Verona, Italy

The book is set in Bryant Light
and Letter Gothic Standard